TEXTILES FROM BENEATH
THE TEMPLE OF PACHACAMAC, PERU

MUSEUM MONOGRAPHS

TEXTILES FROM BENEATH
THE TEMPLE OF PACHACAMAC, PERU

A PART OF THE UHLE COLLECTION
OF
THE UNIVERSITY MUSEUM
UNIVERSITY OF PENNSYLVANIA

By
INA VANSTAN

PUBLISHED BY
THE UNIVERSITY MUSEUM
UNIVERSITY OF PENNSYLVANIA
PHILADELPHIA
1967

Price $5.00

Please send orders for *Museum Monographs* to

The University Museum
33rd and Spruce Streets
Philadelphia, Pennsylvania. 19104

FOREWORD

The original aim of this project was to do a thorough study and record as much information as possible concerning the Peruvian textiles in the University Museum's Uhle collection, and thus put in accessible form detailed descriptions of these textiles. Although this Uhle collection includes the first Peruvian textile materials for which archaeological data were recorded, few analyses of these have been made and comparatively little has been published concerning them, despite their importance to other textile studies.

Investigation showed the scope of the undertaking to be so extensive that the plan was modified to include, as a beginning, only the textiles from one small area "beneath the Temple of Pachacamac." The number of specimens studied and included in this report was further reduced by the inaccessibility of part of the collection, due to Museum storage problems.

The progress of the project to its present stage has been made possible through the help of many people. Thanks are extended especially to two former members of the University Museum staff, the late Dr. J. Alden Mason and the late Miss H. Newell Wardle, for early encouragement, and to Dr. Alfred Kidder II, Miss Geraldine Bruckner, and Miss Barbara S. Baker, of the present staff, who have assisted with innumerable details. Financial support has been given by the Florida State University Research Council over a period of several years. Thanks are due also to a number of individuals, too numerous to name, who have helped with the drawings, photography and clerical work essential to the completion of the paper, and to Florida State University, where working space and equipment have been provided and faculty time set aside for research.

— Ina VanStan

Florida State University
Tallahassee, Florida

December, 1967

v

CONTENTS

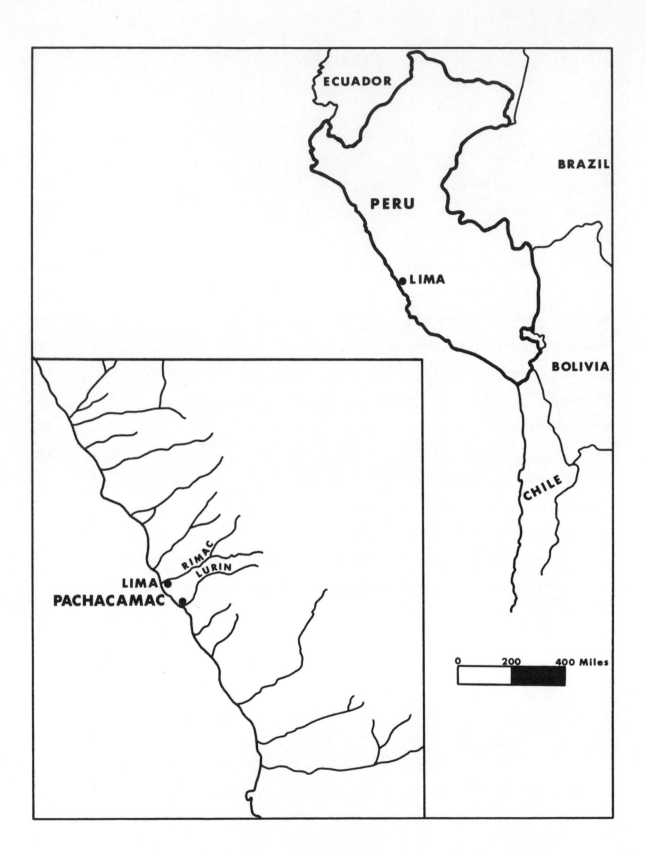

ECUADOR

PERU

BRAZIL

LIMA

BOLIVIA

CHILE

0 200 400 Miles

RIMAC

LURIN

LIMA

PACHACAMAC

INTRODUCTION

This study deals with about 160 of the textiles that were recovered at Pachacamac by Dr. Max Uhle. All were obtained during the William Pepper Peruvian Expedition of 1896-97, sponsored by the University of Pennsylvania Department of Archaeology. The textiles constitute only a small part of the total archaeological collection, now housed in the University Museum, and the present group represents only part of the textiles from the section of the Pachacamac site which Uhle designated, "Beneath the temple of Pachacamac." The 160 specimens are a random lot chosen on the basis of their accessibility in the Museum at a particular time. Although some types listed in the catalogue are not represented, the group appears to be a fair sampling of the whole. Many of the pieces are fragments. Some are ragged or badly charred. A large number are without ornamentation of any kind.

The information which Uhle provided about his textile finds seems meager until compared with the much scantier offerings of more modern archaeologists. Uhle gave each item a number and entered these numbers, with identifying descriptions, and sometimes added comments, in his *Field Catalogue* (1896-97). Generally the numbers are in sequences related to the digging or collecting and are arranged under headings and subheadings. A few of the textiles, together with other artifacts, are identified as parts of specific grave lots with references to mummies or skeletal remains (skull numbers). Unfortunately, as with most old handwritten records, some parts of the catalogue are now illegible and it is impossible to determine the items to which certain of the notes and headings apply. This original catalogue, now bound but not published, is in the University Museum Library in Philadelphia.

The only report which Uhle prepared for publication was the single volume, *Pachacamac* (1903), and no other major study of the Uhle collections from Pachacamac has been published. Uhle's report includes references to only a small proportion of the artifacts he found. The site is described, previous work reviewed, and conclusions are presented with supporting evidence. The emphasis is on the nature of the designs as they represent various styles having sequential relationships as indicated by the archaeological stratifications which Uhle found. Since practically all references to specific items are presented in terms of these styles, usually ceramic-based, the textiles, except where designs distinguishable as belonging to one of these styles are present, are usually left without bases of reference. Although Uhle included maps and diagrams of the areas he excavated (1903, Plate 3, Figs. 2-5) and Strong and Corbett, who worked nearby in 1941-42, have presented one of Uhle's diagrams in a simplified form (Strong, Willey and Corbett, 1943, Fig. 2), it is difficult if not impossible, to place particular artifacts in their correct archaeological categories. References, which no doubt were clear to Uhle, are obscure when considered with today's limited knowledge of the site as it was in the last years of the nineteenth century. Since no further clarification is possible at present, Uhle's terminology has been adhered to in this report wherever possible.

In his descriptions of the textiles, in both the *Field Catalogue* and *Pachacamac,* Uhle frequently listed techniques, colors, and fibers, added notes on styles, sizes, and proportions for certain of the specimens, and sometimes commented on their style affiliations. Despite this, when a large proportion of the textiles are unpatterned and many fragments show only small portions of what may have been widely varying patterning, ceramic-based, design-oriented style sequences are of limited usefulness in textile classification.

For such classifications, a body of textile-based information is needed, one built up through the analyses of the textiles themselves, to form an independent source of reference which can supplement and be supplemented by the ceramic-based data. Some studies of this type have been made. The presentation of many more detailed studies and cross studies will be required before a workable framework of textile reference material can be constructed and before broad conclusions, which are more than hypotheses, can be drawn.

Detailed reports of the textiles and related artifacts belonging to specific burials provide one means

for setting up a body of textile reference material. While studies of this kind can and should be made for some of the Pachacamac textiles, many of the specimens came from disturbed burials and their grave associations have been partially or completely destroyed. Uhle noted the presence of intrusive burials of later dates, and of grave soil which had been reworked and, in one case, used as fill under the walls in the rebuilding of the temple. Further, since the present group of textiles consists of a random selection, only parts of some of the existing grave-lots are included.

Another means for providing an organized body of textile reference material is through classifications based on the weaves or other methods of fabrication. Generally this method is applicable only when dealing with a homogeneous group of selected examples, but due to its value in distribution studies, it should not be overlooked.

A third method relies on the characteristics of the textiles as artifacts—their form, size, shape, proportions, texture, and the presence or absence of ornamentation with its type and location when present—as the basis for classification. This method has been used for the present study in so far as possible.

In grouping the specimens, both the appearance of the particular item and Uhle's designation, if given, have been used in determining a set of categories and in placing the various specimens in these categories. The classifications in some instances, especially where only fragments remain, are arbitrary and, as more textiles are studied, may prove to be incorrect. It seems most probable that, as work with the remainder of the Pachacamac textiles progresses, additional categories will be required and revisions will be essential.

Each item has been identified by the Museum catalogue number, followed by Uhle's field catalogue number, in brackets. References in the text which are indicated by page number only, refer to the *Field Catalogue* (1896-97). Those from *Pachacamac* are preceded by the date of publication (1903). Color identifications have been used when the colors are sufficiently well preserved for these to be of value. All follow the Maerz and Paul, *Dictionary of Color* (1950) designations. In the text, warpwise measurements precede weftwise, unless otherwise stated. Warp counts precede weft counts, and warps are mentioned first in yarn crossings which distinguish one weave from another. In the illustrations, except for the made-up articles, or where design units have been presented independently, the warp direction is vertical or indicated by an arrow. The parts of any one illustration, other than inserts of enlarged detail, are alike in scale.

GROUP I: POUCHES

A considerable number of these textiles from beneath the temple of Pachacamac are listed as pouches. Uhle has described these variously as mummy pouches, pouches of the mummy bales, small pouches for *remedios,* and pouches for implements. Presumably he considered some to have served only funerary purposes while others were intended primarily for use by the living. In *Pachacamac* Uhle has mentioned several decorated pouches but although undecorated pouches are more numerous in the Catalogue listings, he has described only one in his published report.

UNDECORATED POUCHES

Thirty of the undecorated pouches are presently available for study. Included with these is one having two simple stripes; all of the others are monochrome. These pouches have certain basic features in common. Two major types are present and one of these has three style variations.

Each individual pouch consists of a single, rectangular, four-selvage web folded in half. The fold follows the direction of a thread of the fabric and forms what appears to have been the lower, horizontal edge of the pouch. The juxtaposed selvages are sewed together on two, or all three, of the non-folded edges (Fig. 1). Cords extending from the corners served as a means for attaching or suspending the pouches. All of the fabrics have been woven in plain weave or a simple variation of plain weave and all yarns are of cotton, cream white, except for brown in the warp stripes of one cloth. The sewing consists of the whipping and running stitches seen commonly in Peruvian textiles. Both sewing and weaving yarns are also of familiar Peruvian types and show a tendency toward standardization (Tables 1, 2). While texture differences between the individual pouches are present, few conspicuous variations occur within any one pouch, except where the fill-in wefts used to close the four-selvage webs were inserted either too sparingly or in groups of two or more.

Some of the pouches are bag-like in form. Others are belt-like with the length of the pouch extending horizontally. In the first type the fold of the fabric is weftwise (Fig. 1a) and suspension cords are present on the two upper corners of the pouch only, points which coincide with the intersections of the warp and weft selvages. The second type has a warpwise fold (Fig. 1b) and cords at all four corners, two additional cords having been added where the fold meets the end selvages. Some of the bag-like pouches have the entire top open; more usually both types have only a small aperture left along the upper edge, or are closed completely by sewing.

The bag-like pouches are either square, narrow and deep, or broad and shallow with fringe. Eighteen of the examples are of the first variety, nearly square (Fig. 2). Two specimens are of the second style, each approximately twice as deep as broad (Fig. 3, *left* and *right*); and two are of the third variety, in which the bag breadth is twice the depth and a warp fringe is present, making the total exterior proportions nearly square (Fig. 3, *center*). There are eight pouches of the belt-like type. These are long and shallow, with lengths ranging from five to eight times the widths (Fig. 4).

Bag-like Pouches. The eighteen small square bags (30735 [1180k], 30737 [1177g], 30738 [1180o] 30739 [1137e], 30741 [971k], 30742 [1180u], 30743 [1180n], 30744 [1180t], 30745 [1180i], 30746 [1180r], 30747 [1180-l], 30748 [1180m], 30749 [1180p], 30750 [1180q], 30751 [1180s], 30754 [1177f], 30760 [3776], 30793 [3216]) shown in Fig. 2, vary somewhat in size. The average is approximately six and one-half inches in both height and breadth. The fabric in each case has been woven twice the finished depth of the pouch. (Web dimensions are given in Table 1.) Each cloth has been folded in half along a weftwise line and, with one exception (30742 [1180u]), both sides, from the fold to the end selvages, have been closed with coarse whipping stitches. Some have firm sewing with closely set stitches; others have widely spaced loose stitches. The one exception has whipping

3

stitches on one side, long running stitches on the other. Three of the bags (30741 [971k], 30743 [1180n], 30754 [1177f]) have been turned inside out after the sides were sewed, so that the stitches are now on the inside of each bag. One of these (30743 [1180n]) may have been turned at some recent time since the top is completely open. The upper edges of the other two are sewed together and turning would have had to precede this sewing. All of the square bags, except one (30760 [3776]), are flat and appear to have been closed at some time along their entire top edges with either running stitches (varying in length from one-fourth to five-eighths inch) or running stitches used in conjunction with whipping stitches. Parts of the upper edges of two of the bags (30735 [1180k], 30742 [1180u]) are now unsewed, and two others (30743 [1180n], 30793 [3216]) show only thread ends and stitch holes, their tops being completely open. Each of the small webs has been woven in a one-over-one plain weave. Two loomstrings or heading cords have been used at each end. In most cases the heading cord ends have been allowed to extend beyond the sides of the fabric. Those from a single corner are twisted together loosely. Where those from two corners meet when the cloth is folded, the cord ends are paired and frequently knotted with those from the opposite end of the fabric. The string ends are generally severed short lengths. In a few cases, long ends remain, with those from the opposite sides of a bag joined together to form a loop about a yard in length. In the one pouch (30760 [3776]) that is not flat, all of the string ends have been tied together so tightly that the two sides of the bag meet, leaving the remainder of the bag top open. A remnant of a bast fiber cord, which is now looped under the tying cords of this bag but not otherwise attached, probably served to attach the bag to the mummy bale and was not a part of the pouch itself.

Three of the closed pouches contain bits of powdered, dried leaves. Uhle mentions, in his Catalogue, a small piece of cotton being present in one "closed by sewing" (30739 [1137e]). He has made no mention of any other content. Some of the bags have holes that rodents may have gnawed, others have openings along their seam lines, and some appear to have been cleaned at some fairly recent time. Nothing conclusive can be ascertained about the original contents, although the general assumption has been that such bags were used for carrying coca. The one plain pouch that Uhle has shown and described in his published report is a "small pouch with coca leaves" (1903, Pl. 7, Fig. 18). "This pouch of plain linen, is nine inches high by five inches wide, filled with coca leaves; the top is closed by sewing" (*ibid.,* p. 38). This, which is one of two "small pouches with articles of food" from *Grave b* in "a second stratum of the new soil in front of the temple" (*ibid.,* p. 37), has been ascribed by Uhle to the Inca civilization, later in time than the others. In the illustration it is shown enveloped in a protective covering of rushes and neither the fabric nor the construction can be seen. No such coverings have been mentioned for the bags of the present group.

Twelve of the small square pouches, all from the same *Field Catalogue* group (1180i, k-u), are designated simply as pouches found among the external objects of a mummy. Two others (30754, 30737 [1177f, g]) are listed as square mummy bale pouches "found with a youthful mummy." These, together with the one in which cotton was noted, came from the same place "at present the site is beneath the temple" (p. 27). One pouch (30741 [971k]) is described as "one of twelve ordinary pouches" which, with others, were hung on a mummy bale "from a very deep grave" (p. 8). The locale is identified only as the "foot of the temple" (p. 1). All of these examples were outside furnishings of their respective bales, while a single item (30760 [3776]), classed as a small pouch of a mummy bale found beneath the temple, presumably was inside a bale. For one specimen (30793 [3216]), no description other than "pouch" has been provided. This was from the "burial place number one" beneath the temple.

The second group of bag-like pouches, the deep, narrow variety, is represented by one all white example (30736 [1160d]) and one white with brown stripes (29805 [1160c]). Both are identified as pouches for implements. They are almost identical in size, about eleven inches in depth and five in breadth. The sides of both are closed with coarse whipping stitches; the tops are open and show no

evidence of sewing. The fabrics of both are firm, warp-face, one-over-two basket weaves with two loomstrings or heading cords at each end. The heading cord ends extend beyond the edges of the cloth at the upper corners of the bags. On the monochrome pouch some of the sewing thread ends have been twisted together with those of the heading cords, and an additional cord has been tied to one of these ends to increase its length. In the bag with the brown stripes, the brown yarn has been used for both the heading cords and the whipping stitches. The ends of some of these yarns are tied together at the top of the bag, the loop length equalling the breadth of the bag. Presumably, all of the strings were so joined, but part of these now consist of short loose ends. The bags are empty and no mention has been made of any specific content. Both bags are described as being "found with a mummy interred very deeply" (p. 32) and "found in the soil, which in ancient times was banked up as a sub-stratum for the enlarged construction of the temple" (p. 30).

The two remaining bag-like pouches both have fringe. They are the most interesting of the group, technically, due to the manner in which the fringe has been constructed. In total size these are larger than the others of the bag-like type (Table 1). The depth of the pocket of each is about 6 inches, while the breadth of one (30801 [1180h]) is 12½ and that of the other (30815 [1137d]) 13¾ inches. The former has fringe 4½ inches deep; the latter, 5½. The sides of both pouches have been closed with whipping stitches, the tops with running stitches. The smaller pouch has one very long stitch, measuring two and one-half inches, which provides an opening near the center of the upper edge; the other bag is completely closed, all of the stitches are about one-fourth inch in length. In each case, the coarse yarns used for sewing the top continue from the two sides toward the center, where the ends have been tied together in a bowknot. This made access to the interior of each bag possible, even without the opening provided in the one. As with the webs of the other examples, there are two heading cords at each end and these continue to form suspension cords extending from the upper corners of the pouches. In both, the pairs of adjacent heading cords have been twisted together and then knotted to the corresponding ones from the opposite end of the cloth, some five inches from the corner. Beyond these knots, the ends from each corner extend as a single cord. One of these, on each bag, has been lengthened to almost a yard by means of tied-on yarns; the total lengths being 32½ inches for the smaller, and 34½ for the larger. In the latter case, although these tied-on yarns are now in two sections, they appear to have been the ends extending from the opposite sides of the bag. If continuous, these would have provided a loop handle 45 inches in length. The severed ends of the cords of the other bag now show no indications of having been joined together; originally these also may have formed a loop.

A reconstruction of the fringe-making technique, which presumably was alike for both bags, indicates that in the first steps the usual Peruvian method of setting up the warps and beginning the weaving of a simple four-selvage fabric was followed, using a one-over-one plain weave. When five and one-half inches, the desired depth of the bag, had been woven, one very coarse weft yarn was inserted. The same process was then repeated from the opposite end of the warp, ending with a second coarse yarn placed in a shed alternate to that of the first. Between these, a span of bare warps remained. The length of this unwoven section was slightly in excess of twice the fringe depth. Midway of this section of bare warps, two additional coarse wefts were put into alternate sheds. Next, two small smooth sticks were inserted; one in the same shed as the first of the heavy wefts at the base of the weaving, another following that of the corresponding heavy weft of the other section of unwoven warps (Fig. 5a). The warp tension was then relaxed and the yarns over the sticks were drawn out to form two sets of loops, each consisting of alternate warp yarns. These loops became the fringes. In this process, it was necessary to draw the warps between the two heavy central wefts, half in one direction, half in the other (Fig. 5b). (As an alternative method, it would have been possible to have drawn the fringes out prior to inserting these two central yarns, in which case the yarns would have been put in with a needle rather than a shuttle, in a manner corresponding to the closing of the usual type of four-selvage web.) The drawing out of the fringe loops would have brought all of the heading sections of the fringe together, with the

two woven ends of the web adjacent to one another. Making the fringe loops into twisted cords would have involved the releasing of the yarns held by the sticks, and allowing groups of five or six adjacent yarn loops to twist together (Fig. 5c). This would have held the heading ends of the fringe yarns of each cord close together, since half of the warp ends protrude from the lower edge of one bag face and half from the other. Manual twisting of the individual loops and spontaneous twisting of the group making up each cord could have produced the fairly smooth character and the counter-twisting of the cords comprising the fringes. This method of construction of woven-in fringes not only provided an ornamental finish, but made it possible to produce a four-selvage cloth without the weaving of a fill-in section. It also eliminated the need for sewing the lower edge of the bag, since no opening remained.

There are two meager clues to the possible use of these bags. Both bags show somewhat curved contours that probably were the result of continued suspension by the cords from the corners. One pouch (30801 [1180h]) contains two small wads of raw cotton. Perhaps, hanging from belt or shoulder, these once held raw cotton convenient to the spinner's hand.

By implication Uhle has classed one of these fringed pouches (30815 [1137d]) as a mummy pouch. He has described it as "similar, but square" and the two preceding items are identified, respectively, as a "long red pouch from the mummy bale" and a "white pouch, similar" (p. 27). All were found with a mummy (Skull P68). The other fringed pouch (30801 [1180h]) is listed as one of a group of pouches (p. 36) which constituted part of the external objects found with a mummy (1180-1183). Both of the fringed bags came from the site described as "at present . . . beneath the temple," the same locale from which some of the other pouches were recovered.

Belt-like Pouches. The belt-like pouches, the second of the major types, are all of a single style (Fig. 4). They differ from the others in being folded lengthwise, along a warp thread, so that two halves of each end selvage are juxtaposed and the warp is horizontal (Fig. 1b). There are eight examples of this type. No two are quite alike in either size or texture. Five are woven in a one-over-one plain weave, the others in one-over-two variation. Two of the eight specimens (30827 [1162f], 30834 [1162e]) are fairly fine. These and one other (30838 [1180f]) have closely set yarns (Table 2) and have been woven with care. Although, with one exception (30835 [1180g]), the others are reasonably sturdy, the general quality of the fabrics is poor. Despite this, the fill-in sections tend to be inconspicuous. The lengths of these pouches vary from 19 to 25 inches; the widths, as folded, from 2½ to 4¾ inches (Table 2).

Generally both the ends and the long side of each pouch, where the selvages of the folded cloth meet, have been sewed closed with running stitches. Whipping stitches have been used in two examples. In one of these (30835 [1180g]), running stitches appear at the ends of the pouch and along the central part of the long side, except for a span of about four inches at the midpoint, which is now open and shows no evidence of sewing. These stitches are partially overlapped by whipping stitches extending inward from the ends of this long side. In the second example (30834 [1162e]), which is not completely intact, unusually fine whipping stitches close both ends and the remaining section of the long side. No running stitches are present but coarser whipping stitches have been used to oversew part of the long edge.

Each of the webs for these pouches has been made with two loomstrings at each end. The cord ends continue to form extensions in all of these examples. In one (30827 [1162f]), these have been supplemented by an extra yarn sewed through the pouch corner, in another (30832 [3775]), by an end of a warp yarn. Two of the heading cord ends have been used for sewing in one instance (30835 [1180g]), thus reducing the number of ends extending from the corner. Sewed-in yarns provide the tying cords at the folded edges. These are absent in only one specimen (30836 [1177e]), apparently never having been added. Tying cords may consist of a single yarn drawn through the fabric, near the corner of the pouch, and the two ends laid together; a loop put through the cloth and the doubled yarn ends pulled through the loop; or a sewing thread end, securely fastened, continuing from the

adjacent seam. Sewing thread ends also may supplement the sewed-in tying cords. Although the adjacent yarn ends generally are twisted together loosely where they emerge from the woven sections, no effort appears to have been made to twist them into single cords. In one example (30835 [1180g]), they are braided together at one corner. Frequently the cords from the separate corners are joined. In several specimens the cords extending from the two corners at the same end of the pouch have been knotted together beyond the cloth, at distances varying from 2½ to 15 inches. Similarly, the ends adjacent to the long seamed side have been knotted together to form a yard-long loop in the pouch which lacks ties at the folded side, and in one having four cords (30840 [1137c]). Yarns from the long seamed side, plus one set from a corner of the folded edge, have been joined in another (30835 [1180g]), forming a longer loop. Pieces of cord added to increase the lengths of the loomstring ends of the various pouches, have been knotted to other ends in haphazard ways. Many of the ends are broken and a piece of bast fiber cord has been incorporated in the knotting of one set of cords (30834 [1162e]).

At present little remains in the way of bag content. One pouch (30831 [1177d]) contains a small quantity of powdery dried leaves, another (30840 [1137c]) has three short lengths of reed, a third (30836 [1177e]) has bits of both reeds and leaves. No mention of content has been included in the *Field Catalogue* descriptions and no reference to these pouches has been made in *Pachacamac*.

Uhle has classified all of these specimens of the belt-like type as mummy pouches or pouches belonging to a mummy bale and has described them as either "long" or "large" in the catalogue. All are from the "Foot of the temple of Pachacamac." Of two from the area described as being "at present . . . beneath the temple" (p. 27), one (30840 [1137c]) was among the external objects of a mummy bale (Skull P68), the second (30832 [3775]) found with a bale. The others came from the soil "banked up as a substratum for the enlarged construction of the temple" (p. 30). Of these, two (30838 [1180f], 30835 [1180g]) are classed as external objects of a mummy. For two (30834 [1162e], 30827 [1162f]), "it is not known for certain to which mummies they belong" (p. 33), and two (30831 [1177d], 30836 [1177e]) were "found with a youthful mummy (Skull P75)" (p. 35). No further designations or descriptions have been provided.

Summary. A review of the preceding data indicates the use of established procedures and practices rather than the introduction of new or specialized techniques or methods in the construction of these plain pouches. Some of the features, such as the weaving of small, four-selvage webs in predetermined sizes, the use of plain weave cotton fabrics made from single- and two-ply yarns, with a tendency toward warp counts in excess of the weft counts, may be seen as common practices. The same may be said for the use of running and whipping stitches. Other features seem to have been selected for use in one or more of the pouch styles and adhered to with few exceptions. Several of these features may be noted. Well established size and proportion standards were used for each group of pouches. Each web was woven with two loomstrings or heading cords at each end, these heavier yarns, as well as the sewing threads, always consisting of multiple ends of the weaving yarns, which were either twisted together or merely grouped. Also, when yarns were two-ply, the direction of twist was always Z for the first spinning and S for the second twisting. Crêpe-twisted yarns are absent, even where single-ply yarn was chosen. Quite definite patterns were followed for the position of the suspension cords, but no attempt was made to provide durable cords or tapes for carrying or attaching the pouches, such as would be expected for bags meeting the demands of everyday use. Further standardization may be seen in the use of the simple one-over-one plain weave for the fabrics of all of the small square bags, and for the two fringed pouches, with one-over-two half basket weave for the two deep pouches. Only the belt-like type shows variation in this respect, five of the examples being in the simple plain weave, three in the one-over-two half basket.

The only feature appearing in any of these pouches that can be classed as unusual to Peruvian weaving, is the method used in the construction of the cord fringes. These fringes may have been produced by means of a technique invented or modified for use in this one particular variety of pouch.

Although closely related to other cord fringe types, the others are made from the end sections of the warps. Due to the formation of the fringe from the midsection of the warp on which the body of the pouch was woven, the usefulness of the technique would be limited. It could serve only where the two parts of the woven end sections were to be juxtaposed. While adaptations to uses other than bags would be feasible, this is the only obvious purpose for which the technique would be of value. In this case, the fringe is utilitarian as well as decorative. It provides weight, to aid in keeping the pouch upright, and a means of closing the lower edge of the bag. The method of construction also avoids the necessity for adding fill-in wefts to complete the four-selvage web.

PATTERNED POUCHES

There are fourteen specimens in this category. The two general types, bag-like and belt-like, are represented. The bag-like group includes one example of the square style, which does not conform to the prototype; two that are narrow and deep; and three of the broad and shallow style. Of the latter, two are more or less intact and one is a cloth which appears to have served as a pouch. The pouches of the belt-like type, of which there are eight, adhere, with one exception, more closely to the basic style of the unpatterned pouches than do the patterned bag-like specimens. All are primarily of wool and are ornamented with allover patterns or patterns which form warpwise stripes.

Bag-like Pouches. The only pouch of the square type (30126 [1161u]) is approximately four and one-half inches deep and three and one-half inches wide. It appears to have been constructed of a scrap of fabric that was woven for some other purpose. The state of preservation is so poor that little can be said concerning its original appearance, although its form can be seen to be different from that of the square, undecorated pouches. The cloth has been folded along one side and seamed at the opposite side and along the lower edge with closely set whipping stitches. These stitches oversew or reinforce previous sewing of these edges, producing a corded effect. Warp loops are present along part of the open bag mouth, of which a considerable section has been destroyed. No heading cords remain, or evidence of a drawstring or handle. The fabric is warp striped and warp-face. It is basically plain weave, one-over-two in the beginning section, one-over-one elsewhere. Minor parts of the striping change to pattern weave one and one-half inches below the selvage loops at the mouth of the bag. The fold is warpwise and the stripes are vertical. The colors appear as dark red, green, medium and dark brown. The yarns are all wool, Z-S spun, soft to medium twist, and approximately one forty-eighth inch in diameter. The warps average 86 per inch; the wefts, 22. The same yarn, doubled, has been used for most of the sewing; a few yarns are coarser and of a lighter brown than any of the weaving yarns.

This specimen has been classified simply as a "small pouch" (p. 33), one of the "Additional objects found with mummy interred further up" (p. 31), the reference being, apparently, to "the soil, which in ancient times was banked up as a substratum for the enlarged construction of the temple" (p. 30).

Like the square bag, the two figured, narrow, deep pouches (30119 [1151e], 29792 [1182d]) fail to follow the pattern of construction of the undecorated deep pouches. Instead, the warp runs horizontally and the fold, which is weftwise, is along one side of the bag (Fig. 6a). The lower edge has been closed by sewing. In place of a side seam, the fabric has been ring woven, in at least one (30119 [1151e]) of the two examples. In this, the warp loops of the two ends pass around a common heading cord, usually in alternating groups of three (Fig. 7). The equivalent of two heading cords at each end was used, but since the outer cord serves both ends jointly the total is three rather than four. The whole top of each bag is open. The method used in weaving the other bag may have followed a similar pattern. Due to its poor state of preservation the evidence is not conclusive. Part of the side "seam" is open, part is closed with coarse whipping stitches, while in one section a remnant of a common yarn running through alternating groups of warp loops is present. In each of these bags, the width of the

fabric equals the bag depth, and the length of the fabric is twice the bag width. Both cloths are warp-face and warp striped. They differ in texture and in pattern details.

One of the two bags (30119 [1151e]) is eight and one-half inches deep by six and one-fourth inches wide. The cloth is entirely of plain weave, the figured stripes being woven in small checkerboard blocks produced by the beading or log cabin technique, in which alternating warps of contrasting colors are brought to the surface intermittently (Fig. 8b). The colors which remain show only three shades of brown and light gold-color or cream-white, now badly stained. Despite the deterioration, it seems likely that this bag had no other colors, although a henna may have been present.

The sewing at the lower edge of the pouch is of the compound buttonhole or needleknitted type (very similar to a type shown by O'Neale, 1937, Pl. LXIII e). This has produced a firm, cord-like decorative finish. The mouth of the bag appears to have had no reinforcing, but a cord, sewed to the edge at regular intervals, formed a series of scallop-like loops through which a drawstring may have been run. Only a few of these loops, each about one inch in length, remain intact. The cord is like one classed by O'Neale as a four-loop, needleknitted cord (*ibid.,* Pl. LXV c). An extension of this cord, to which a different yarn has been added, indicates the beginning of a non-matching repair that was not completed.

A loop handle was attached to the bag by sewing. The joinings were near the midpoints of the sides (Fig. 6a), rather than the upper edge as in the other bags (Fig. 6b). This handle, of which an incomplete length of 11½ inches remains, is now attached to only one side. A roll of hair-like fibers covers the point of joining. These fibers have been loosely braided and wound around the base of the handle until the total diameter is about three-fourths inch, extra padding being used to round out the flat outer surface adjacent to the handle. The side of the bag has been reinforced with buttonhole stitches at the point of attachment to the handle. This sewing is similar to that at the bottom of the bag but less bulky. It continues for a length of one and one-fourth inches. Corresponding stitches are present on the opposite side of the bag, although this section of the handle has been destroyed.

The bag shows evidence of extensive use. It has been mended in several places, and there are large darned sections in the lower part which have been worn through.

The fabrics of both the bag and handle are warp-face. Both are made of two-ply, Z-S spun, medium to hard twist wool yarns. The warps average 64 and the wefts ten per inch, for the bag section, and the yarn diameters are about one thirty-second inch, with some wefts coarser. The heading cords consist of four ends of the coarser weft yarns.

The handle is made of a strip of double-cloth about one-half inch wide which has been cut from a wider piece. Whipping stitches on both edges retard ravelling. The design is in alternate brown and light gold-color triangles. For a double-cloth, the fabric is unusually thick and compact. The warp count is 48 per inch for each face or a total of 96 per inch for the two layers. The weft count is ten.

Uhle has entered the following notations in the Catalogue: "Woolen pouch (belonging here?)" (p. 31) and "found with a mummy buried in an analogous manner" (p. 30). Presumably this was analogous to that "found in the soil, which in ancient times was banked up as a substratum for the enlarged construction of the temple" (p. 30). No specific reference to this pouch has been made in *Pachacamac.*

The second of the deep pouches (29792 [1182d]) has only two colors, a dark brown, and a lighter tan which probably was either cream-white or a light gold-color, originally. This bag has a simple, geometric, warp float pattern which forms indistinct stripes. These figured stripes, all of which are approximately alike, alternate with slightly narrower, plain tan stripes. Near one end of the web there is an area of narrow horizontal lines produced by the log cabin technique. As in the other deep pouch, stripes run crosswise (Fig. 8a) and the lower edge has been closed, in this case with closely set, tight whipping stitches. The top is completely open. The only evidence that a handle may have been present consists of a string knot near one of the upper corners, and this may have served some purpose other than attaching a handle. The pouch is 14 inches deep and 10½ inches wide. The

yarns, which are approximately the same as those of the other deep pouch, show less variation, probably due to the presence of only two colors. The darker yarns tend to be of a softer twist than the lighter. Both appear in the weft as well as the warp. The heading cords are unusually coarse and, although very brittle, seem to consist of multiple ends of the lighter colored weaving yarns. The warp count is 48 per inch; the weft, 12.

Uhle has classed this item as a woolen pouch among "other objects accompanying the mummy (1182)" (p. 36) and has left doubt as to the specific locale from which it came. Except for Uhle's identification as a pouch, the specimen might have been placed in another category, since the fabric is not so firm as that of the other pouches and there is nothing to confirm the existence of a handle.

No content has remained in either of these deep bags and Uhle left no notations concerning finding anything within the bags. The smaller saw hard use prior to being discarded or included among funerary offerings. The larger, although badly deteriorated, lacks signs of wear.

Although the shapes of these bags place them in a deep pouch category, one, and possibly both, of the patterned deep pouches show the use of ring weaving in pouch construction and may indicate the presence of an additional general pouch form, one in which the warpwise grain was placed horizontally and sewing required at the lower edge only. The smaller of the two bags displays, in addition, the use of loops at the mouth of the bag, fabric cut from a larger piece serving as a handle, and the attaching of the handle at the midpoint of the sides rather than at the top.

The two broad, shallow pouches conform to the type in general construction, but have no fringe. One (30106 [1161s]) measures 6 inches by 11; the other (30080 [1161r]), 6 by 14 inches. Both are in very poor condition, showing the effects of hard usage as well as deterioration. Both have been darned and reinforced with various other sewing stitches. Each bag consists of a single four-selvage web woven in a warp-face stripe, with warp patterns in some of the stripes. Both bags have weftwise folds at the lower edge, with seaming at the two sides. The tops are open. Other than mending stitches, the two heading cords at the ends of the webs serve as the only reinforcements at the bag mouths. Woven bands, three-fourths inch wide, have been attached at the upper points of the side seams to form loop handles, each of which is now about 20 inches in length (Fig. 6b). The bands used for the handles are four-selvage webs, presumably woven for this specific purpose. The weaving yarns are primarily two-ply, Z-S spun, with twists varying from soft to hard.

The smaller bag (30106 [1161s]) has more patterning than the larger and is darker in coloring. The pattern, in both cases, is more complex than that of the deep bags (Fig. 8). Originally the colors of the smaller bag probably included dark red, brown, gold-color, henna, and blue-green. Compound buttonhole stitches or needleknitting, similar to that of one of the deep bags, has been used to close the sides of the bag. Small tassels of a simple but distinctive type have been added at the lower corners. Each is composed of a group of yarns sewed through the corner of the bag and bound around at the bag corner to form a tassel head; the free yarn ends provide the tassel fringe. The binding, in this case, consists of a series of needleknitted loops which enclose the group of tassel yarns and form a line, like chainstitch, on two opposite sides of each cap (Fig. 9). The handle of this bag is now in two sections, which have been knotted together near the midpoint. These appear to be the two parts of a single strip. This handle differs from those of the other bags in having two layers of fabric and a cord-like padding extending lengthwise through the central part of the handle strip. The ends of the handle have been attached to the bag by means of added "warp" yarns extending between the band ends and the bag, a distance of about one and one-fourth inches. These extensions are darned, or interwoven, with crosswise yarns to make small sections of coarse cloth (Fig. 11a). The strip of fabric which comprises the major part of the handle has been constructed in a manner which attests to the ingenuity of Peruvian weavers. At one end, the weaving has been done in a warp-face, basket weave. This part is about seven-eighths inch in width. It has side borders three-sixteenths inch wide in red and light red-brown, woven two-over-two, and a central section in gold-color and three shades of brown, woven

four-over-two. One of the browns now is a red-brown, another is greenish, the third, a dark seal brown. Beyond the basket-weave section, which is one and one-fourth inches long, the weaving continues on the same warps, for the remaining length of the handle, with the borders in a one-over-one plain weave and the central part consisting of two semi-independent layers of cloth, in pattern weave. The pattern weave is the type which appears as a plain weave on the face, with the pattern elements in different colors. The unused yarns, those of colors not needed for the design, float on the back of the cloth from one design unit to another of like color. The distinction between the borders and the central section has been retained in the patterning, the central section showing various simple geometric motives against a ground of the dark brown, while the borders continue in a simple repeat of red against red-brown. The cord-like padding rounds out the central part of the handle. Only the borders remain flat.

The technique employed in weaving the major part of the handle appears to have been a modification of double-cloth weaving. One part of the fabric, which is approximately one inch in woven width, includes the borders and one layer of the central section. This uses, in any one pick, all of the border warps and half of the warps of the central part. The second layer of fabric, which probably was woven concurrently, is built on the remaining warp yarns and its wefts cross only this central area of the web, turning back around a weft of the basic fabric at the inner edge of the border (Fig. 12). While the two sets of wefts are independent of each other, except at the two edges of the central section, the warps are not. Since all of the four colors appear on each outer face of the central section, the warps interchange at the margins of the color units of the pattern, as in standard double-cloth. The unused lengths of the pattern yarns, i.e., those which are not required for the pattern of either layer of the fabric and which do not show on either outer face, float between the two layers of cloth for varying distances to form the padding which rounds out the handle and provides reinforcement through added bulk. This increased thickness makes the finished breadth of the handle slightly less than that of the woven fabric.

Long running stitches sewed into the borders near the padding, serve no apparent purpose. Other stitches, the remains of which are present along parts of the handle edges, likewise appear to have had no function.

The yarns of this bag vary, with the colors, in diameter and in degree of twist. The weft yarns are all brown and are slightly coarser and of a harder twist than most of the warp yarns. The average diameter of the warps is one thirty-second inch; of the wefts, one twenty-fourth. The fabric of the body of the bag originally was firm and compact, having about 60 warps and 16 wefts per inch. The heading cords are of a darker brown than the shades appearing elsewhere and each consists of four two-ply yarns twisted into a firm cord. The patterning of the handle strips differs from that of the body of the bag, although the yarns and colors appear to have been alike. Both the tassels and the stitches closing the sides of the bag show evidence of having been multicolored with the various hues arranged in regular sequences.

The larger bag (30080 [1161r]) is now predominantly a dull gold-color and the wefts are gold-color yarns which match some of the warps. All of the colors are badly deteriorated. The body of the bag shows gold-color, two distinguishable shades of brown, together with a bit of henna color; the handle strip, brown and gold-color. The weaving yarns are slightly finer than those of the smaller bag, varying between one thirty-second and one forty-eighth inch in diameter. The fabric is compact with counts averaging 82 per inch for the warp and 12 for the weft. Each of the heading cords consists of four ends of two-ply, gold-color yarns twisted together loosely.

The sides of the bag appear to have been sewed with the same type of compound buttonhole stitches as the other bag, although only a small segment of this sewing remains intact. The major lengths of the bag sides are now open, with only the stitch holes and a few thread ends indicating the former presence of sewing. The handle has been woven in a pattern weave, very similar in both technique

and design to the patterned stripes of the body of the bag. It has been attached by means of yarns put through the warp loops of the band ends and then sewed into the upper corners of the bag in a manner similar to that of the other bag. This process has been managed in a haphazard way. On one side, these extra "warps" have been wrapped tightly with additional yarns. On the other side, a second set of extending loops has been added, and those nearest to the bag have been darned or interwoven with a few weftwise yarns adjacent to the bag top (Fig. 11b). This handle may have been a replacement, since the yarns and colors differ slightly from those of the body of the bag. Like the other bag handle, this is now in two parts, although the severed ends match.

The fabrics used in these bags probably were woven specifically for this purpose. The general layout of the patterning is shown in Figure 8a. Although some of the details are now lost, the basic design type can be seen to be one which occurs frequently in Peruvian bags. In each case, the warp-face weaving forms vertical stripes, intermittently plain and patterned. The patterned stripes are in designs developed in alternate warp yarns of two colors. These stripes are broken, along the bottom section of the bag, by narrow weftwise lines produced through the use of plain weave, in which one pick brings all of the yarns of one color to the surface and the next pick brings up the alternates. Both the general pattern layout and the simple strap or band handles, frequently with the "darned warp" section connecting the handle of the bag, appear to represent standardized practices (*e.g.,* d'Harcourt, 1934, Pl. XIX or 1962, Pl. 20; Jijón Y Caamaño, 1949, Pl. LXXVII, Fig. 9).

There is nothing to indicate the specific uses of these two pouches. The present examples are without content and Uhle has provided no helpful information. The Catalogue listings are respectively, "Old pouch" and "Similar" (p. 33). Both, like the figured square bag, are among "additional objects found with mummy, interred further up" (p. 32).

One piece of fabric (30855 [1155g]) consisting of a single web 18½ by 13 inches is of the same type as that used in the shallow bags and shows evidence of having been folded weftwise and sewed closed at the sides. The cloth has warp striping. The major part is in one-over-one plain weave; three narrow stripes are in pattern weave. Like the others, it is warp-face and the striping has been bisected, horizontally, by a section in log cabin weave. Sections of compound button-hole stitches remain on both side selvages of the web. When the cloth is folded like a pouch, torn off sections of the selvage correspond to the adjacent sewed lengths. Other parts of the side selvages which are intact show evidence of stitch holes. There are holes and large darned sections in the central part of the web and at the corners, suggesting the wear to which a bag might have been subjected and the tearing away of a handle. The fabric was woven with two heading cords at each end. Most of these are intact and there is no evidence of an additional edge finish along these end selvages which would have formed the mouth of the bag.

The yarns are wool, two-ply, Z-S spun, medium twist and average one-fiftieth inch in diameter. Some of the warp yarns are finer, the differences occurring between yarns of different colors. All of the colors now are shades of brown. Indications are that the lightest hue was a cream-white originally, and that a henna or other reddish hue was present. The weft yarns match the lightest-colored warps. Each of the heading cords consists of four to six ends of yarn similar to the other weft yarns. The same type of yarn was used for the buttonholing.

Uhle has classed this as one of two samples of fabric found with child mummies accompanying a large mummy (Skull P72? p. 31), one of the group which seems to have come from the "soil banked up as a substratum" (p. 30).

Belt-like Pouches. The most colorful of these patterned pouches, as they appear today, are six red and white, belt-like specimens. Although the fabrics of these differ in weave as well as color, the pouch construction is basically the same as that of the plain white prototype. Each pouch is made o a single, long, narrow web folded in half lengthwise and sewed together at the ends and along all or part of the long selvages. Most of the sewing consists of coarse running stitches, with occasional use of whipping

stitches. The cloth is a pattern weave which, on the face, appears to be a simple plain weave. Both the basic warps and the wefts are of two-ply red wool yarns. White cotton yarns, also two-ply, form the pattern. Two, or sometimes four, of these white yarns alternate with groups of four to six red yarns in the warp set-up. In weaving, the white yarns have been brought to the surface intermittently, as required for the pattern, the whole of which is composed of continuous or broken pin stripes. The design consists, in each case, of a central area in a latchhook pattern and end sections in simple stripes (Fig. 10). The white yarns which form the pin stripes contrast with the ground only in color and yarn texture. They are approximately the same in diameter as the red yarns and are a part of the plain weave fabric on the face of the cloth. Only on the underside, where the white yarns continue from one pattern segment to another, do they appear as loose floats. The proportions devoted to the latchhook patterning and the striped end sections vary with the different pouches. The same is true of the compactness of the latchhook designs. Where these are compact (29728 [1137b], 29730 [3193c]), they are clear and effective; where spread too widely (29731 [3193c]), the pattern is scarcely discernible.

The sizes and proportions of the red pouches are approximately the same as those of the white, the red tending to be slightly narrower in proportion to length than the white (Table 3). As with the white, each web has been woven with two heading cords at each end. The ends of these cords, together with various tied-in yarns and ends of sewing threads, served as ties on four of the six pouches. These remain intact on two examples (29729 [1180e], 29728 [1137b]). On the former, the two yarns are knotted together ten inches from the fabric and joined with those from the other end of the pouch to form a 50-inch loop. The ties are lacking from the corners at the folded edge of one (29734 [3211c]) and from the two corners at one end of another (29735 [3211c]). For some of the tied-in cords a simple loop of yarn has been passed through the fabric and the yarn ends pulled through the loop. Most of the cord ends have been broken off. The other two of the six pouches (29730 [3193c], 29731 [3193c]), have been provided with woven tapes for tying purposes. Two of these tapes extend from each end of the pouch, adjacent to the corners. Each has been woven about one-half inch wide, for a length of about six inches. At this point the two have been joined together by means of a continuous weft, which crosses both sets of warp yarns, forming a single tape three-fourths inch in width (Fig. 13a). This wider section is about nine inches long and has the left-over warp ends continuing, unfinished, beyond the end of the weaving. In constructing each of these tapes, about eight yarns (half the required number of warps) were threaded through the fabric of the pouch, in sequence, and doubled back to form the warps. The wefts were put in in simple plain weave (Fig. 13b,c). The yarns used for the heading cords, the sewing, the added tying ends and the tapes are all white cotton, primarily two-ply. The red yarns of the different pouches vary considerably in color, diameter, and degree of twist, although all are two-ply, Z-S twist. In one of the pouches (29728 [1137b]) part of the weft yarns are lighter than the others, and in another pouch (29729 [1180e]) various scraps of red yarns, all of which differ slightly, appear to have been used.

The pouches which have tapes for tying (29730 [3193c], 29731 [3193c]) have been classed in the Catalogue as "two red cotton mummy pouches" (p. 136) from the "excavations at burial place number one. Beneath the Pachacamac temple, continuation" (p. 135). Those which lack half of their ties (29734 [3211c], 29735 [3211c]) also are described as "two red cotton pouches" (p. 137) and as being from the same excavation as the above. Presumably each pair came from a different mummy bale. Although these are listed as cotton, all are primarily of wool.

One of the others (29728 [1137b]) is identified as a "long red pouch for the mummy bale" (p. 27), found among the "external objects of a mummy" (Skull P68). The other (29729 [1180e]) is described as "pouches" among the "external objects" of "the mummy bale: 1180" (p. 36), under the general heading "Found in the soil, which in ancient times was banked up as a substratum for the enlarged construction of the temple" (p. 30). Both of these pouches are among the objects from the

"Continuation of the excavation at the place from which I obtained the objects Nos. 1000-1087. At present the site is beneath the temple" (p. 27). These numbers are listed as from the "Continuation of the collections from Pachacamac, on the foot of the temple of Pachacamac."

Three short sections of reed remain inside one of the red pouches (29728 [1137b]). Otherwise they are all empty and Uhle has made no mention of contents for any of this group.

None of these red belt-like pouches has been mentioned in *Pachacamac* although Uhle has described a pouch of like coloring and fabric which he has identified as a pouch for implements (29733 [954e]). Judging from Uhle's description, this pouch is of the deep bag type rather than the belt type and of a bag style differing from any of the decorated pouches which are immediately available for study. Uhle has described the patterning technique in considerable detail. "The cotton stuff of which this pouch is made has mostly red woolen warp threads with a few white cotton ones and a woof of common brown cotton. While the two ends of the stuff are woven like plain linen, the central part shows a design which was produced by skipping the white threads of the warp in places and leaving them loose on the reverse side. Thus a complementary design of a diagonal meander was made to cover the entire space, in one part of which the red threads are mixed with the white, in the other unmixed" (1903, p. 32). Like the belt-type pouches, this has been listed in the Catalogue as one of two long red pouches for the mummy bale (presumably that of Skull P38) and from the area listed above (nos. 906-1087). In Uhle's illustration (*ibid.,* Plate 6, Fig. 16), this piece has been opened out, showing the weaving to have basic identity with that of the six red belt-like pouches.

There is one brown and white cotton pouch (29738 [1137b]) which follows the same general form as the red and white examples. Only part of the weft yarns are now intact. The part which remains shows comparatively long end sections of pin stripes with a very short central pattern area (three and one-fourth inches). The total warp length is about 17 inches; the woven width, 6 inches. Heading cords of white cotton are intact. The remaining parts of the two long selvages appear to have been joined by means of a yarn which was threaded alternately through the two sets of weft loops. All of the yarns are single-ply. The warps are brown and white; the wefts, part gray, part brown. The heading cords consist of white two-ply yarns loosely twisted together. This specimen carries no specific identification in the Catalogue, but has been grouped with one of the long red pouches (29728 [1137b]).

The major constructive features, like those of the white pouches, show a general standardization of textile practices: the yarns, the four-selvage cloths, the heading cords, the provision of ties, and within the group a conventional patterning and limited color choice. Although Uhle mentions the presence of additional colors in other pouches of like weave, none of these is present among the specimens presently available for study.

Two distinctive features may be noted, the weave itself, and the structure of the woven-on tapes which replace the more usual insecure tying cords.

There is one other patterned belt-type pouch (29742 [1232a]), one which varies in both patterning and pouch construction. It is made up of two independent webs. One is a plain white, cotton warp-face piece six and one-half inches by two inches. The other is brown and white cotton, the same length as the white, and three and one-half inches wide. These strips both have been doubled length-wise and the four long selvages sewed together. The sewing consists of coarse whipping stitches of a two-ply bast fiber yarn. At present the brown and white web is only partially woven. One end shows a pin stripe pattern. In the central section is a section of one-half inch brown and white checks, in which the extra yarns float on the reverse face of the cloth while the obverse face appears in plain weave. The technique is closely related to that of the red and white pouches. The wefts are missing from the remainder of the pouch length. The ends of both webs have been drawn up by means of their heading cords. These yarn ends have been knotted together at one end and, at the other, have been braided loosely with the ends of the sewing thread. These cords, extending from both ends, are

knotted together to form a loop some fourteen inches in length. With this pouch there is a bit of raw brown cotton with a seed attached, although it is doubtful that this can be considered as content. Uhle has not referred to this specimen in *Pachacamac,* except as reference to checkerboard patterns in the discussion of the red and white spindle pouch noted above may be so interpreted (1903, p. 32). In the Catalogue this is listed as one of two long pouches (p. 41). The particular locale from which it came is not clearly defined. It is under the general heading "Continuation of the Pachacamac Collection" (p. 38).

Summary. In most respects these decorated pouches show the use of familiar Peruvian textile procedures and methods. Some distinctive applications and variations of techniques are noteworthy and some procedures which appear as oddities. Among these features are: The use of ring weaving in bag construction. The use of related techniques in producing the modified double-cloth of the padded bag handle, the weave of the red and white belt-like pouches and of the one brown and white checkerboard pouch. The application of the decorative needleknitting technique to tassel construction. The construction on some of the belt-like pouches of woven tapes with the two parts formed into one in the weaving.

Indications of standardization may be noted in the color and designs of the red and white pouches and, in a less rigid form, in the pattern layout of the shallow bag-like pouches. Certain routine practices appear to have been followed in regard to the selection of yarns and the determination of sizes and proportions, as well as the methods of construction, for items within any one category. Of all the pouches, only the decorated bag-like styles show clear evidence of having been made as utilitarian objects, objects which saw hard wear before being consigned to funerary use.

GROUP II: PONCHO SHIRTS

The shirt-like garments which are called ponchos in the *Field Catalogue* constitute the second largest group of made-up textile articles. Fourteen are in the present group. Many more are listed in the Catalogue. Of the fourteen, half are miniature garments, half large sizes. There are, in addition, four fragments which appear to have been parts of large poncho-shirts. Some of the specimens are without decoration of any kind; some have narrow borders; in others the decoration covers a considerable area of the fabric. Among the present examples, none of the ornamentation is elaborate, although a considerable number of decorative techniques have been used. Except for the basic construction, the garments of this group are notable for a lack of conformity. They probably represent a variety of different categories that are not identifiable among so small a number of specimens.

Like all shirts, these garments are constructed to provide covering for the upper part of the body. They are closed at the sides and have openings to accommodate the head and arms. Sleeves are optional. The true poncho consists of a rectangle twice the length desired for the finished garment, with a central lengthwise slot providing a neck opening. The width of the rectangle exceeds half the body girth. When worn, half the length of the fabric hangs in front, half in back. The sides of the poncho are left open. The length of the neck aperture is at least half the circumference of the head of the wearer, but not so large as to require fastenings to keep the garment in place. All except three of the present garments have been constructed in a simple combination of the shirt and poncho forms, poncho-like, but with the sides closed, except for arm openings. Sleeves have been added in one instance. Three of the miniature garments deviate from this general standard. Although basically rectangular, they are tubular, not poncho-like, with horizontal rather than vertical apertures (Fig. 14).

MINIATURE SHIRTS

The seven doll-size shirts (Fig. 15) include five which are undecorated and two which have simple warp striping. The basic weaving is in one-over-one plain weave, although weft yarns have been paired in some areas, principally in the fill-in sections. Except for one striped garment, all are of unbleached and undyed white or brown cotton yarns.

Poncho-like shirts. Three of the monochrome shirts (29831 [3214b]), 30727 [1122n], 30740 [1137e]) and one with stripes (29832 [3214b]) have been constructed in the poncho-shirt manner (Fig. 14a). Each of these consists of a single four-selvage web with a kelim slot serving as the neck opening. The cloth has been folded in half, weftwise, with the fold at the shoulder line and the two end selvages at the lower edge of the shirt. Whipping stitches close the side seams, the sewing extending along the side selvages from the end selvages to the lower point of the arm hole. One of the three plain shirts is white. The other two are brown, as is the major part of the striped garment. All of the browns differ slightly, but all are within the color range of natural brown cottons.

The white shirt (30740 [1137e]) measures 4½ by 5-5/8 inches (Fig. 15a). The fabric, woven nine inches long, has two-ply, Z-S spun, hard twist yarns, averaging one thirty-second inch in diameter for the warp. The weft yarns differ in being soft twist and slightly coarser. The counts average 34 per inch for the warp; 13 for the weft. There is one heading cord at each end of the web, made up of four of the warp yarns grouped together. At each side of the garment an end of one of these hangs free. The other two ends have been used to sew the side seams. The end selvages, with the heading cords, provide the only finish at the lower edge of the shirt. The side selvages and the selvages of the kelim slot, likewise, are the only finishes at the arm and neck openings. The weaving is poor in quality and leaves the impression of having been done hurriedly. The fill-in section is conspicuous, due partly to the wide spacing of the wefts and partly to its comparatively large expanse in relation to the diminutive

size of the shirt. There are no signs of use, not even stretching of the neck opening, which would be expected had the garment been placed on a doll or figurine.

Uhle has not described this particular specimen. The listing in the Catalogue (1137e) refers to a pouch. The Museum number is distinct, however, indicating that, originally, the two items bore the same number. If this assumption is correct, the poncho was found among the "external objects of the mummy 1137 (Skull P68)" in the "continuation of the excavations at the place from which I obtained the objects Nos. 1000-1087" (p. 27) or the general area "on the foot of the temple of Pachacamac" (p. 1).

The smaller of the two plain brown shirts (29831 [3214b]) is approximately the same as the above in size and form (Fig. 15b). Its measurements are 4½ by 5¼ inches. It differs from the white shirt in being of firmer fabric and of better workmanship. The warp and weft yarns are alike, both two-ply Z-S spun, hard twist and one forty-eighth inch in diameter, with 48 warps and 42 wefts per inch. In this example the heading cords have been removed so that a tiny loop fringe finishes the lower edge, a fringe which is in scale with the miniature garment, but which may have resulted more or less accidentally with the removal of a coarse heading cord. There are several holes in the fabric of the upper section, at the shoulder and neckline, but since it has been cleaned at some recent time, the cause of these cannot be determined. The warpwise selvages form the neck and armhole finishes.

This specimen is classified as one of "two very small ponchos, one of which is striped" (p. 137), from the "Excavations at burial place one. Beneath the Pachacamac temple, continuation" (p. 135).

The second of the "two very small ponchos" (29832 [3214b]) has warp stripes in the central section (Fig 15c). Unlike the other, it is longer than it is wide, measuring 4 by 3½ inches. It has been constructed in the same manner as the preceding, even including the tiny fringe loops at the lower edge. The fabric is slightly heavier and is warp-face. The major part is brown, of a darker shade than the other, with 52 warps and 40 wefts per inch. The brown yarns are two-ply cotton, Z-S spun, hard twist and one forty-eighth inch in diameter. The yarns of the stripes are of wool. They are similar to the other warps, except for having softer twists. Brown cotton yarn like that of the warps has been used for the wefts and, doubled, for the sewing. The striping consists of a central half-inch of gold-color, edged on each side by a three-part stripe, three-eighths inch wide, divided equally into black, white, black. The yarns of the various colors skip from one block to another, leaving a few long floats at the lower edge and on the inside of the shirt. This specimen is well preserved and shows no evidence of any type of use.

The larger of the two plain brown ponchos (30727 [1122n]) exceeds the others of this style in size and is crêpe-like in texture (Fig. 15d). Its dimensions are 7½ by 7¼ inches. The weaving is loose and open. The yarns, which are brown with bits of white intermixed in the spinning, are single-ply, S-twist, crêpe-spun, for both the warp and the weft. They average one forty-eighth inch in diameter, with 34 warps and 16 wefts per inch. For heading cords, three of the weaving yarns have been used together in each of three picks. These three yarns are simply grouped together at one end of the fabric; at the other, each group of three has been twisted into a single yarn. At one side the ends have been turned back into the shed; at the other sewed in with the seaming. Along the side selvages, the weft loops extend beyond the last warp yarn, indicating that an edge warp, possibly a temporary one used to aid in keeping the sides of the web straight, has been removed. The sewing threads consist of three strands of the weaving yarn used together. The stitches are coarse whipping stitches, as in the other miniatures, but are inconspicuous due to the crêping of the fabric. There is nothing to indicate that the shirt was used in any way, although stretching would be impossible to detect with the crêped texture. Uhle has classed this garment as "A miniature poncho found with the mummy No. 971 and seq: (1122)" (p. 25) from the "Continuation of the excavations some 10 meters to the west of the foregoing one, at the foot of an old half-terrace. (1088-1134)" (p. 20).

Tubular shirts. The three additional miniature shirts have been constructed with horizontal neck and arm apertures. These have been described in considerable detail in an earlier paper (VanStan, 1961 a). Like the others, the fabric has been folded weftwise, but in these the warp runs crosswise in the garments. The finish for the lower edge is provided by one side selvage; the finish for the neck and armholes, by the other side selvage (Fig. 14b). Compared with the preceding group, all of the tubular shirts are coarse and clumsy in appearance. All are of unevenly spun, single-ply yarns, generally crêpe twisted. Two are cream-white. One is brown and white.

The two all white specimens (30707 [1090c], 30732 [1104-I]) are approximately alike (Fig. 15e,f). Both have an unusual type of seamless construction, similar to that of one of the deep, figured bags (Fig. 7). In the shirts, individual warp yarns from the two ends of the web loop alternately around a pair of heavy wefts which serve as a common heading cord for both ends (*ibid.,* p. 527, Fig. 3). (In the bag, the warps are in groups of three.) The only sewing consists of whipping stitches used to close sections of the upper shirt edges to form shoulder seams. Unsewed sections provide openings for the arms along this top edge, adjacent to the sides of the garment, and an opening for the neck, at the center (Fig. 14b). There are no vertical openings. In addition to the ring or tubular weaving and horizontal apertures, these shirts are distinguished by having two pleats, one on either side of the front (?) neck opening, folded and held in place by the shoulder seaming.

One of the two specimens (30707 [1090c]) measures 7 by 9¼ inches, the length of the web being 18½ inches or twice the breadth of the garment. There are 24 warps per inch; the wefts vary from 13 to 17. The warp yarns average one thirty-second inch in diameter; the wefts, one twenty-fourth inch. Generally both the weaving and the sewing are of poor quality. The sewing yarns are coarse, one-sixteenth inch in diameter, two-ply, Z-S spun, medium twist.

The second of the white shirts (30732 [1104-I]) is 6¾ inches by 9½. It shows one structural difference from the preceding. In the former, the heavy line of cording, where the two ends of the web meet, is located between the pleats in the front (?) of the garment, while in the second it is in the back (?) away from the pleats. The weaving shows one variation also. Coarser warps have been used for a span of about three inches along one side of the web. This thicker section, extending around the bottom of the garment, has produced a slight flare which, with the pleats, gives the shirt the false appearance of having been shaped in the weaving. The yarns are basically like those of the other white shirt; some are slightly coarser. The average warp count is 22 per inch; the weft count, 14.

The brown and white shirt (30731 [1093b]) is smaller than the others and has not been ring woven (Fig. 15g). It is 4¾ by 5-5/8 inches. The two ends of the web are joined together with coarse whipping stitches to form a single side seam. Whipping stitches also close the shoulder seams along the upper edge of the garment; spaces left unsewed provide the neck and arm openings. As with the other two shirts of the same type, the side selvages provide the only edge finish, both at the lower edge of the shirt and at the neck and arm apertures. The fabric is tweed-like in appearance and is divided into two parts, the larger predominantly cream-white, the smaller predominantly brown. The brown section, which has been woven as a two-inch strip adjacent to one side selvage, forms a yoke-like horizontal band at the top of the garment. All of the warp yarns have been spun with an admixture of either brown or white fibers. The brown yarns have a small white component; the white, a smaller percentage of brown fibers. All of the wefts are of brown and, since they are not hidden by the warps, add to the mottled effect of the white area. The yarns, which are single-ply, crêpe twisted, and average one thirty-second inch in diameter, have considerable dimensional variation, frequently giving the effect of modern slubbed yarns. These factors produce the tweed-like character of the cloth. The weaving is principally one-over-one plain weave with counts of 28 by 13 per inch. Sections of two and one-fourth inches in length, at each end of the web, are in a one-over-two basket weave. In these areas the weft count is 11, paired, and the fabric is somewhat more compact than the central part. The heading cords at each end consist of two two-ply yarns used together and one four-ply used alone. All of these have

been made up of the basic weaving yarns. The yarns used in sewing are similar, four-ply and brown.

These three garments, like the miniature crêpe shirt, came from the "continuation of the excavation of Pachacamac . . . at the foot of the old half-terrace" (p. 20). Each has been identified as a "miniature poncho," without further description.

Summary. The single-web construction of these tiny garments and their lack of added edge finishes, reinforcing, or decorative devices set them apart from many of the poncho-like shirts of wearable sizes. The horizontal neck and arm apertures of three of the examples, together with the yoke-like decoration of one, the tubular construction and the use of pleats in the other two, are distinctive characteristics. The tweed-like fabric appears to have no connection with the nature of the garment, although the yoke-like arrangement of the brown striping may have been intended as a decorative device of the same general category as the central striping of the small shirts of the more usual style.

LARGE PONCHO-SHIRTS

The seven large shirts, which are all of the poncho type, show considerable variation in the details of their construction. Most of these consist of two webs seamed together along one set of side selvages to produce the desired garment width. The neck opening was provided by leaving a section of this seam unsewed. One specimen consists of three webs, with the neck opening cut in the central web. The side seams have been closed in the same manner as those of the single-web poncho-shirts. The fabrics are of both cotton and wool and they vary from sheer crêpes to coarse, rough textures. Included are loosely woven cloths that are approximately square count, and firm, smooth reps with a preponderance of warps. Plain weave predominates, but pattern weaves are present. Three examples are unpatterned; four are decorated.

Two of the unpatterned shirts (30935 [1180a], 30293 [1090g]) have the excessive breadth and tiny armholes characteristic of the garments used to dress the mummy bales. One of the decorated garments (29772 [3189]) also shows excessive breadth but has armholes of a usable size, while another mummy-size garment (29875 [1155a]) seems to have had an exceptionally small neck opening.

The fragments include four specimens, only one of which Uhle has classed as part of a poncho. The classification of the others is based on remaining bits of sewing, stitch holes, the sizes of the webs and the nature of their decoration. In no case is the evidence conclusive.

Undecorated. Three construction variants are represented in plain shirts. One is of the simplest two-web construction and apparently of a utilitarian type. One, which has sleeves, is oversize with very small armholes and sleeves. The third has two of the fabric edges folded back, as if to reduce the size of a larger garment. Two are cotton, one is wool. All are plain weave.

The simplest of the large undecorated ponchos (30935 [1180a]) is made of unbleached white cotton plain weave fabric in a coarse, rough texture which might have served well for a utilitarian garment (Fig. 16a). Composed of two webs, it is 23½ inches from shoulder to lower edge and 45½ inches in breadth. Each of the component webs measures 47 inches warpwise and 22¾ weftwise. Arm apertures 11 inches in circumference have been left at the sides. The neck opening, along a center seam line, now measures 17 inches in length. Presumably this was slightly smaller originally, since there is a loose end of sewing thread at one end of the opening. Although the cloth shows the rhythmic spacing of the wefts which is characteristic of the work of an experienced weaver, no particular care appears to have been taken with the weaving. The warps have been drawn together near the selvages so that compact edge sections, varying from one to one and one-half inches in width, are present along the major parts of both webs. The wefts, in some instances, have been turned back neatly around the outside warps, while irregular loops are present elsewhere. The fill-in sections are conspicuous. The warp yarns of both webs are two-ply, Z-S spun, medium to hard twist. Most of the wefts match the warps,

although some are soft to medium twist. The yarn diameters vary widely within any one yarn. The average is about one twenty-fourth inch. Bits of brown fibers have been mixed with the white prior to the spinning of some of the yarns. In weaving, these mixed yarns have been used at random with the larger proportion in the weft. Considerable variation in both the warp and weft spacing is present in different areas of each web. The counts average 18 per inch for the warp; 15 for the weft. The weaving of one web appears to be slightly more compact than that of the other, although no differentiation between the average yarn sizes and counts can be noted. Two heading cords, each consisting of four to six ends of the weaving yarns twisted into a cord, have been used at both ends of each web. Some of the sewing yarns are like the heading cords; for others, two to four ends of the weaving yarn have been used together without additional twisting. All of the sewing consists of coarse whipping stitches. In addition to the sewing of the center and side seams, whipping stitches extend five to six inches along the lower edge of the shirt, adjacent to the side seams. These stitches appear to have served to finish off the thread ends rather than as reinforcements or edge finishes. At one side of one seam these stitches are lacking and the cord ends hang free. Weft yarns have been doubled in a few picks adjacent to the heading cords and in the fill-in sections. Otherwise all of the weaving is in a one-over-one plain weave.

This shirt, although badly soiled, is well preserved; only one section at the lower edge of one web is lacking. Uhle has described this as a "Poncho of a mummy-bale" (p. 36). Presumably this was among the "External objects" (p. 36) "found with a youthful mummy (Skull P75)" (p. 35) and from the "Continuation of the excavation at the place, from which I obtained the objects Nos. 1000-1087. At present the site is beneath the temple" (p. 27).

A second undecorated shirt (30293 [1090g]) differs from the others in having tiny sleeves sewed to the armholes (Fig. 16b). Except for the sleeves, this garment has the usual basic two-web construction. It is made of a fine, sheer, slightly crêped, natural white cotton fabric. The shoulder to lower edge length is 22½ inches; the breadth, 39 inches. Both of the webs comprising the body of the garment were woven 45 inches long; one is 20 inches wide; the other, 19. The seams, which have been sewed carefully with fine whipping stitches, are inconspicuous. A neck opening ten inches long has been left in the central seam; and arm apertures six inches in circumference, at the sides. The sleeves, each three inches long and consisting of an individually woven web, have been sewed to the armholes. Each of the sleeve pieces was woven six inches long and three inches wide, and the ends were sewed together to form the tubular sleeves. With one end of a sleeve seam meeting the upper termination of a side seam of the shirt, a side selvage of the sleeve has been sewed to the section forming the armhole of the shirt. The sewing matches that of the other seams. A one-over-one plain weave has been used throughout. In the large webs, the yarns are all fine, single-ply, S-spun, crêpe-twisted and about one sixty-fourth inch in diameter. The average yarn counts are 44 per inch for the warp and 40 for the weft. The warp yarns used in the sleeves are coarser than those of the large webs and less evenly twisted; the weft yarns are finer. The average count for the warps is 60 per inch; for the wefts, 28, producing a somewhat sleazy fabric. Three heading cords, each consisting of a four-ply, S-Z spun, hard-twist yarn, one forty-eighth inch in diameter, have been used at each end of the large webs. In the sleeve pieces there are two heading cords at each end. Each cord is two-ply, S-Z spun, hard twisted, and one forty-eighth inch in diameter. All of the yarns used for sewing are like the heading cords of the sleeves. No reinforcements or edge finishes are present.

Uhle has described this only as a "cotton poncho," one item of a group classed as "Remnants of fabric (1090)" (p. 21), from the "Continuation of the excavation at Pachacamac. Excavation some 10 meters to the west of the foregoing ones, at the foot of an old half-terrace." (p. 20).

A divergent form of construction has been used in one all wool, undecorated garment (30284 [1178g]). This shirt now measures 17 inches from shoulder to lower edge and 30 inches in total breadth. Each of the two matching webs has been woven 34 inches long and 20½ inches wide. The

excess width of each section (four and one-half inches for one, six and one-half inches for the other) has been folded back, so that the edges at the central seam and neck opening are folds rather than selvages (Fig. 16c). The back and front seams have been sewed with coarse whipping stitches, with crosswise running stitches used as reinforcement at the neck and bottom terminations of the sewing. The length of the present neck opening is ten inches. Baseball or saddler's stitch has been used for the sewing of the side seams and the same type of running stitch reinforcement has been used at both ends of these seams (O'Neale, 1937, Pl. LXVII e). The armhole is eleven inches in circumference (original size). Five ends of yarns like the wefts have been used together for sewing the side seams. The yarns used for the center seams are of slightly looser twist and four ends have been used together. Closely set whipping stitches form an edge finish along the unseamed selvages parallel to the present neck opening. The presence of these stitches indicates that, originally, either the center seam, with the neck opening, was along these selvages, in place of along the fold, or the intention was to construct the garment in this manner. For this sewing the yarns are like those of the side seams. It is not possible to determine whether or not the center seams were once sewed along the selvages and later changed to their present position, since no evidence of stitch holes or yarn ends is present along the armholes. There are some indications that the garment has been worn, but charring, not wear, has been the chief cause of deterioration.

The fabric, although originally sturdy, is now brittle. It is a warp-face, one-over-one plain weave with eight times as many warps as wefts. The warp count is 104 per inch; the weft count, 13. The warp yarns are two-ply, S-S spun, hard-twist, and one thirty-second inch in diameter. The wefts are two-ply, Z-S spun, medium twist, and average one twenty-fourth inch in diameter. The direction of spinning of the warp yarns and their compactness have given the fabric a gabardine-like appearance. The weaving is of a high quality throughout. The whole garment is now medium-dark brown in color with considerable discoloration evident. It seems probable that extensive color change has taken place, possibly involving a complete alteration of the hue. A one-fourth-inch loop fringe is present along the lower edge of the shirt. This, like the corresponding fringes of some of the miniature ponchos, has been produced by the removal of the heading cords. These fringes and the remains of whipping stitches at the armholes provide the only edge finishes for the garment as it is at present. Presumably, in its original form the whipping stitches which are now along the free selvages were at the neck. No evidence of any other type of ornamentation is present.

Uhle has described this as a "woolen" poncho and classified it as one of the "objects inside the mummy bale (1178)" (p. 35), the same bale with which the large undecorated sleeveless shirt (30935 [1180a]) was associated.

Decorated. One shirt of fine, sheer, slightly crêped, unbleached white cotton cloth (29772 [3189]) has a narrow red and brown decorative border around the bottom, in which wool yarns have been used for the patterning. The garment is 33½ inches from shoulder to lower edge and 50 inches broad. It has the standard two-web construction, with a neck opening 14 inches long and armholes 17 inches in circumference. Each web is 67 inches long and has been woven with a one-half inch border in a stylized bird design at each end (Fig. 17a). The width of one web is 25½ inches; of the other, 24½. The weave is a one-over-one plain weave, except in the borders, where there is a combination of brocade and damask with the red and brown yarns, which are of wool, in the weft. Adjacent to a single heading cord is one pick in which cotton yarns have been paired. Following this and prior to the beginning of the pattern weaving on one web, there is one pick with a single cotton yarn, while on the other web there are two picks with single yarns. In the pattern, two red or brown yarns have been used in each pick. At one end of each web the initial pick of the border is in red; on the other, brown. The remainder of each border is in the alternate color. The central section of each patterned band is in brocade technique with a single cotton yarn serving as a tabby between the pattern shots. The last nine picks of each border are damask weave; the yarns are all wool, the cotton binding yarns being omitted.

In joining the two webs, the border colors have been alternated so that half of the front and half of the back of the garment have borders which are predominantly red, the other halves being predominantly brown. The lower points of the neck opening have been reinforced with needleknitting (O'Neale, 1937, Pl. LXIII d) for a distance of three inches, at both back and front. One section is red; the other, brown.

The cotton yarns of both the warp and weft are single-ply, S-spun, hard to crêpe twist, and one ninety-sixth inch in diameter. The warp count is 46 for the wider web and 48 per inch for the other, except at the edges where the warps are markedly more compact. Although these compact selvages are present on both sides of each web, they vary in width from one-eighth to one-fourth inch and it seems probable that they resulted more or less automatically with the use of the very fine yarns, rather than being a planned change in the warp spacing made to increase the firmness of the fabric edges. The weft count is 44 in the wider web; 46 in the other. Both the spinning and weaving are remarkably even. The fill-in sections are discernible but not conspicuous. The workmanship indicates a high degree of skill in both spinning and weaving.

The heading cords consist of ten ends of the weaving yarn grouped together. The wool yarns, both brown and red, are two-ply, Z-S spun, medium twist, and one forty-eighth inch in diameter. Although the differences in the weft counts of the pattern and plain areas are inconspicuous, the weaving is much more compact in the pattern, due to the differences in the yarns and the weave. The red and brown yarns used in the needleknitting, at the points of the neck, match those of the borders.

All of the seams of the garment have been sewed with fairly fine whipping stitches. The sewing threads are cotton, four-ply, Z-S spun, medium-twist, and one forty-eighth inch in diameter. At the lower edge of the shirt the heading cord ends have been knotted at the terminations of the seam lines and the ends cut short. The ends of the sewing threads appear to have been finished off independently by being stitched back into the seam. At the upper ends of the center seams the needleknitting conceals the seam endings. At the armholes the sewing thread ends have been continued in whipping stitches for about an inch along the selvages on one edge of the opening. In addition, on one side of the garment an extra thread has been used for a corresponding length of whipping stitches on the opposite selvage, suggesting that these stitches were intended to reinforce the armhole where it would be subject to strain.

The garment is well constructed. There is nothing to indicate either haste or carelessness. The state of preservation is fairly good, with most of the garment intact. There are no evidences of wear, although the sizes of the neck and arm apertures and the length of the garment, as well as the reinforcements at the neck suggest that it was made to be worn. Only the excessive breadth is indicative of its having been constructed for a funerary purpose. Uhle has described this as a "light poncho with narrow figured border; was among the coverings of the mummy bale" (p. 136). The bale came from the "Excavations at burial place number one. Beneath the Pachacamac temple, continuation (1379-3218)" (p. 135).

One poorly preserved large poncho (29875 [1155a]), which has an added polychrome border, appeared as little more than a bundle of brown rags with a narrow strip of tapestry. Careful straightening and piecing together of the fragments revealed the construction of the shirt to be the usual two-web type, with the addition of a narrow decorative band sewed to the lower edge (Fig. 17b). The body of the garment is of a sheer, crêped cotton material, all brown, in a one-over-one plain weave. The border is of polychrome wool tapestry, woven independently and attached with the warps perpendicular to those of the other webs. The seams are so inconspicuous as to be difficult to locate. They have been sewed with fine, closely set whipping stitches in brown yarns which match, in color, those used in the weaving.

In so far as it is now possible to determine the dimensions, the poncho length, from the shoulder to the lower edge, including the border, was 29 inches; the side to side breadth, 52; the length of the neck opening, approximately 8; the girth of the armhole, 21. Each of the brown webs has been woven

about 56 inches long and 26 inches wide. The crêping has produced a size differential which, due to the charred and fragmentary condition of the fabric, cannot be measured. In joining the sheer crêpe and the comparatively stiff tapestry, the former appears to have been stretched, causing the tapestry band to fall in ripples. It is now impossible to determine the degree to which this rippling was due to original differences in the unstretched lengths of the abutting edges and how much to later shrinkage of the cotton fabric. The warp and weft yarns of the two large webs are all brown cotton, single-ply, Z-spun, crêpe twist and one sixty-fourth inch in diameter. There are about 40 warps and 36 wefts per inch. No heading cords are present, but the weft yarns have been doubled in the first four or five picks at the ends of each web.

The tapestry band was woven in sections, each one and one-half inches wide and probably about 44 inches long. Kelim technique was used and the design shows a central warpwise band with a simple repeat of a small animal figure, in blue (28-F-2), outlined in dark purple (46-F-9), and placed in a red (5-K-9) field. Edging this on each side is a one-eighth inch strip of the dark purple. A three-sixteenths inch strip of dull gold-color (12-H-9), adjacent to one of the purple strips, completes the edge of the border which has been sewed to the brown (14-A-9) cloth. The opposite edge of the band has a one-eighth inch strip composed of alternate sections of plain red (5-L-3) (a red which differs from the red of the central ground area) and a unit of equal length divided into five and one-eighth inch squares. The colors of these tiny squares are blue, red, gold, red, blue, with each of these colors separated from its neighbor by a one-sixteenth inch span of purple. There is one section of the tapestry, about 14 inches in length, where the pattern has been altered in this outer strip to make the color repeat: red, gold, red, blue, red, gold, red, with the same purple dividers but with the long segment in blue, in place of red. The tapestry border was woven in two or more long, narrow strips. Each appears to have been finished across the ends with a one-eighth inch band of the purple, which, in effect, is a continuation of the other purple strips to which it is perpendicular. One section of the tapestry border, 44 inches in length, has this purple strip at both ends. Both of these ends have been sewed to other tapestry sections, each of which has a purple terminal band at one end, so that two of these come together at each seam line. End selvages, if present, are concealed by the closely set whipping stitches of the seam, and the yarns are too brittle for probing to reveal the warp loops which probably are present. Of the two sections of the border joined to the one complete length, one is a small fragment, one inch at its longest point. The other is 39 inches long, with one end rotted away. There is one additional fragment, three inches in length, which includes no end finish. This is attached only to a section of the brown cotton fabric, now separate from the remainder of the garment. The warps of the tapestry are of unbleached white cotton, two-ply, Z-S spun, medium to hard twist, one sixty-fourth inch in diameter, and are set 26 per inch. The weft yarns are all of wool. The gold-color is single-ply, Z-spun, hard to crêpe twist and one sixty-fourth inch in diameter. The remaining colors, including a bit of cream-white used in the eye of the animal figure, are two-ply, Z-S spun, medium twist and about one forty-eighth inch in diameter, with the variations in twist and diameter no greater between the colors than within a single yarn. The weft count shows remarkably little variation, being 88 for all yarn colors. The tapestry weaving is basically of the kelim type, with wrapped weave included in the outlining of the animal figures. Where the color divisions are parallel to the warps for a considerable length, as where the strips of purple meet the gold and the red, a weft yarn of one color interlocks around an adjacent warp of the strip of the alternate color, first from one side and then from the other, at intervals of about three-sixteenths inch. The heading cords, if present, like the warp loops, are hidden by the sewing which joins the ends of the tapestry bands.

The sewing threads are of several types. The lengthwise seams that join the plain brown webs are sewed with two-ply, hard-twist yarns which have been Z-Z spun, and are about one forty-eighth inch in diameter. These appear to be two ends of the weaving yarn, doubled and twisted together in the same direction as the original spinning. There is at least one instance where two of the single-ply weaving yarns

have been used together for sewing, without additional twisting other than that occurring during the sewing process. The threads used for sewing the border to the plain section are two-ply cotton yarns, S-Z spun, medium twist and one forty-eighth inch in diameter, while those which have been used to join the border ends are also cotton and two-ply but are coarser and of softer twist than the above and have been Z-S spun.

The tapestry border provides the only added edge finish, at present, although remains of whipping stitches along parts of the armholes suggest the possibility that another piece of cloth of some type was attached to these selvages. A few extraneous stitches, for which no function is apparent, also are present on parts of these same edges. Neither of the seamlines of the tapestry meets a seamline of the body of the garment, as the two have been joined, although the direction of the figures of the tapestry band reverses at one of the seamlines, providing a logical center front or center back, which, it seems, should have been contiguous to a corresponding shirt seam if the band was woven to be part of this specific garment. In this respect, it may be noted that two 44 inch lengths of tapestry would be insufficient to reach around the bottom of the shirt, while three lengths would exceed its circumference by about 28 inches.

Uhle has classified this as the "Remains of a brown gauze poncho, with party-colored gobelin border" among "Other objects (1155 - 1157) found with the mummy 1152 and 1153" and "Found with one or more mummies, which were interred equally high up (Skulls P72, etc.) (1152, 1153, 1155 - 1157, and 1161)" (p. 31). Presumably this whole group was "Found in the soil, which in ancient times was banked up as a substratum for the enlarged construction of the temple" (p. 30).

A poncho with decorative stripes (29497 [1182a]) has been made of a soft, woolen fabric of good quality, woven with a plain red ground and wide, vertical, two- or three-colored stripes in pattern weave (Fig. 18a). This garment shows the usual two-web construction. The length from the shoulder to the lower edge is now 19½ inches; the width from side to side, 44¾ inches (Fig. 17c). One of the two component webs is 23 inches wide; the other, 21¾. The end selvages have been almost completely destroyed. Two short bits of the heading cords, remaining adjacent to one side selvage of one of the webs, indicate that the woven length of this web was 40 inches. There is no finish at the lower edge of the shirt, only the frayed ends of the cloth. One five and one-half inch span of coarse whipping stitches, where the fraying had extended most deeply into the fabric, appears to have been added to retard the ravelling.

The sewing used to convert the fabric into a poncho displays a variety of stitches, but not the high quality of workmanship seen in the spinning and weaving. Part of one center seam has closely set whipping stitches in red yarn, similar to the weaving yarns but of softer twist, used four ends together. A section of the other center seam is sewed like the first, except that a baseball stitch replaces the whipping stitch. Red wool yarns appear also in a short span of whipping stitches on one side seam. These stitches are more widely spaced than those of the center seam and have been pulled so tightly that the fabric edges overlap. This sewing thread, used double, is coarser than the red weaving yarns. Another short length at one end of this side seam shows whipping stitches in light brown, hard-twist, cotton yarns, one forty-eighth inch in diameter, used three together; and at the other end, similar stitches in which cotton yarns, like the above, have been twisted tightly together into a single cord. Only two short lengths of sewing are intact on the other side seam. This sewing is like that in which three ends of the cotton yarn have been used together without added twisting. On all of the seams spaces are present where the sewing has disappeared. The ends of the center seams near the neck have been oversewed with whipping stitches, on parts of both the back and the front. For this sewing, three ends of dark brown wool yarn, which differs from the weaving yarn, have been used together. One section has two layers of stitches; the first, sewed for about four inches, and the second, oversewed from the opposite direction so that the diagonals cross each other. At the other end of the neck opening, the stitches extend for two inches in a single direction and a few running stitches, per-

pendicular to the seam, have been added as a reinforcement at the base of the opening. The edge of the neck aperture is in poor condition and there are some indications that stitches have been removed carelessly from these selvages. The length of the neck opening was about 11½ inches. The selvages at the armholes have been destroyed and parts of the frayed edges have been rolled back until the distance from the original edge is one and one-half to two inches. This has produced a somewhat curved armhole with a slight resemblance to the shaping of a modern garment. The original circumference was 14 inches or less. The sewing of these edges consists of short lengths in a knot stitch (Fig. 18b) using three ends of brown cotton yarn. In one instance these stitches are a continuation of a short length of the sewing of the side seam. The other armhole shows a little of this same sewing, part of which has been oversewed with blanket stitches in dark brown wool yarns, which appear to have been warps pulled from the cloth.

Each width of fabric was woven with four pattern stripes, each about three inches wide, in which the pattern is formed partly by warp floats and partly by the use of yarns in two alternating colors. The color combinations in the first stripe are red with light gold-color, and a dark navy blue (actually a blue-violet which appears blue due to the near-by red areas) with a light jade green; in the second, dark brown and light gold, red and light gold; in the third, red and light gold, dark brown and light gold; in the fourth, red and light gold. All of the red matches the ground color. In the stripes in which the red is on the outer edges of the main stripe, a one-eighth inch line of dark brown separates the red of the stripe from that of the ground. In the fourth stripe, where only one two-color combination is present, the width of the brown line has been increased to one-fourth inch. The color sequence is the same on both webs. These hues may be identified in the color dictionary as: red, 7-L-7; light gold, 13-G-6; dark navy blue, 48-E-2; light jade green, 29-C-4; dark brown, 8-E-8. Exclusive of the stripes, the fabric is red, woven in a warp-face, one-over-one plain weave. There are 68 warps and 16 wefts per inch in the plain areas. In the pattern, the number of warps increases to 84. The warp yarns are two-ply, Z-S spun, principally medium-twist, and one forty-eighth inch in diameter. There are a few differences between the yarns of different colors. The navy is slightly harder twist and the gold and green are softer than the other colors. The weft is all light brown (8-C-12). It differs from the warps in being of soft to medium twist, one sixty-fourth inch in diameter. The bits of heading cords show two cords, one in each of the first two picks. These cords consist of six ends of two-ply Z-S spun, hard-twist, cotton yarn, twisted into a single yarn of medium twist, one twenty-fourth inch in diameter.

This fabric probably was made for a purpose other than a shirt. The sequence of the stripes is alike on both webs and the repeat, as sewed, is continuous, not reversed to produce bilateral balance. Apparently the center seam was sewed with red yarns which matched the warp and, subsequently, part of this sewing was ripped out to produce a neck opening.

The sewing of the side seam is not in keeping with the original in type, yarn variety, or quality of workmanship, and presumably was added when the fabric was converted into a poncho. A lack of appreciation of the fineness of the fabric is indicated by the destruction of the larger part of the lower and armhole edges by hard use and abuse which seems to have been related to the conversion into a poncho-shirt.

Uhle has described this specimen in the Catalogue as "Woolen stuff for poncho" (p. 36) among "Other objects accompanying the mummy (1182)" and "found with a mummy (1180-1183)" (p. 36). This is under the general heading "Continuation of the excavations at the place from which I obtained the objects Nos. 1000 to 1087. At present the site is beneath the temple" (p. 27).

Listed as a "Piece of a cotton poncho, found on the bale" (p. 137), another specimen (33003 [3210]) is only partially intact. It is made of three webs, sewed side by side, with a slit in the central web serving as a neck opening (Fig. 17d). This corresponds to the use of a kelim slot in the miniature poncho-like shirts, but, in this case, the opening appears to have been cut, not woven in. It is finished with a needle-knitted edging. The central web differs from the other two. It is of red wool with a

white pattern. Both the design and the technique are of the same type as seen in the figured pouches (Fig. 10). The whole cloth, including the patterning, appears to be in plain weave on the obverse face; floats appear on the reverse (Fig. 19). The web is warp-face, woven 39¼ by 19-3/8 inches. The patterning is arranged in two lengthwise stripes or bands, each about eight inches wide, leaving plain sections, about five-eighths inch wide at the sides and one, one and three-fourths inches wide, at the center of the web. The neck opening, which is in the central plain area, is about 11½ inches in length.

A piece of rep-like cotton material has been sewed to each side of the red web. On one side only a fragment, 13 by 2¼ inches, all unbleached white, remains. The piece sewed to the opposite selvage also is fragmentary. Enough of this is intact to show that these additional webs (presumably both were alike) were woven about 38 inches long and 12½ inches wide. The remaining web consists of a plain cotton section about nine inches wide, followed by a striped section, continuing to the outer selvage. Although most of the weft yarns of the striping have disintegrated, it can be seen to have had a red ground with two one-fourth inch figured stripes in black, red, and white and four groups of pin stripes, two of which are brown, gold, brown, and two all brown, arranged dark, light, dark. The red of this striped area is yellower than that of the central web. The white warp yarns of the striping are of cotton; the others are wool. Whipping stitches have been used for sewing both seams joining the side selvages of the two outer webs to those of the central section.

A very small part of one side seam remains which has been sewed in the same manner. The needle-knitted finish of one armhole is still attached near one end of this, although most of the cloth to which it was attached has disintegrated, the wefts having disappeared. The arm opening is 11½ inches. The needleknitting appears to have been in alternate color blocks of red and dark brown, each roughly one-half inch long. That at the neck, also in blocks, seems to have been in two shades of brown, gold-color, and red. One size adjustment has been made in constructing the garment. A five-eighths inch tuck has been sewed across one end of the red web and fastened flat with coarse hemming stitches. Presumably this was done to shorten the central web to coincide with the lengths of the two side webs. This makes the length of the shirt, from shoulder to lower edge, about 19 inches and the width of the garment about 44-3/8 inches.

The red cloth was woven with 62 warps and 24 wefts per inch. The red yarns of both warp and weft are two-ply, Z-S spun, medium to hard twist and one forty-eighth inch in diameter. The white pattern warps are two-ply, Z-S spun, very hard twist, and one sixty-fourth inch in diameter. These white yarns are of cotton. All of the wool yarns of the striped section of the outer web are approximately like the red of the central web. Some are slightly coarser, and some have softer twists, variations generally following color differences. The warp counts are the same as for the red, 62 per inch. In the cotton section there are 72 warps per inch. The cotton warp yarns, except for being coarser, one forty-eighth inch in diameter, are like the white yarns of the central section. The wefts, used twenty-five per inch, are like the cotton warps. The small section of cotton cloth remaining on the opposite side of the red web, is made of the same type of yarns, but the counts differ slightly. There are 84 warps and 24 wefts per inch. The heading cords of the red fabric have been removed, leaving the small warp loops at each end of this web. Two heading cords are present at both ends of the striped web. At one end they consist of six ends of the cotton warp used together. Those at the other end appear to have been the same but are too badly charred for checking to be possible. Except where patterning is present, one-over-one plain weave has been used throughout. The narrow patterned stripes have warp floats. The red and white section has warp floats on the reverse face only; the obverse having the appearance of plain weave.

This specimen came from the "Excavation at burial place number one. Beneath the Pachacamac temple, continuation (3179-3218)" (p. 135). In Uhle's discussion of a red and white pouch of the Epigone style in *Pachacamac,* which has been woven in the same manner as the red and white web of the present piece and with the same design (1903, Pl. 6, No. 16), Uhle has mentioned one poncho of

the same type, design, and colors *(ibid.,* p. 32). Presumably, although no specimen number has been given, this is the garment to which he referred. He has commented further in the same discussion that "However plain the design and technique of these stuffs and numerous the articles made of them, they still belong exclusively to this oldest period, to judge from the objects with which they were found." *(id.)*

Fragments. There are four specimens consisting of cloth fragments which may have been sections of poncho-shirts. Uhle has described one of these as part of a sleeve and, since the only sleeved garments that have been identified are poncho-shirts, the "sleeve" has been assumed to have been part of one of these. Each of the other three specimens shows some of the characteristics of the poncho-shirts, but in no case is the evidence sufficient for judgments concerning the original form of the garments to be verified.

The section of a sleeve (29684 [3214c]) is shown in *Pachacamac* (1903, Pl. 6, Fig. 11) and described as "part of a sleeve with narrow tapestry border. The border is only one inch wide and closed in a ring shape by a seam, the full length of the sleeve is fourteen inches . . ." *(ibid.,* p. 31). All that remains at present is a strip of fine tapestry banding sewed, with whipping stitches, to a fragment of plain, light weight, brown woolen fabric. The brown fragment is 12½ inches long and two inches wide, with a selvage extending along one side for most of the length. The tapestry strip, 15¼ inches long and one inch wide, is now in two sections, the shorter of which is one and three-fourths inches long, and does not form a ring. Two ends of these have been sewed together. If the pattern color repeat is allowed for, where the band has parted, the circumference of a ring, formed by the present seam, would have been 17 inches. One of the side selvages of the band has been joined to the remaining side selvage of the brown cloth, making the remaining sleeve length three and one-half inches, dimensions which are difficult to reconcile with Uhle's.

The brown fabric, which is firm but neither stiff nor thick is woven in a two-over-one half basket weave with 52 (times two) warps and 24 wefts per inch. All of the yarns are single-ply, S-spun, crêpe twist and one ninety-sixth inch in diameter. The larger part of the weft yarns of the tapestry are brown, of about the same value as the brown of the plain cloth but slightly redder. The tapestry wefts are wool, two-ply, Z-S spun, soft to medium twists with diameters averaging one sixty-fourth inch. These have a glossy appearance, which the other yarns lack. The colors are dark brown, a light roan or mahogany (which may have been red originally), gold-color, cream-white and green-blue. The gold-color yarns are slightly coarser than the others. The warp yarns, also of wool, are two-ply, Z-S spun, hard twist and one-eightieth inch in diameter. They are of mahogany color of a lighter tint than the weft of a similar hue. There are 28 warps and 118 wefts per inch. The ends of the band which have been joined appear to have been cut and the ends over-sewed, prior to their having been sewed together. The seam, with three layers of stitches in most places, forms a ridge about one-eighth inch thick. The pattern consists of alternate blocks of brown and mahogany, one and three-fourths inches and three-fourths inch long, respectively, with a small animal figure (1903, Pl. 6, Fig. 11) in each of the brown blocks. These figures are repeated in a color sequence of cream, mahogany, gold-color. These same colors, and the blue-green, have been used in details to provide color accents. The yarns used for sewing the band to the "sleeve" appear to consist of four ends of the weaving yarns of the plain fabric, twisted together in a Z direction. Some of the sewing yarns used at the ends of the banding are like the above, others are coarse, cream-white cotton, single-ply, S-spun, hard twist and widely variable in diameter.

In the *Field Catalogue* this is listed as one of three "small pieces of figured fabric, in poor condition (?); may possibly be of use" (p. 137). This does not coincide with the description in *Pachacamac* (p. 31). The specimen came from the "Excavation at burial place number one. Beneath the Pachacamac temple, continuation (3179-3218)" (p. 135).

There are two red wool tie-dye fragments (30296a,b [1770o]) which fit together as parts of a single web. This web was sewed, on either side, to other webs, at least one of which consisted of similar red wool fabric. As reconstructed (Fig. 20a), the cloth measures 40½ by 17-3/8 inches. The one web was woven 17 inches wide; the extra three-eighths inch width is part of an attached web of similar red fabric. Part of one end selvage is present, also parts of the two side selvages of the one web and short lengths of one side selvage of the second web. Sewing, consisting of neat, closely set baseball stitches, produces decorative seaming along parts of the remaining side selvages (Fig. 21). On one side these end abruptly and have been fastened at a point 30½ inches from the end selvage. The remaining ten inch length of the one selvage continuing from this point shows no evidence of sewing, thread ends, or stitch holes, suggesting the possibility that this may have provided either the neck or an arm opening of a poncho-shirt. The opposite side of the web has only three bits of side selvage. At the juncture with the end selvage, the sewed-in bit of the beginning, or termination, of the sewing of the joining seam remains. Twenty-six inches from this are three and one-half inches of the baseball stitch which still holds bits of extraneous red wool yarns, indicating that the attached web on this side was also of red wool. The end of this sewing shows a few whipping stitches on top of the main sewing, suggesting that reinforcing may have been added and that this was near the point where the seam ended. A one-half inch length of selvage beyond this point shows no evidence of having been sewed, although the length would have accommodated three stitches matching the others. It seems probable that another of the poncho-type openings was present along this selvage.

The patterning consists of a number of large hollow rounded squares of the type typical to tie-dye cloth (Fig. 21). These were arranged to form four rows across what may have been the shoulder section of a shirt. Eleven or more of these squares continued in a row along one side selvage, with one, possibly two, of these at the opposite side. One or more continued in the opposite direction on the other edge of the wide band (Fig. 20a). The fabric was woven in cream-white, or possibly a light wheat-gold. After the pattern was tied the cloth was dyed red. This dyeing may have taken place either before or after the webs were sewed together. The colors of the adjacent parts of the two webs match exactly, indicating that these were dyed at the same time. However, the sewing threads are lighter, although alike in hue. They may have been dyed separately, or may have been lighter than the cloth prior to dyeing. Most of the squares are now gold-color, but this, apparently, is discoloration since considerable areas of the red are brownish, especially where the deterioration is greatest.

The fabric is rep-like, all woven in a one-over-one plain weave, with 60 warps and 19 wefts per inch. The warp yarns are two-ply, Z-S spun, hard twist, one-fortieth inch in diameter. Most of the wefts are the same; some are medium twist. Two loom strings remain along the section of end selvage. Each of these consists of six ends of the warp yarn. For the sewing, four ends of two-ply wool yarn, Z-S spun, soft to medium twist and one forty-eighth inch in diameter, were used together. A few odd sewing yarns, perhaps mending yarns, are very hard twist, slightly coarser than the others and have been used two together.

Uhle has classified these as "Two pieces of cloth dyed and figured after weaving," among "different kinds of remains of cloth" (p. 78), from "Pachacamac, continuation (first burial place) 1735-1779" (p. 76). No mention of this specimen has been made in *Pachacamac*.

One section of the cloth is shown and a brief description included in a previous report (VanStan, 1961b, p. 35).

Two ragged pieces of cloth, classed as a single specimen (29857 [1182g]), may represent half of a worn-out poncho which was cut up and used for some secondary purpose. The size of the cloth, as reconstructed, together with remaining bits of sewing, points toward its having been part of a poncho (Fig. 20b). The two fragments appear to comprise the major part of a single web which was 20½ inches wide and approximately 53 inches long. The fabric is warp-face and was woven of unbleached white cotton, with the exception of warp stripes at the sides, which are in red and brown wool. One

of the side borders consists of a red stripe, one inch wide, which includes the side selvage, and three adjacent one-fourth inch stripes, in a brown, white, brown sequence. On the opposite edge of the cloth the colors are reversed; the edge stripe is brown, about three-fourths inch wide, followed by red, three-sixteenths inch; white, three-eighths inch; red, three-sixteenths inch. The colors have deteriorated, but it can be noted that the white of the stripes probably matched the ground of the fabric; the brown was a seal brown and the red a rose-red. The red and brown wool yarns are two-ply, Z-S spun, and one forty-eighth inch in diameter. The red is medium twist; the brown, soft twist. The cotton yarns are two-ply, Z-S spun, hard twist; some of these, in both warp and weft, are one forty-eighth inch in diameter, others are one sixty-fourth inch.

A one-over-one plain weave has been used throughout, with 72 warps per inch and 23 wefts. The heading cord at one end now consists of two weft yarns in the first pick, but the slackness of the warp loops suggests that one or more additional heading cords were removed. The selvage has been turned back about one-fourth inch, presumably to form a hem at the lower edge of the shirt. The crease of the fold, stitch holes, and a few remaining thread ends indicate that this hem was once sewed in place. The same is true of the small section of the end selvage which is intact on the other segment of the cloth. There is some evidence that this second end may have been sewed to another length of fabric or to a fringe or border, rather than being simply hemmed. In this second piece, the thread fragments show four ends of cotton yarn used together as the sewing thread. These are similar to the weaving yarns but of softer twist. Four ends of the same thread also were used together in an edge finish along part of a side selvage on each of the cloth segments. This sewing, a very tight loop or knot stitch akin to buttonholing (Fig. 18b), probably was continuous and served to reinforce the armhole of the poncho. If this was the case, this armhole was originally 14 inches or more in circumference.

Remains of stitches, which appear intermittently along the better-preserved section of the opposite side selvage for a distance of approximately 22½ inches beginning at the end selvage, and a few brown cotton threads of the same type remaining in the corresponding section of the other fragment, indicate the location of a seamline. The central (?) sections of these edges, beyond the remnants of the cotton sewing threads, show parts of an embroidered finish in blue, red, yellow, brown, and green wool yarns. The total length of the two embroidered edge sections is now ten and three-fourths inches and presumably represents the approximate length of the neck opening of the shirt. The wool yarns used for the embroidery are two-ply, Z-S spun, generally soft-twist, and about one thirty-second inch in diameter. The condition of the embroidery is so poor that the exact technique cannot be reconstructed, although it can be seen that the stitches, some slanting to the right, some to the left, went over the edge of the fabric and crossed each other, apparently forming a diamond pattern through the order of the color crossings, in a manner similar to that used in the wrappings of reeds found in Peruvian tombs. Over-sewing, chiefly whipping stitches, in brown yarns, darker than the brown of the original embroidery and slightly coarser, appear to represent repair work. These stitches are at odd angles, which do not conform to those of the diamond pattern.

One four inch span of red wool thread ends which denote the presence of another type of sewing along the "seamline," casts some doubt on the authenticity of this reconstruction. Either the lengths of the front and back central seams of the poncho, as reconstructed, differed by about six inches, or ornamental sewing or repair stitches were present adjacent to one end of the neck opening. The red yarns of this extraneous group of stitches are medium twist and slightly finer than the other red yarns. Both appear to have matched in other respects.

The two fragments are now joined together, with one edge overlapping another. The sewing is in long running stitches and obviously of later date than the part described above, since the coarse, unbleached white cotton threads are not soiled and discolored, as are all the original parts of the cloth.

No description of this specimen has been included in Uhle's *Field Catalogue*. (The item number refers to maize.) However the Museum catalogue lists three specimens (27674a-c, 29857, 30955a,b)

carrying the same *Field Catalogue* number (1182g), one of which (29857) is that of the present textile. The serial numbers (1182a-i), among which the present specimen number falls in the *Field Catalogue,* are classed under the heading "Other objects accompanying the mummy" (p. 36), from the "continuation of the excavations at the place from which I obtained the objects Nos. 1000 to 1087. At present the site is beneath the temple" (p. 27).

Two fragments of striped wool fabric (30027a,b [1748a,b]) may be remnants of another poncho. In the catalogue, one part of a group description refers to "fragments of a poncho-like under-garment, from the double covering of a mummy bale" (p. 77). A second listing of the same specimens (a and b) describes them as "two strips of cloth, found with the mummy 1748." (*id.*) The two remaining sections do not appear to be parts of a single web, although they are so nearly alike in patterning, color and workmanship that they must have been woven of yarns of the same lots and by one weaver. It seems probable that they were sections of two webs of a poncho-shirt, similar to the wool garment with patterned stripes (29497 [1182a]) described above. The longer of the remaining fragments is 32½ inches by 9½ inches. One bit of end selvage and most of one side selvage are intact. There are imprints of stitches along this side selvage which indicate that the edge was seamed for a length of 24 inches with either whipping or baseball stitches. At the termination of this seam a group of reinforcing stitches crossed at right angles. For the short section of selvage beyond this point, the marks of stitches are closer together and more nearly perpendicular to the edge than the others, indicating a different type of sewing, perhaps an edge finish, and suggesting that this formed either a neck or arm opening (Fig. 20c). This fragment has two pattern stripes, each approximately three inches wide and consisting of three warpwise rows of pattern weaving separated by narrow plain stripes (Fig. 22). Colors are red, green, gold, and brown in the stripes; the ground is red. The second fragment is 16½ by 19 inches with parts of one end and one side selvage remaining. In this, a few ends of red wool yarns are present along the side selvage, but no clear evidence of sewing, like that appearing in the other piece. Four of the patterned stripes are present on this scrap. The handling of the pattern near the two end selvages differs slightly.

Except for the patterned bands of the stripes, the weave is one-over-one plain weave. The cloth is warp-face, with 84 warps and 18 wefts per inch. All of the yarns are of wool. The warps are two-ply, Z-S spun, principally medium twist and average one forty-eighth inch in diameter. In the stripes, the green and brown yarns are hard twist and the gold-color yarns are slightly finer than the others. The wefts, like the warps, are all of wool. They are two-ply, Z-S spun, soft twist, and slightly finer than the average of the warp yarns.

These remnants are listed as from "Pachacamac, continuation (first burial place) 1735-1779" (p. 76).

Summary. Each of these large poncho-like shirts shows individual characteristics. Except for the tendency to be short and wide there is little homogeneity within the group. This tendency toward excessive width may be due to their construction for use on mummy bales rather than as wearing apparel. The chief distinction between the two categories appears to be in the sizes of arm apertures. Considerable alteration for re-use is evident, a factor which may have influenced both garment proportions and the nature of the fabrics used. There appears to have been a customary choice of natural colored white and brown yarns for the undecorated fabrics and for the larger plain areas, with a preference for red for other ground areas. The patterning is fairly simple and tends to be used in narrow borders or in stripes. The fabric textures vary greatly.

GROUP III: ODD MADE-UP FABRICS

There are five specimens in which one web has been folded and joined to other pieces of fabric, altering the original simple rectangular form in which each was woven, or added web fragments or stitchery indicate the presence of an unfamiliar form. Each specimen is a one-of-a-kind style. Two are folded and sewed. Two others have added bits of contrasting fabric and one has oddly placed needle-knitted edgings.

FOLDED TYPES

The two folded fabrics differ markedly. In one, a square has been folded diagonally to produce a triangle and narrow bands have been added to the two short sides. The other specimen consists of a long narrow band, with the midsection folded lengthwise and a second piece of cloth inserted between the layers of the folded band. The three layers were sewed together, presumably producing an apron-like form.

The Triangular Cloth. This specimen (29714 [3270d]) consists of three webs, a 22 inch square of gauze weave and two bands of pattern weave, each two inches wide and slightly longer than the sides of the square (Fig. 23a). With the diagonal folding of the square, a side selvage and an end selvage came together. These form the sides of a triangle; the fold making the hypotenuse. One of the figured bands has been sewed to each set of selvages. Needleknitting finishes the outer right angle corner where the bands meet (Fig. 23d).

The square is all cotton, woven in one of the simplest of gauze weaves (O'Neale and Clark, 1948, Pl. 3 B). There are 16 warps and 10 wefts per inch. The yarns of both warp and weft are two-ply, hard twist, Z-S spun and one forty-eighth inch in diameter. Although badly discolored, they probably were cream-white originally. The use of two-ply, hard twist yarns has produced a seine-like quality in the gauze weave, quite different from the more familiar crêped texture produced by single-ply, crêpe twist yarns. The two strips of banding, which are approximately alike, contrast with the gauze in both color and texture. Primarily of red and brown wool, they are thick and firm. Each has three distinct warp stripes. A central stripe, one inch wide, is brown, with a block pattern in cream-white produced by a simple, non-reversible pattern weave that looks like warp-face plain weave on the obverse face (Fig. 24b) and has long floats on the reverse (Fig. 24a). Outer one-half inch stripes in plain weave are red. Shadow stripes in like hues appear in both the red and brown sections, but color deterioration has advanced to the point where it is impossible to determine whether these were intentional or accidental variations. The patterning is limited to a simple repeat of one figure, a highly stylized double-headed fish (Fig. 24b). Both the red and brown yarns are wool, two-ply, Z-S spun. The red are medium to soft twist; the brown, medium to hard. Both average one forty-eighth inch in diameter with greater variations in the brown yarns than in the red. The cream-white pattern yarns are of cotton and differ from the yarns of the gauze weave only in being spun more evenly. The weft yarns are red wool similar to the warps, except they are medium twist and slightly coarser. There are 64 warps to the inch in the unpatterned parts of the band, with an added 52 per inch for the pattern (48 in all for the width of the patterning). The weft count is 19.

One odd feature appears in the weaving of one of the bands. The pattern yarns do not extend the whole length of the basic warp but have been cut off and knotted together, in groups of four, just beyond the last pattern unit, about two inches from an end selvage (Fig. 24a). This has caused no alteration in the design, since the unused pattern yarns all float on the reverse of the single-face fabric. All of the cotton yarns have disintegrated at the corresponding end of the second band leaving no evidence of the method used for their termination. At the opposite end of the first band, where the last

pattern block is only three-eighths inch from the end selvage, the pattern warps are the same length as the other warps and encircle the same pair of heading cords. The fill-in section of the weaving is in the two-inch length beyond the knotted pattern yarn ends. The heading cords, two at each end, consist of three of the cream-white cotton yarns used together. At the second end of the second band, only two picks of the regular weft have been inserted beyond the pattern block. Coarser yarns have been substituted and the warps grouped in pairs for the terminal length of about three-eighths inch. The heading cords, if present, are concealed completely by the needleknitting.

The method of attaching the bands to the square shows marked similarities to present day practices when decorative edgings are hand sewed to other fabric edges. After the square was folded, one section of banding was placed face down on the gauze with right angle corners of the two fabrics coinciding and a side selvage of the band meeting a side of the triangle. The three superimposed selvages were then sewed together with whipping stitches (Fig. 23b). This band was turned out to form a flat extension. The second band was added in a manner similar to the first, except this band was placed to extend across the end of the first (Fig. 23c). In each case the excess length of the band continued beyond the acute angle of the gauze triangle to form tab ends of approximately equal lengths (Fig. 23d). In attaching the first band, the gauze was stretched to compensate for the two-inch added length needed to extend the second band across the end of the first.

Needleknitting similar to an example shown by O'Neale (1937, Pl. LXIII d) was used to finish the right angle corner of the scarf (Figs. 23d and 24b). The yarns used for sewing the bands to the gauze are like the cotton weaving yarns, except they are medium twist; they have been used double. For the needleknitting the yarns are principally of wool and appear to have matched the warps of the banding, the colors being arranged in blocks. Due to soil and deterioration all are now muddy browns. Decorative stitchery was used also to add raised, colored dots to the fish design of the bands. There are three of these, one each in red, green, and gold-color, at each end of the design motive (Fig. 24b). For these, the yarns are wool, similar to the wool yarns used in the weaving, but have softer twists. The stitch is like one shown by O'Neale among embroidery techniques (*ibid.,* Pl. LX h, lower right).

Uhle described this triangular cloth as a "sample of fabric with changing warp, from so long ago" (p. 141). He made no mention of its unusual form. It is listed as one of the items from the "continuation of the finds in the burial place beneath the temple" (p. 140) and the only key to a more specific location is the entry which places the group following in the Catalogue as "from a burial place, situated about two meters higher, at the stone wall, in clay, and belonging to the later pre-Incasic (that is older than the rebuilding of the temple)" (p. 141). A cloth similar to this, from Ancon, is shown by Reiss and Stübel (1880-87, Vol. 2, Pl. 43a, Fig. 2). Both have been discussed in another paper (VanStan, 1965).

The Apron-like Cloth. This specimen (29568 [1345]) consists of a narrow belt or band with bordered ends. Woven approximately 52 inches long and three-fourths inch wide, the band is now in two segments. The longer of these has been tied into a knot about ten inches from one end border. Except for the decorative end sections, which are polychrome and about three inches in length, the fabric is all cream-white cotton in one-over-one plain weave. Adjacent to the knot and extending for a distance of 25 inches, the band has been folded in half lengthwise and the two layers sewed together with long running stitches (Fig. 25a). Brown dust and a few bits of charred plain weave fabric remain inside the fold, giving the folded edge a slightly rounded contour. Uhle's description, a "Band (or strip) with colored ends, torn from a half-decayed cloth designed in colors after weaving," (p. 54) indicates that the dust and brittle bits of textile are all that remains of a cloth which may have had a pattern in tie-dye. Judging from the length of the sewed section of the band, this cloth was about 25 inches wide (or long) and of unknown length (or width). A reconstruction of the specimen is shown in Figure 25b.

All of the warps and most of the wefts of the band are two-ply, Z-S spun, medium twist and one

forty-eighth inch in diameter. There are 56 warps and 22 wefts per inch in the plain cotton areas. In parts of the patterned sections, three warps have been grouped together and the weft counts are higher. The band has been widened gradually to one and three-eighths inches at the end selvages. The patterning (Fig. 26) is approximately alike on both ends of the band. It is made up of three weft-wise stripes of plain dark red tapestry, each five-sixteenths inch deep, separated by two one-fourth inch stripes of two-color twill weave, one blue and green, one red and gold-color. The term *two-color twill* has been used to designate a weave which may be classed equally well as a double-face brocade. In this, alternate wefts, all of one color, form a two-over-two twill. The second set of alternate wefts, all of another color, do likewise (Fig. 25c). In this example, three yarns are used together as a single warp. This grouping is constant throughout the twill weave and tapestry sections. It is broken down where cotton tabby wefts have been used. Below the twill bands is a section, three-sixteenths inch deep, in red brocade with tabby wefts matching the warps. Following this is a terminal band of red and gold-color twill adjacent to the heading cords. Wherever two colors have been used their positions in the patterning are exchanged on the two faces of the cloth (Fig. 26). Each of the heading cords consists of two yarns, each made of eight of the warp yarns twisted together in a Z direction. The ends of these extend about one and one-half inches beyond the sides of the fabric and a loop is present in one instance, where one length of yarn has been doubled back to form the second heading cord. The pattern yarns are wool. The dark red (7-J-4) is two ply, Z-S spun, medium twist and one-fortieth inch in diameter; the blue (30-K-1) is approximately the same; the green (23-H-1) and two shades of gold-color (13-H-7, 12-F-6) differ only in having softer twists.

The nature of the fabric to which the band was attached can be judged only on the basis of Uhle's description and a few bits of charred cloth, now dark brown, which show a one-over-one plain weave. The yarn, in both warp and weft, is wool, two-ply, Z-S spun, hard twist and one sixty-fourth inch in diameter. The count, based on an area about one-fourth inch square of extremely brittle fabric, is 36 by 32 per inch. While the reconstructed shape suggests the form of a breech cloth, there is nothing to confirm this interpretation.

The specimen came from "a second entire gravefield superficially rifled, of about the same age as the first worked, eminently old (1330-1350)" (p. 54).

CLOTHS WITH SEWED ADDITIONS

Of the three specimens in this category, one is a polychrome wool tapestry with both woven- and sewed-on sections of plain cotton fabric. One is a tie-dye cloth with an undecorated web added. The third is a fragment with a brocade border and a section of needleknitting along each side.

A Loin Cloth. This specimen (29680 [1182b]) is a fragment of which little more than the tapestry section remains. Uhle has shown most of this in *Pachacamac* (1903, Pl. 6, Fig. 8) and has described it as a part of a loin cloth (*ibid.,* p. 31). The whole specimen consists of the tapestry section, 14 by 16¼ inches, with fragments of plain white cotton fabric at both ends, all woven on one set of warps, and a similar strip of cotton fabric sewed along one side (Fig. 27). At one end the cotton fabric, woven in a one-over-one plain weave, changes to tapestry along a weft line, with only about one-fourth inch of the plain cloth remaining. The opposite end of the tapestry forms a series of step triangles with the plain cotton cloth continuing between and beyond these. Parts of the side selvages are intact, but no end selvages. A plain cloth band, one and one-half inches wide, also of cotton, which Uhle has mentioned (*id.*), has been sewed with saddler's stitches to one side selvage of the tapestry. Although not now a part of the tapestry web, it is possible that it once was a part of the same web, since the end sections, where the two might have been joined by common wefts, have been destroyed. There are remains of sewing stitches along the outer side of the band and torn edges, as if another segment had been de-

tached. The present band length is 10½ inches and includes no part of an end selvage.

The warp yarns are two-ply, Z-S spun, hard twist cotton, one sixty-fourth inch in diameter. The wefts of the plain sections are the same. The warp count is 60; the weft, 20 per inch. In the tapestry the wefts are wool. Four warps have been grouped together making the count 15 (times four) for the warp. The weft count averages 104. Generally the wool yarns are two-ply, Z-S spun, and approximately one sixty-fourth inch in diameter. They differ considerably between colors, primarily in the degree of twist, ranging from very soft to hard. A few are S-Z spun. Reds, from deep pink to garnet, predominate. Included also are cream-white, gold-color, green, green-blue, brown and black. The main pattern, a latchhook, fish motive combination is arranged in diagonal bands (Fig. 28), no two of which are alike in coloring, although the individual hues have been repeated. The weaving is of the kelim type. Where very long warpwise slots would have occurred due to the vertical lines of the pattern, notably where a single wrapped warp forms a pattern outline, the wefts of one color have been interlocked around an adjacent warp at intervals of about one-eighth inch. Similar slots at the edges of the step-triangles have been sewed closed with fine saddler's stitches, like those used to attach the band to the tapestry. A small, stepped diamond form appears in the tapestry triangles. Adjacent to the main tapestry section, between the bases of the triangles, the plain cotton cloth has been woven one-over-four, like the tapestry, for about one-fourth inch. The remainder matches the other sections of cotton fabric. The band has cotton warp and weft yarns like those of the other plain sections. There are 80 warps and 24 wefts per inch, producing a cloth firmer than the other cotton sections. The sewing yarns are the same as the weaving yarns and have been used double. The sewing of the kelim slots at the sides of the triangles and the joining of the band to the tapestry appear to have been contemporaneous parts of the construction.

In the Catalogue this specimen is listed, simply, as a "Piece of Gobelin" among "Other objects accompanying the Mummy (1182)" (p. 36), with no applicable group heading to designate a specific locale.

A Tie-dye Cloth. A second cloth with a sewed addition (30211b [1770n]) consists of parts of two cotton webs which have been sewed end to end. One fragment has a tie-dye pattern in brown and cream-white. The other is an unpatterned putty-colored web. Included with these is a part of a second web of tie-dye material (30211a [1770n]), very similar to the first, which is not connected to the others. All are one-over-one plain weaves. Each of the tie-dye webs has an allover pattern in the doughnut-shape figures common to cloth tie-dye. Diagonal rows of the circular figures, each about one-fourth inch in diameter, cross to form a diamond pattern; a similar larger figure about five-eighths inch in diameter is centered in each diamond. The larger circles show evidence of over dyeing. The lighter parts are browner than the original off-white ground where the cloth is undyed and each figure is surrounded by an irregular spot of darker brown (Fig. 31b). The undulations in the fabric, resulting from the tying, subsequent immersion in a dye bath, and the drying of the tied fabric, are still present in both of the patterned webs. The tie-dye web of the two-web cloth is 22½ by 16½ inches and has two end and one side selvages intact. The attached fragment of unpatterned cloth is seven by 18½ inches, with parts of one end and one side selvage. End selvages of the two webs have been joined by means of fine whipping stitches. The remaining side selvages, one on each web, are at opposite sides of the specimen (Fig. 31a), indicating that the original width of the webs probably was about 19 inches. The texture of the plain piece differs only slightly from that of the tie-dye piece. The yarns of the two are alike, except in color. All are single ply, S-spun, hard to crêpe twist and one sixty-fourth inch in diameter. There are 50 warps and 34 wefts per inch. The same type of yarns, grouped together and twisted Z-wise, form the heading cords. There are two at each end, where these are intact, with all of the ends finished neatly by being turned back into the shed. The sewing yarns are two-ply, S-Z spun, hard twist, and one-fiftieth inch in diameter. Sewing thread ends of the same kind, all light brown, are present along the side selvages of both the plain and the patterned webs. An additional fragment of

unpatterned cloth, two by four and one-half inches, including a bit of end selvage with heading cords corresponding to those of the other web, is tied to the other plain piece with a length of bast fiber cord (two-ply, Z-S spun, hard twist, one-twentieth inch in diameter). Presumably this was a section of the other end of the same web, drawn up and tied when the fabric was attached to the mummy bale, the central area having rotted in the interim. A photograph and description of this specimen have been published in *Expedition* (VanStan, 1961b, pp. 35-36).

The second piece of tie-dye cloth resembles the first closely. The scale of the pattern is slightly larger. The warp and weft yarns are alike and differ from the others only in being slightly coarser, one-fiftieth inch in diameter. There are 48 warps and 32 wefts per inch. The heading cords are like those of the other webs. Parts of both end selvages and one side selvage are preserved and bits of sewing stitches remain along all of these. On two edges the thread is like that used for the other sewing; on one end the yarns are soft twist, in place of hard. This web was woven 24 by 19¼ inches. The shape of this fragment, in its decayed state, is very similar to that of the other patterned fragment. Each has a long weftwise tear suggesting that these were overlaid on the bale and torn at the time of removal. Other than the sewing thread ends, nothing remains to indicate that the two sections (a and b) were joined together. If the irregular shapes and the tears of the two pieces are matched, both are face up (or down), rather than with the corresponding faces together, showing that the two were not seamed together at the time that the major part of the decaying took place.

In the *Field Catalogue* these are described as "Two pieces of cloth, dyed and figured after weaving" among "Different kinds of remains of cloth (1770a-u)" (p. 78), "From Pachacamac, continuation (first burial place) 1735-1779" (p. 76).

Border with Needleknitting. This cloth fragment (30174 [1090s]), made of two narrow webs, has white cotton ground with a brocaded border 9¼ inches deep which is finished with heavy needleknitted edging where the border meets the side selvages (Fig. 29). The needleknitting (O'Neale, 1937, Pl. LXIII d) is of a type frequently appearing as reinforcement at points of hard wear, but it has no apparent purpose in the position at the side selvages of the border unless to conceal unsightly lengths of selvage where the pattern yarns turn back.

The ground fabric of each of the two webs is cream-white cotton, in a one-over-one plain weave, except in one web where the warp yarns are in pairs at irregular intervals of an inch or more. The brocade pattern is a zigzag diagonal formed of a bird design arranged in bands (Fig. 30). Now in two shades of brown, the patterning probably was originally red and brown. The pattern yarns are wool, two-ply, Z-S spun, soft twist, and one thirty-second inch in diameter. Cotton yarns like the other cotton wefts, form the tabby wefts and produce the cream-white ground of the brocade section. At the top and bottom edges of the decorative band are one-fourth inch strips of two color twill woven in the wool yarns without the tabby wefts. All of the cotton yarns are two-ply, Z-S spun, medium twist and one forty-eighth inch in diameter. The warp count throughout is 56 per inch. The weft count in the plain weave sections is 34; in the brocade, 42; and in the twill, about 96. The needleknitting is worked in a diamond pattern in wool yarns similar to the wool weaving yarns, but not matching exactly. The colors are arranged in blocks and appear to have included dark brown, red, white, and at least one other hue.

The cloth is now about 16 inches long and 21 inches wide; each of the component webs is roughly 10½ inches wide, with the seaming along warpwise selvages. The pattern band is two inches from the one remaining section of end selvage. About eight inches of this selvage are intact and there is no evidence of a finish other than the heading cords. There are three heading cords and these have been finished neatly at the one corner which had not been destroyed. Each is made of four-ply cotton yarn, Z-S spun, and one thirty-sixth inch in diameter. Whipping stitches in cotton yarns, similar to the weaving yarns but softer twist, have been used double for the seaming.

The patterning of the border appears on both faces of the fabric, with the light and dark areas

produced by the ground and pattern yarns reversed in the brocade, and the red and brown, in the two-color twill. On the reverse face the meeting of the wool yarns of the two colors, where they turn back at the edges of the diagonal pattern lines, has not been handled carefully, indicating that the intention was to produce a single-face pattern. This feature probably was responsible for Uhle classifying this as "embroidery," although the change in weft counts with the introduction of the pattern yarns, as well as the presence of the narrow two-color twill bands, indicates that all of the patterning was produced while the cloth was being woven (Van Stan, 1967, Figs. 1,2). The needleknitting is rounded over the edges, showing equally well from either face of the cloth. The remaining sections of plain cotton fabric extending above the border provide no indication of the original length. The cloth appears to have been torn weftwise after sections had decayed. The specimen has been cleaned since recovery.

Uhle has identified this as an "Embroidered piece of cotton fabric" one of several "Remnants of fabric (1090)" (p. 21) from the "Excavation some ten meters to the west of the foregoing ones, at the foot of an old half-terrace. (1088-1134)" (p. 20).

SUMMARY

These five specimens are important because their forms indicate that garments or other accessories were made in a number of styles which have not been noted or have tended to be overlooked. A few technical features are noteworthy: The presence of a seine-like quality in a gauze weave fabric. The use of "two-color twills," which probably indicates a familiarity with the principle of twill weave but a preference for a more conspicuous style of diagonal patterning with greater color flexibility. The carefully controlled shaping of a narrow band through changes in weave and increased weft bulk, rather than the addition of warps. The weaving of a border-like tapestry area with plain cotton fabric extending from both ends, with the implied possibility that both ends continued for lengths of more than a few inches. The preservation of the undulations resulting from tying and dyeing of cloth to produce a pattern.

GROUP IV: SHROUDS

A fourth category of cloths, one in which seaming occurs as a frequent but not essential part of the construction, is that of the large cloths used as mummy shrouds or mummy bale coverings. Whether or not fabrics were constructed for this purpose or only adapted to this use is not clear. It seems probable that both practices were followed. The present group shows fairly large single webs and cloths in which two or more long, narrow webs are seamed together along warpwise selvages to produce a large cloth. No folding or other obvious shaping was part of the scheme. Although one or more of the component webs may be decorated, there are no fringes or other added borders or decorative edge finishes.

Uhle has identified these as *wrappers,* as *coverings for the mummy bale,* or *wrappings of the mummy* and sometimes has indicated their being from the inside or outside of a bale. In a few cases the present classification as shrouds has been based on the large size of the cloth, with its use confirmed by the presence of random ends of bast fiber yarns showing that the cloth had been sewed to the mummy bale. The latter, alone, would provide insufficient evidence, since these ends appear in numerous specimens of other types. These have been grouped in two categories, those which are undecorated or have simple stripes and those which have more elaborate ornamentation.

UNDECORATED OR WITH SIMPLE STRIPES

All of this group are plain or basket weave fabrics and are chiefly of undyed, unbleached yarn. Solid white and brown are present as well as tweed effects, hit-or-miss striping and planned striping. Individual fabrics are of either cotton or wool. Both single and multiple web specimens are present.

Single Web. Only one of this group, all of which are cotton cloths, has been clearly identified as a shroud. The others appear to have had a similar use.

One large white cotton cloth (30954a,b [1180c]) is classed in the *Field Catalogue* as an "Inner white wrapper" among the "External objects" which were "found with a mummy" (p. 36). Although now in two sections, the irregular ends, where the two were cut apart, match exactly showing the woven length of the cloth to be 125½ inches. Both end selvages, each with three heavy heading cords, are intact. The complete width of the web is 33 inches. Segments of bast fiber yarns, which were used to sew the piece to the bundle, are scattered along both edges, with a few in the central part of the cloth. The fabric is cream-white, woven in a one-over-one plain weave. There is no evidence of any type of decoration, but a strip eight and one-half inches wide, adjacent to one side selvage, has warps which differ from those of the major part. In this narrow section some of the regular wefts turn back, at intervals of about three inches or less, forming pairs of extra wefts. The spacing of these is irregular and some extend the full eight and one-half inches from the selvage or slightly less, some extend between four and five inches, others between one and three inches. Like the regular weft yarns, each enters a shed at the cloth edge and returns in the next shed (Fig. 32). These extra wefts probably produced a slight flare in the one side of the fabric but, if so, it is no longer noticeable. The change in warp yarns is more conspicuous. The warps of the major section are two-ply, Z-S spun, hard twist, and one thirty-second inch in diameter. There are 42 per inch and the texture is firm and rep-like (Fig. 33). The warps of the eight and one-half inch strip are the same, except for having a slightly harder twist and being only one forty-eighth inch in diameter. These finer yarns are set 60 to the inch. The wefts, also two-ply, Z-S spun, are soft to medium twist, and average one-fortieth inch in diameter. There are 14 per inch. The heading cords consist of six to nine ends of the coarser warp yarn twisted together to form a cord. These have been doubled back close to the selvage at one side of the web. On the flared side, the ends extend one to seven inches and at one corner two have been knotted together to form a loop.

37

This specimen is from the "Continuation of the excavations at the place (on the foot of the temple of Pachacamac) from which I obtained the objects Nos. 1000 to 1087. At present the site is beneath the temple" (p. 27).

Only the large size of one specimen (30934 [1097c]) and the fact that it was found with a mummy support the classification as a shroud. The cloth is coarse and thick with a remarkably soft, almost silky, texture (Fig. 34). In its present condition, it appears to be a piece of yardage. The remaining length is 85 inches with no part of an end selvage at either end. It is obvious that both ends have been cut, with any ragged parts trimmed away, and that the specimen has been cleaned since recovery. The woven width is 41 inches. A few ends of a bast fiber yarn, near one selvage and at random locations in the central area, presumably represent stitches which held the cloth to the mummy bale. They are the only indication of sewing. The construction is a simple one-over-one plain weave. The weaving yarns are all of unbleached white cotton, two-ply, Z-S spun. The warp is hard twist; the weft, medium to hard. The yarn diameters vary widely within each length of yarn, the diameters of the warp yarns ranging from one twenty-fourth to one-twelfth inch, the wefts from one-sixteenth to one-eighth inch. The counts per inch average 15 for the warp, 8 for the weft.

Despite its large size for a single web, there is no evidence of a fill-in section. The workmanship is good, the weaving even and the texture constant throughout, the uneven yarn diameters lending interest rather than detracting from the quality. No indication of ornamentation of any kind is present. Except for a few charred holes, the fabric is in excellent condition. Identified in the *Field Catalogue* only as a cloth similar to another "found with the mummy" (1097) (p. 22); one of those from the "Excavation 10 meters to the West of the foregoing ones, at the foot of an old half-terrace" (p. 20).

Two unattached pieces of cloth (30955a,b [1182g]) for which no description or identification has been given in the *Field Catalogue* seem to have been wrappings. (A single number [1182g] applies to four specimens identified only by the one word "corn.") Both of these textile specimens are fragments woven of unbleached white cotton yarns. The larger (30955a) is woven in a two-over-two basket weave (Fig. 35). The remaining length is 66 inches; the complete width, 29¼. Parts of both side selvages and two segments of one end selvage are intact. The cloth is sleazy and the fill-in section is conspicuous. Although the straightness of the selvages suggests the work of an experienced weaver, the workmanship is generally poor in quality. For such a sleazy fabric, the width is remarkably constant, varying less than one-half inch in the 66 inch length. Both the warp and weft yarns are single-ply, Z-spun, hard to crêpe twist, and one forty-eighth inch in diameter, with considerable variation present in both the degree of twist and the diameter. The count shows 13 (times two) warps and 7 (times two) wefts per inch. There are two heading cords consisting of four of the weaving yarns grouped together in each pick. There are no indications of decoration of any kind. The only evidence of sewing consists of bits of bast fiber yarns near the fabric edges.

The second of these fragments (30955b) is unlike the first. It is a one-over-one plain weave, with a marked preponderance of warp yarns (Fig. 36), 38 to 14 per inch. Both the warps and wefts are two-ply, Z-S spun, hard twist, and one forty-eighth inch in diameter. One end selvage is intact, with three heading cords. Two of these consist of four, the other of five ends of the weaving yarn grouped together. The remaining length of the web is 35½ inches; the complete width, 27½ inches. There is evidence of neither sewing nor ornamentation of any kind.

Both of these pieces were with the "other objects accompanying the mummy" (1182) (p. 36), and are listed under the same general heading as the second preceding specimen (1180c).

Multiple Webs. These include one two-web cotton cloth and two three-web wool cloths. The latter are brown with striping along one side and are approximately alike.

In the cotton cloth (30933 [1176d]) two mixed brown and white webs, which are approximately alike, have been seamed along lengthwise selvages with coarse whipping stitches. Each web is warp-face one-over-one plain weave woven 79 inches long and 28¼ inches wide. Most of one web is intact. The

central section of the other is lacking; only the two end sections remain, both of which are still sewed to the other web. All of the end selvages are present, one complete side selvage and parts of the other three. The yarns are either plain white, plain brown or a mixture of brown and white cotton. Brown yarns and yarns which are predominantly brown have been used to produce irregular warpwise stripes. The cloth has been cleaned and the brown is faded in most areas. There is one distinct brown warp stripe, one-half inch wide and ten inches from one side of the web which is in two segments. There are also four shadow stripes, five-eighths, one, two and five-eighths, and four and three-fourths inches wide, the two narrower ones at the selvages; the others between these and the one distinct stripe. These shadow stripes are made with warps in which the yarns are mixed brown and white. In most of these mixed-color yarns (Fig. 37), the mixture has been made in the stock before spinning so that the amounts of brown and white differ within each yarn as well as between different yarns. In a few instances one ply is of brown and the other of white. Similar yarns have been used for parts of the weft, with plain brown for a section six inches deep near the center and plain white for the major parts. Most of the warps of this web are two-ply, hard twist, and about one thirty-second inch in diameter; some are S-Z spun, some Z-S, a few show S-S spinning. The weft yarns include these same kinds, also some coarser yarns and some which are medium twist.

The assortment of yarns used for warps in the second web is less varied. All are two-ply, Z-S spun, most are hard twist, and one thirty-second inch in diameter; a few are crêpe twist and a few are finer than the others. The striping in this web appears to have been simpler, probably with wider stripes, and only three of these, two mixed, one plain brown, but this cannot be discerned clearly. The wefts are plain white, except for a few mixed brown and white, used principally in the fill-in section, which is conspicuous due to the wider weft spacing. The weft yarns differ from the warp only in being slightly coarser and medium twist. Some are unusually coarse, one-sixteenth inch in diameter. For both webs the average warp count is 48 per inch; the average weft count, 13.

Three heading cords, made up of four to thirteen ends of the warp yarns twisted together, have been used at each end of each web. In the sewing, which appears to have been done hastily, the two selvages were held together with the two webs face to face and the stitches taken through the two layers, about one-fourth inch deep and one-half inch apart. A few ends of the bast fiber yarn used to sew these cloths to the bale are present, also.

The indications are that these cloths were woven largely of left-over yarns, but even so, a certain amount of attention was given to placing these odds and ends in stripes in the warp, which have a degree of asymmetrical balance with the mixed-color yarns producing a tweed-like effect.

This specimen is listed as a "Wrapper of the mummy" (p. 35), one of the fabrics "Found with the mummy (Skull P 74)" which is classed under the general heading which refers back to the main classification "on the foot of the temple of Pachacamac" (p. 1).

There are two brown wool cloths which are basically alike in appearance but differ in a number of details. These are listed as coming from two different mummies. Both are brown wool rep-like fabrics which are firm but not stiff or harsh in texture. Each is made of three webs and has a red and navy blue stripe (Fig. 38) adjacent to a single side selvage.

One of these specimens (29874 [1180d]) is 116 inches long and 51¼ inches wide. The central web is 17½ inches in width, the plain brown outer web 17¾ inches, and the bordered piece 16 inches. A considerable part of the central section of the cloth has rotted, but parts of all except one of the end selvages are intact. One end of the bordered piece has disintegrated. All of the brown warp yarns are alike, two-ply, Z-S spun, medium to hard twist, and one forty-eighth inch in diameter. The red and blue differ only in having soft to medium twists. The wefts, brown throughout, likewise are the same except they are very soft twist. The warp count averages 70 per inch for all of the webs; the weft count, 13. Two heading cords have been used, each consisting of six ends of the brown wool yarn like the warp. Generally the first cord has been turned back into the second shed. At the

opposite side of the web, one end usually is knotted and hangs free; the other has been used for sewing the seam. The sewing thread is either the same as that of the heading cords, or slightly coarser and used three ends together. For part of the sewing, these yarns have been used without additional twisting; in other parts they have been twisted together in a Z direction. Both seams have been sewed with whipping stitches. One seam, that joining the bordered to the center piece, is securely sewed with relatively short tight stitches, averaging one-fourth inch in length. The other is attached with very long coarse stitches, some as long as two inches. The warpwise border striping on the single length of fabric consists of a brown edge three-eighths inch wide, followed by red, one and one-fourth inches; blue, three-fourths inch; red, blue, red, one-eighth inch each. Most of the color has deteriorated badly, with the larger part of the navy blue turned to brown. In the one section where the colors are well preserved the red matches Maerz and Paul (1950) color 7-L-9, the navy 48-C-7, and the brown 8-H-12. Numerous ends of bast fiber yarns, one to seven inches long, remain in the fabric.

This specimen is listed as one of the "External objects" . . . "found with a mummy: (1180)" and described as a "Cotton (?) wrapper (brown)" (p. 36), among the items referred back to the general heading "on the foot of the Temple of Pachacamac" (p. 1).

The second of these brown cloths (29873 [3182]), described by Uhle as a "Brown cloth, with red border, in which the body was wrapped" (p. 135), is softer than the other and slightly lighter weight. It is also shorter and wider. The over-all size is 104 by 56½ inches, the widths of the three component webs are 18½ and 20 inches (central) for the plain brown, and 18 inches for the bordered. The border striping includes a one-fourth inch brown edge, one and three-eighths inch red, three-fourths inch blue, and three thirty-seconds inch each of red, blue, red. The colors are preserved better than those of the other specimen. The Maerz and Paul equivalents are: brown, 8-J-12; red, 5-K-9; navy, 40-J-9. Both the red and the navy are distinctly bluer than the corresponding hues of the other example. The brown warps are two-ply, Z-S spun, hard twist, and one forty-eighth inch in diameter. The wefts, also brown, are the same except the twist is soft to medium. Some of the red warp yarns are medium to soft twist; otherwise, the red and the blue are like the brown. The warp count is 74, the weft 16 per inch. One end of the cloth remains in excellent condition and all of the heading cords are present. In each case two have been used and the ends, six to 14 inches long, hang loose at the seams. Those of the outer webs have been knotted at the corner of the fabric; one end of the other set is lacking. Most of the opposite end of the fabric is intact and the heading cords are the same, except that the ends have been used for sewing the first parts of the seams. At one outer corner of the cloth these cords have been pulled up so that the fabric is gathered for about three inches and the cord ends have been knotted. The heading cords consist of four to five ends of wool yarn slightly darker than the weaving yarns, two-ply, Z-S spun, hard twist, and one forty-eighth inch in diameter. These have been twisted together, hard twist in a Z direction. The same yarns have been used for some of the sewing. A similar, lighter brown yarn consisting of four ends grouped together, serves for part of the sewing. Two sections, all that remains of the seam joining the bordered piece to the central strip, and part of the other seam, are sewed in tight, fairly small whipping stitches. The larger part of the second seam is open and running stitches hold a section of it near one end. These have been sewed through the two layers of fabric with the selvages together, in the same position used for the whipping stitches. Again, some of the bast yarn ends are present.

Although listed separately, this may have come from the same area of interment as the other similar specimen. It is listed in the *Field Catalogue* under the heading "Excavations at burial place number one. Beneath the Pachacamac temple, continuation" (p. 135).

This specimen has been described, with the other textiles from the same mummy (3179-3186) in an earlier paper (VanStan, 1964a).

DECORATED SHROUDS

The items making up this group are notable for their differences rather than their similarities. Included are a large painted cotton cloth, a monochrome blue-dyed cotton fabric with a pattern in brocade, a large polychrome wool tapestry and, among the smaller fragments, two white cotton cloths with block patterns in wool embroidery or brocade.

Single Web. The one large cotton cloth with a painted design (26721 [3209]) has been placed in this category on the basis of Uhle's description, although it seems likely that it consisted, originally, of more than one web. Technically this is the simplest of the group of decorated shrouds.

Only remnants of this specimen remain and these have been described at length by Uhle in *Pachacamac* (1903, Pl. 4, Figs. 1a - 1c, pp. 22-3). Only two parts, the end fragments (1b and 1c) and two small scraps (1d and 1e) are presently available for study. The present lengths of the two end segments are 37 and 36½ inches; the width of each, 46½ inches. For the whole piece Uhle gives a minimum length of 11 feet, 6 inches, based on an estimate of the length required for the complete design. The combined length of the fragments, as Uhle shows them in his illustration (Figs. 1a, b and c) is approximately three times the width or 11 feet, 9 inches, with part of the pattern lacking, indicating that Uhle's length estimate was too conservative if these were all parts of a single web. The fabric is unbleached white cotton in a two-over-two basket weave. The yarn counts, 28 (times two) for the warp and 24 (times two) for the weft, differ slightly from Uhle's, although he may have considered the paired weft yarns as one single yarn or it is quite possible that the larger remnant of the fabric (not available at present) was woven in this manner, and not like the two separate end sections and the small fragments. The yarns are all single-ply, S-spun, crêpe twist, and one-seventieth inch in diameter. The cloth is firm but not thick and the workmanship is excellent. Three exceptionally heavy heading cords, each one-eighth inch in diameter, produce a corded effect at one end selvage. At the other end, there is one cord about one and one-half times the size of these, but somewhat flattened, and three lighter cords. The cords consist of from 30 to 60 ends of the weaving yarns grouped and Z-twisted. They have been knotted at one side of each cloth segment.

One side selvage of each of the end sections shows evidence of sewing stitches, indicating that this length of cloth was, at some time, sewed securely to another fabric. A three and one-fourth inch segment of the selvage of this other fabric, which appears to have been like the first, is still attached, beginning at a point 11½ inches from one end selvage (the end with four heading cords). The pattern appears to have been painted after the webs were joined, although the evidence is not conclusive and the pattern may or may not have been complete on the one web. The sewing is in tight whipping stitches, sewed over the two selvage edges in the usual manner. The sewing thread is made up of eight ends of single-ply cotton yarn used together. These are similar to the weaving yarns, but are slightly coarser and lighter colored.

In the *Field Catalogue* Uhle lists six fragments of this cloth, only five in *Pachacamac.* Uhle mentions the fragmentary condition of the fabric when found and the fact that the designs of the smaller fragments do not fit into the reconstructed design. These notations together with the presence of another bit of web attached by sewing and the slight discrepancies noted between Uhle's textile descriptions and those observed in the two end pieces indicate the possibility that this cloth consisted, originally, of two or more webs and that the remaining segments were not all parts of one web. If this was the case, the wrapping would not be properly classed as a single-web type.

The complex design, with no evidence of a repeat, is painted in the same colors, browns, orange, and blue, and in the same manner on all of the fragments and there seems no doubt that these were either parts of a single specimen or of two pieces very similar in style.

The specimen came from an undisturbed burial (*Pachacamac,* pp. 22-3) of the "Excavation at burial place number one. Beneath the Pachacamac temple" (p. 135) and is described as "Three pieces (and

three small pieces) of a painted, plain cotton cloth (wrapper?), with interesting mythological representations. Served as a wrapper for the mummy bale " (p. 136). Uhle classified this as "Tiahuanaco" on the basis of the style of the painted designs.

Multiple Webs. A "Fragment of blue-dyed cotton stuff" (p. 20) consisting of four pieces of cloth sewed together (29870 [1084b]), may or may not have served as a shroud. Indications are that the cloth originally was two yards or more in length and about one and one-half yards wide. The central and end sections appear to have rotted away leaving the specimen in two parts (Fig. 39 b). The remaining side selvages are overlapped irregularly and sewed together with coarse running stitches in brown cotton yarn (Fig. 39 a). When the whole cloth was intact, these stitches probably held it in place as a wrapping. None of the ends of bast fiber yarn, usually used to attach the cloth to the mummy bale, are present. Each of the two sections of cloth has a central crosswise seam where the ends of two pieces of fabric have been joined. In each case, one of the two pieces is plain, one patterned, and a rolled hem at the end of each plain piece has been sewed to an end selvage of a patterned piece. All are blue cotton.

The larger of the unpatterned fragments is 34 by 26 inches, with parts of both side selvages but no part of an end selvage intact. The rolled hem, finishing one end, is sewed with a tight knot stitch (Fig. 18b) and whipping stitches have been used to attach this plain web to a patterned web. The latter is now a fragment 12½ by 18¾ inches which is covered, almost completely, with a small, twill-like, monochrome diamond pattern.

The other half of the specimen is similar. The plain fragment is 13 by 8 inches. Like the other, it has no end selvage but a segment of rolled hem at one end and an adjacent length of side selvage. The sewing is the same as that of the other segment. The patterned piece attached to this is 33 by 17 inches and has parts of one end and one side selvage intact. The remaining patterned area although very small, appears to have been like the first. Both seem to have been in the form of stepped triangles (Fig. 39b), with one side of the triangle along a side selvage and the other about one-half inch from an end selvage.

All of the basic fabric has been woven in a two-over-one half-basket weave, with 40 (times two) warps and 24 wefts per inch. The yarns are single-ply, S-spun, crêpe twist, and average one sixty-fourth inch in diameter. For the patterning, extra pairs of wefts have been introduced (Fig. 41) increasing the weft count by 24 (times two) per inch. This patterning, which resembles a herringbone twill on one face of the fabric, is so inconspicuous as to be difficult to locate on the reverse face (Figs. 41,42). Technically the pattern weave is a brocade, with ground and pattern yarns of equal prominence on one face of the cloth. A diagram of the weave, simplified by representing all of the paired yarns as singles, is shown in Figure 40. Of the two sections of end selvage which are intact, one shows three heading cords; the other, four. Each consists of two to four ends of the weaving yarns twisted together unevenly. The first cord has been turned back into the second shed, at the corners which have been preserved.

The whole cloth appears to have been piece-dyed and it is possible that the pattern yarns differed in color, originally. Some appear to be slightly grayer than the ground, but this may be due to deterioration, since the remaining fabric is in poor condition. All of the weaving yarns and those used for the knot and whipping stitches are blue on the surface. Inside the rolled hems, the fabric and the sewing threads are almost white, indicating that the dyeing was done after the cloths were sewed together. A few blue thread ends provide evidence of sewing along the shorter length of side selvage of the largest fragment, suggesting that this edge was sewed to another at the time the cloth was dyed. Some of the blue sewing yarns are like the weaving yarns. These have been used two or three together, sometimes given a soft Z twist. Some, used in the same manner, are two-ply, Z-S spun, hard twist, and very slightly coarser than the others. The brown sewing presumably is of later date and extraneous to the construction of the cloth in its four-section form. The brown yarns are two-ply, Z-S spun, medium twist, and about one forty-eighth inch in diameter. They have been used double.

This is one of the specimens from a "Four-headed (?!) grave in an adobe chamber. The mummies are partly those of children, and are apparently partly put in layers. The grave is half-way under the most northern of the lower terrace-walls of a temple-like building. (P55-57 belong here). P55 belongs to the mummy from which nearly all objects come. This skull has the teeth ground off in a remarkable degree (probably from chewing corn meal for the fabrication of chica). (1068-1084)" (p. 18).

The tapestry shroud (29492 [3179a,b]), which has been described with the other items from the same mummy bale (VanStan, 1964a, pp. 20-24), is only partially preserved and is in two sections (a and b). Incomplete, it is a large cloth, 99 inches long and 40 inches wide. A reconstruction is shown in Figure 43. The specimen is composed of five separate webs, each of which was woven eight inches wide and somewhat longer than the present length of the specimen. These strips have been sewed together with saddler's stitches along warpwise selvages. The ground is red, the pattern, a single motive (Fig. 45a) used in a simple repeat, is polychrome with the larger areas either gold-color or cream-white (Fig. 44). The latter have been arranged alternately to produce a checkerboard effect. Uhle has described this specimen in *Pachacamac* (1903, p. 31) and has shown one of the motives (Plate 6, Fig. 5). In the Catalogue it is identified as a "Large Gobelin cloth with repetitions of a figure with ornaments in the style of the Epigons, of the civilization of Tiahuanaco, as are also the pots. This cloth covered the mummy bale. Another piece" (p. 135).

Parts of side selvages remain on all of the strips; three have sections of one end selvage intact and these have been sewed to produce a continuous selvage at one end of the cloth. The opposite end of the cloth, which is the better preserved, has been cut off close to the edge of a pattern unit. In weaving, all of the figures were horizontal in position. The size of the cloth could have been continued indefinitely, without disrupting the plan of the design, by adding more repeats of the pattern unit or sewing more strips together. This makes it impossible to estimate an original size. The individual figures differ in minor respects and the color arrangements vary considerably but no system or design plan, other than the dark-light alternation, can be seen.

The whole cloth is tapestry woven with unbleached white cotton warps, two-ply, Z-S spun, hard twist, averaging one thirty-second inch in diameter. Most of the wefts are wool, two-ply, Z-S spun, medium to soft twists, and average one forty-eighth inch in diameter. A few wefts are S-Z spun and in a few cases cotton has been used. Yarns of a single color tend to be alike throughout, although there are exceptions. Usually these occur between the beginning and end of a web or between different webs. Warp counts average 24 with very little variation. Weft counts range from 84 to 108 per inch. Eccentric weaving is present and weft yarns interlock around adjacent warps to reduce the length of kelim slots, notably where wrapped yarns have been used in outlining (VanStan, 1964a, Fig. 4). A considerable amount of color deterioration has taken place and it is now impossible to determine all of the hues and shades. In addition to the red, cream-white, and gold-color of the major areas, green, blue, purple, henna, orange, brown, and rose can be distinguished. A few of these appear to be quite well preserved in small areas and these sections indicate a wide range of variation in each of these hues. Among these the following can be noted: red 6-J-5; cream-white 11-A-2; gold-color 12-K-7 and 12-H-9; green 24-L-1; blue 29-E-1, 29-J-2, and 32-L-11; purple 48-H-10; henna 6-I-11; orange 4-A-12; brown 8-E-11; and rose 4-I-8. The sewing threads are cotton and appear to have been natural white originally, although some are now brown. All are basically single-ply, S-spun, hard twist, approximately one forty-eighth inch in diameter. These have been used in several different ways. Two to six may be grouped together and used without additional twisting. Two to four may be twisted together Z-wise. These may be used, in sewing, in any combination that does not exceed six of the single-ply strands. The stitches are even and relatively fine. The only remaining end finish consists of bits of selvage from which the heading cords have been removed.

This specimen is from the "Excavations at burial place number one. Beneath the Pachacamac temple, continuation. (3179-3218)." It is one of the specimens covered by the notation "(numbers 3179-3186 belong to a mummy)" (p. 135).

Fragments. The first of this group is a piece of tapestry 18½ by 27 inches, which is classed with the preceding shroud (29492 [3179a,b]) and bears no individual number. Like the other, it has been woven in narrow strips and has a red ground with a single king-like figure (Fig. 45b) used in a simple repeat. Although it resembles the larger specimen closely, it differs in enough respects to be considered as an independent cloth. The two motives are not identical (Fig. 45 a and b). The strips of the smaller piece are 13½ inches wide and each has two rows of figures which fill the space almost completely, leaving so little of the red ground that the pattern appears as an allover design rather than a repeat. The specimen consists of parts of two strips, which have been sewed together with saddler's stitch. The figures are polychrome and, although less well preserved, the colors appear to have been about the same as those of the other piece. The same alternation of gold-color and white is present.

Nothing can be determined about the original form of the cloth. One end of one strip is finished with whipping stitches set so closely that they overlap and produce a rippled edging. The corresponding end of the other strip has been cut off irregularly and extends beyond the first at the seam line. The seaming has been done carelessly and the patterns of the two strips are not aligned. No end selvage remains. Sewing thread ends are present on the longer of the outer side selvages.

The warps and some of the wefts are of cotton. The warps are unbleached white, two-ply, S-Z spun, hard twist, and about one forty-eighth inch in diameter. The cotton wefts have been spun in the same manner and are either white or putty-colored. Most of the wefts are wool. These are two-ply, Z-S spun, soft twist; the diameters vary from one forty-eighth to one sixty-fourth inch. There are 20 warps and 96 to 172 wefts per inch; weft counts varying with the colors, except in the white, where the wool counts are higher than those where the yarns are cotton. The weaving is of high quality. The yarns used for the saddler's stitches are cream-white cotton, Z-S spun, medium twist, and one forty-eighth inch in diameter. These have been used double. The yarns of the whipping stitches are darker cotton, two-ply, S-Z spun, hard twist, and one-fortieth inch in diameter; a few are soft twist.

This specimen has been described in the same earlier report as the preceding (VanStan, 1964a, pp. 24-25). It has not been mentioned specifically in *Pachacamac*. With the other, it came from the "Burial place number one" (p. 135).

Another small tapestry fragment (29953 [1748f]), a third cloth with a king-like motive, has a slightly less conventionalized figure than the others (Fig. 45c). While the others tend to be rectangular in outline, this is not. The others are nearly square or wider than they are high; this is taller than wide. Judging from the remnant, 18½ by 10½ inches, the cloth was composed of strips ten inches wide. Part of one of these shows two rows of figures placed side by side, with the vertical axes warpwise. In the others the figures are horizontal when the warp is vertical. While the others have all of the heads in one direction, these in the center of the fragment have two courses headed each way and the central figures head to head. The remaining bit of a second web, which is only two and one-half inches long and one-half inch wide, shows a small section of patterning which corresponds to that of the larger section.

Again the ground is red and the figures are polychrome. In this case all of the figures appear to have been almost identical, both in outline and coloring. The color alternation seen in the others is absent. There is a considerable use of black, but very little white. In addition to these, and the red of the ground, the colors seem to have been limited to pink, blue, brown, gold-color, and green.

The warp yarns are single-ply cotton, S-spun, hard twist, and one sixty-fourth inch in diameter. They are whiter than the usual cream-white cottons. The wefts are primarily of wool, two-ply, Z-S spun, soft to medium twists, with diameters from one forty-eighth to one sixty-fourth inch. A few of the brown and the white yarns are cotton and somewhat coarser than the wool yarns of corresponding colors. No part of an end selvage is intact. The weaving is in a kelim technique and a few of the longer slots have been sewed closed. Threads for some of this sewing are similar to the warps, but finer. These have been used double, or Z-spun into two-ply hard twist yarns. Others, also cotton, are brown, two-ply,

S-Z spun, medium twist, and one forty-eighth inch in diameter. For the seam joining the two webs, an odd three-ply, Z-S spun, very hard twist, white cotton yarn, one forty-eighth inch in diameter has been used. There are 22 warps per inch and 88 to 136 wefts per inch, the variations usually following color changes. The workmanship is excellent.

Uhle's description of this is somewhat confusing. Eight specimens (1748a-h) are grouped as "Many small square pieces of cloth, dyed and figured after being woven; fragments of a poncho-like undergarment, from the double covering of the mummy-bale. The upper garment was an exceedingly fine Gobelin poncho with heads etc. in pure Tiahuanaco style. The cloth went completely to pieces, when removed, owing (to) the very fine thread." And, under a repeated listing, including four items only (1748e-h), "Small pieces of cloth." (p. 77). These are all from "Pachacamac, continuation (first burial place)" (p. 76).

A distinctly different cloth (29661a,b [1084]), one of three described as "Embroidered pieces of fabric from a wrapper, which was composed of different fragments" (p. 20), consists of parts of two white cotton webs sewed together along their remaining bits of end selvage. The larger of these is ornamented with a nearly square motive (average dimensions one and one-half by two inches) repeated checkerboard fashion to form a block 12 by 14¾ inches. This has been placed near one side selvage and is pointed on the inner end, with the colors of the motives arranged to emphasize the reversed diagonal which forms the chevron-like block (Fig. 46). The larger web section is 30 by 20½ inches; the smaller, two by three and one-half. Parts of both of the side selvages of the larger web are intact and a ten and one-half inch length of one has been sewed with a very tight knot stitch (Fig. 18b) which appears to have been superimposed on the remains of earlier sewing. Thread ends indicate the former presence of sewing on the opposite side selvage.

For both webs, a one-over-one plain weave has been used and the yarns of the warp and weft are alike. All are two-ply, Z-S spun, hard twist, and one forty-eighth inch in diameter. The counts are 50 for the warp and 24 for the weft. The patterning is produced by weftwise supplementary wool yarns of red, brown, blue-green, and gold-color. These wool yarns are similar, structurally, to the cotton weaving yarns. They differ in being soft twist, except the blue-green, which is medium twist. Although Uhle has called the design producing technique, embroidery, the major part appears to be brocade, added as the fabric was woven, rather than after the weaving (VanStan, 1967). The indications are that only some of the smaller bits of color were sewed in after the major part of each design unit was complete, but probably prior to the removal of the web from the loom. About half of the motives are predominantly red; the others are predominantly brown. Accents are in the alternate color, with gold-color and blue-green added.

The stitches used to join the short bits of end selvages of the two webs are fairly fine, tight, whipping stitches sewed with a double thread, one strand of which matches the cotton weaving yarns. The second strand matches the thread ends left on one side selvage, which are about the same, except the color differs slightly; a color difference which has not been lost despite general discoloration of the whole specimen. The sewing threads used for the knot-stitch are similar to the others but are soft to medium twist and are lighter in color than the others. Three of these were used together in the sewing.

Uhle has shown a section of another fabric (29663 [3229a]) with a like design, in *Pachacamac* (Pl. 6, Fig. 14), and has described it as an "Embroidered design upon a plain cotton cloth shroud" (*ibid.,* p. 31), but has added no notations to aid in the determination of the original size or form of either piece. The only entry in the Catalogue for the specimen which Uhle has shown is "certainly from the burial place number one" under the heading "other objects" (p. 138). The piece in hand has a note on the museum tag "one of two pieces," but the second piece has not been located. It was found, with a number of other artifacts, with a mummy (Skull P55) in a "four-headed (?!) grave in an adobe chamber . . . The grave is half-way under the most northern of the lower terrace-walls of a temple-like building" (p. 18).

A very ragged piece of discolored white cotton cloth with two rectangular figures near one corner (29662 [1085a]') is classified as a "Fragment of an embroidered fabric, from the wrapper which was composed of different fragments" (p. 20). The specimen is 31 by 18 inches with one bit of end selvage intact. The remaining ornamentation is at the opposite end and consists of two distinct motives (Fig. 47), one three and one-fourth by three and one-half inches, the other three and one-fourth by three. Part of one pattern unit has been cut off along one side, and this side and an end of the cloth have been folded back through sections of both design blocks for a depth of approximately one inch. Along the side this hem has been sewed with long running stitches, some of which are over an inch in length. The opposite end of the cloth appears to have had a one-fourth inch hem and, principally along the folds, odd stitches indicating that the cloth had seen use in more than one form prior to becoming part of a shroud.

The weave is a one-over-one plain weave with 60 warps and 23 wefts per inch. Both warps and wefts are two-ply, Z-S spun, hard twist, and one forty-eighth inch in diameter. The designs are in wool yarns, one predominantly red, the other predominantly brown. Both have accents of gold-color and blue-green. The pattern yarns are two-ply, Z-S spun, soft twist, and average one-fiftieth inch in diameter. The major parts of the figures appear to have been put in as the cloth was woven, but each of the figures is outlined and the indications are that the outlining was added as needlework after the weaving of the unit had been completed (VanStan, *op.cit.*). All of the pattern yarns are weftwise and alternate with cotton tabby wefts.

This was "Found with a mummy, interred very deep (Skull P58: near to P59), (1085) " (p. 20).

SUMMARY

It is difficult to distinguish "wrappings" or shrouds from some of the other textiles found within or with a mummy bale. While it is obvious that fabrics which had served other purposes were used as shrouds, cloths (distinct from the out-size poncho-shirts) also seem to have been prepared especially for this purpose, although it is possible that some may have served as wall hangings, canopies, or robes of state prior to their use as funerary furnishings. The fabrics in the present lot constitute a hetero-geneous group. They include a wide variety of techniques and a considerable range of colors. Three characteristics, more or less common to all the specimens of the group, may be noted: The cloths are generally large in size. The textures are sturdy and the cloth opaque; sheer and openwork fabrics have been excluded. Ornamentation, when present, is flat; elaboration in the form of supplementary bands, borders, fringes, tassels, and the like, is absent.

GROUP V: SHAWLS,
FRONTLETS, AND FALSE-HEAD COVERINGS

Uhle has listed variously as *shawls, fillets,* and *frontlets* eight cloths which are long and narrow and three *frontlets* which are more nearly square. These fabrics have low yarn counts and are quite soft. In addition there are two examples identified as coverings for the false heads of mummies which are of the "square" style but are larger and rougher in texture than the frontlets. All seem to have been used as coverings for the head, neck or shoulders. There are six unpatterned, monochrome examples and two patterned fragments classed in the first category. Of the "square" frontlets, one is plain, one plaid, and one is striped with a simple pattern weave in some of the stripes. One of the false-head coverings is undecorated, one is patterned. All of the specimens, except the patterned false-head covering, are single-web cloths.

NARROW SHAWLS AND FRONTLETS

This group consists of one unbleached white cotton cloth and five in red wool. All are one-over-one plain weaves. The two patterned fragments have simple pattern-weave stripes.

Unpatterned. The one white cotton cloth(30418 [1099b]) is a crêped fabric woven of single-ply, Z-spun, crêpe twist yarns varying from one sixty-fourth to one forty-eighth inch in diameter. There are 30 warps and 29 wefts per inch. Recent cleaning appears to have increased the degree of crêping of the cloth. The web is completely intact and stretched out measures 49 by 12 inches. The weaving is well done except for the fill-in section near one end. The loomstrings, three at each end, are of three-ply, Z-S spun, hard twist yarns, one thirty-second inch in diameter. At the side selvages each loomstring has been turned back to form the succeeding cords. The resulting loop, and one terminal end, have been tied in a finger knot at one corner. The other terminal ends have been cut off about three-eighths inch from the edge of the fabric.

Uhle has described this as one of a group of "Cloths for frontlets (?) (1099)" (p. 22). It is from "The excavation some 10 meters to the west of the foregoing ones, at the foot of an old half-terrace. (1080-1134)" (p. 20).

All of the red cloths are similar, but no two are identical. Lengths vary from 64 to 106 inches, with only the longest completely intact. Widths range from six and one-half to 14 inches. Two-ply yarns, generally Z-S spun and alike in warp and weft, have been used in the weaving.

The one example with four remaining selvages (29850 [3181]) is eight inches wide. It is silky in appearance (Fig. 48) and cherry red (6-D-6) where the color has not deteriorated. There are 22 warps and 18 wefts per inch. The yarns follow the general pattern and are soft twist, one thirty-second inch in diameter. The weaving is generally neat and even, except for a section near one end where the yarns are more compact and the fabric breadth has been reduced to six and one-half inches. This is a gradual rather than an abrupt change and therefore not conspicuous. There are two heading cords at each end. These consist of a reddish brown yarn, two-ply, Z-S spun, hard twist, one thirty-second inch in diameter, used three ends together. First tests showed these as cotton but the wool-like appearance belied this and further testing revealed a mixture of red wool and brown cotton in the stock, with one or the other predominating in different parts of the yarn. This probably accounts for the reddish brown color which was first believed to be due to color crocking from the red warps (VanStan, 1964a, p. 28).

Uhle has described this only as a "Red woollen shawl" (p. 135). It is from the "Excavations at burial place number one. Beneath the Pachacamac temple, continuation (3179-3218)" *(ibid.).*

The next longest (29840 [3215b]) is 116 by 8 inches. This has the warp loops intact at one end, where the loomstrings have been removed. The other end has been cut irregularly and finished with a knot stitch (Fig. 18b). The weaving yarns differ slightly in color from those of the preceding and range from soft to medium twist. The count is 20 by 13. The red is a rose red (5-K-4). The sewing yarns, used for the knot stitch, are smoother and of a slightly bluer red. They are wool, two-ply, Z-S spun, soft twist, and one sixty-

fourth inch in diameter. Three ends have been used together.

Uhle has listed this as one of "Two red shawls" (p. 137). Both are from the same excavation as the preceding.

The second of these two red shawls (29841 [3215a]) is the widest of the group. It is 64½ by 14 inches. The red (6-I-6) differs somewhat from the preceding. One end selvage is present, with two loom strings. The opposite end has been cut and sewed with a knot stitch in natural white cotton yarn. The warps are closer together at the sides of the web than in the central part. Each of the compact side sections is about one-half inch in width but there is no clear line of demarcation between these and the less compact central area. The warp yarns are primarily Z-S spun; a few are S-S spun. All are hard twist and one forty-eighth inch in diameter. The wefts are Z-S spun, medium twist, and one-fortieth inch in diameter. In the central section there are 31 warps and 22 wefts per inch. For the loomstrings, six ends of the weft yarns have been used together. At one side the yarns have been turned back into the second shed to form the second cord; the ends have been broken off at the opposite side.

Darning is present in three places. For two of these, red wool yarns, which do not match the fabric exactly and have not held their colors so well as the weaving yarns, have been used. These are double, and sewed in warpwise rows of running stitches and weftwise interweaving, as in modern darning. The third spot of darning, most of which has been worn away, is of yarns matching the weaving yarns, except for being soft twist and one thirty-second inch in diameter. The cotton sewing yarns of the knot stitch are two-ply, Z-S spun, medium twist, and one-fiftieth inch in diameter.

The "red fillet" which is the softest in texture (29844 [1161q]) is the narrowest of the red cloths. It measures 88 by 6¼ inches. The red is a rose-red (6-J-5). One end selvage is intact. The other end of the web has been cut and has a rolled hem sewed with tight whipping stitches about one-fourth inch apart. Both the warp and weft yarns are soft twist and one twenty-fourth inch in diameter, the counts 19 and 18 per inch, respectively. Three ends of the weaving yarns have been used together for the heading cords. These have been turned back at one side of the cloth, knotted together at the opposite side and cut off near the knot. The sewing yarns are slightly darker, medium twist and one-fortieth inch in diameter.

This is one of the "Additional objects found with mummy, interred further up (1161)" (p. 32).

A "red woollen frontlet, fragment" (p. 36), which is 82¾ by 8 inches (29847 [1181a]) is a yellower red (5-K-5) than the others. It has the brightest coloring of the group and appears to have been cleaned since recovery. Sections of the cloth have deteriorated and in these the red has changed variously to red-violet, light brown, and gold-color. Both ends of the fabric have been cut, rolled, and sewed with a knot stitch in brown cotton yarn, two-ply, Z-S spun, medium to hard twist, and one sixty-fourth inch in diameter. The weaving yarns are like most of the others, wool, two-ply, Z-S spun, soft twist, and one thirty-second inch in diameter. The count is 21 by 21, the only true square count, although most of the other counts are approximately square.

Uhle has listed this among the "internal objects found with a mummy (1180-1183)" (p. 36), for which he has given no specific locale.

Patterned. The two fragments considered in this category may belong in another group, but their widths and textures coincide with those of the plain narrow webs. Parts of the side selvages are intact, but no evidence of the end selvages remains. Both are primarily of wool and the ground color of each is red. All of the ornamentation is in the form of warpwise stripes.

One fragment (30038 [1149d]) is 10 by 8 inches. Both ends are torn and the general condition of the fabric is poor. The patterning consists of a central stripe composed of eight three-eights inch pattern stripes, all of which are alike in design and have plain outlines, one-eighth inch wide, on each side. Alternate pattern stripes have light green (22-L-1) grounds with red (7-J-10) borders. The others have gold-color (12-H-7) grounds and brown (16-A-10) edge stripes. In both cases the pattern yarns are red and brown and form a simple block pattern with the positions of the two colors reversed on the two faces of the cloth. The pattern is formed by short warp floats and the interchange of red and brown. The technique is the same as that shown

in Fig. 18a. A strip of plain red extends on each side beyond the central patterned area. One of these is one and one-fourth inches wide, the other is one and one-half. Except in the pattern stripes, the cloth is plain weave and warp-face; the counts are 80 and 19 per inch. All of the yarns are wool, two-ply, and approximately one-fiftieth inch in diameter. Most of the warps are medium twist and appear to be S-S spun; some are Z-S spun. The wefts are all red, Z-S spun and medium to soft twists.

Uhle has listed this simply as a "Sample of weaving." It is "from a burial-place at the east-front of the construction, where the graves are almost beneath the terraces. These finds were obtained in an analogous manner as were those from the north-front (skull P69) (1146-1149)" (p. 30).

The second patterned fragment (29787 [1141q]) is six by five and one-half inches. Like the preceding, the fabric is warp-face and the warps are in several colors with red predominating. There are three five-eights inch pattern stripes, each with a simple repeat of an S-shape figure and a single crosswise bar. The central stripe is gold-color on brown; the two others, a light brown on red. The remaining space is divided more or less equally into plain red stripes and groups of three pin stripes. In each group, the two outer pin stripes are brown, with the central pin stripe of gold-color, light green, green-blue, mahogany, or rose color. The arrangement of these hues is not bilateral and one of the outer red margins is about one-fourth inch wider than the other. The weft yarns and the light brown pattern warps are of cotton, two-ply, Z-S spun, hard twist, and one sixty-fourth inch in diameter. The other warps are of wool and slightly finer. Except for having softer twists, the wool yarns have been spun in the same manner as the cotton. The pattern is formed by warp floats and is not reversible. Except for the three pattern stripes, the fabric is in a one-over-one plain weave, with 72 warps and 22 wefts per inch. The brown, gold-color, and green are very similar to the corresponding colors of the preceding example; the red is bluer.

This is one of "Seven samples and remnants of fabrics" (p. 29) among the "Internal furnishings (1141)" (p. 28), "Furnishings of a mummy (skull P69) was photographed together with P68 (1139-1141)"; all are from the "Continuation of the excavations . . . beneath the temple" (p. 27).

"SQUARE" FRONTLETS

The one plain frontlet of this group (30423 [1099a]) is a single web 21 by 15½ inches. It is woven in a one-over-one plain weave, except for the fill-in section near one end where the number of picks in one shed varies from two to five. All of the yarns are coarse, natural white cotton. Most of the warps are single-ply, Z-spun, crêpe twist, and average about one forth-eight inch in diameter. The wefts are two-ply, Z-S spun, hard twist, and one thirty-second inch in diameter. The warp count averages 26, the weft count 16 per inch. There are two loomstrings at each end of the web, each consisting of six ends of the warp yarn S-twisted. The loomstrings protrude at three corners of the web and have been knotted together at one of these corners.

The plaid frontlet (30273 [1099d]), the most nearly square, is 24 by 23½ inches. It is also a single web woven in the simplest of plain weaves. The ground is of natural white cotton; the warp and weft stripes of natural brown cotton, with the arrangement approximately quadrilateral (Fig. 49). The quality of the weaving is better than that of the preceding example. The warps and wefts, both brown and white, are alike; single-ply, S-spun, crêpe twist, with average diameters of one forty-eighth inch but with considerable variation within each yarn. These yarn irregularities have produced an interesting fabric texture, a result which may have been planned rather than accidental. Counts are 30 to the inch for both warp and weft. The cloth has three heading cords at each end. These are unusually fine and inconspicuous and the cord ends extend only about one-half inch beyond the corners of the web. Each is four-ply, S-Z spun, hard twist, and one-fortieth inch in diameter. The specimen is in perfect condition and evidence of diagonal folding and stretching is still present, although the exact manner in which the cloth was used has not been recorded.

The patterned frontlet (30242 [1099c]) also brown and white, has warp stripes in both plain and

pattern weave (Fig. 50). It is 19¼ by 18 inches. The plain weave varies from one-over-one to two-over-one, two-over-two, and one-over-two. Most of the warps have been used singly; two have been used together in some of the stripes. Slightly more than half of the web has single wefts; in the other part they are paired and, although the cloth is nearly warp-face the section with the double wefts appears lighter in coloring than the other part (Fig. 50). Where the yarns are not paired, counts average 56 per inch for the warp and 24 for the weft; where the wefts are paired, the average is 26 (times two). The same pattern weave technique is shown in Fig. 18a, the pattern being produced by short warp floats. All of the yarns are cotton. Those of the warp are natural white and brown, beige, which also may be undyed, and a rose-beige. The latter may have been a deeper rose color originally and probably was a dyed yarn, its color being the only one which appears to have deteriorated. Both the warps and the wefts are single-ply, S-spun, and hard to crêpe twist. The diameters of the warp yarns range from one ninety-eighth to one thirty-second inch, with most but not all of the variation occuring between yarns of different colors. The wefts have diameters of about one sixty-fourth inch, with those which are paired slightly finer than the others. Most are brown, lighter in value than the brown warps. In a few places the rose-beige warp yarns have been used for weft. There are four loomstrings at one end of the web made up of four ends of rose-beige yarn Z-twisted. At the opposite end three loomstrings, made of the brown warp yarns in the same manner, have been used. All of the cord ends have been finished flush with the selvages. Like the preceding, this cloth is in excellent condition and shows diagonal creases and stretching.

These three "square" frontlets are from the same group as the plain white narrow frontlet (30418 [1099b]).

FALSE-HEAD COVERINGS

The specimens identified as coverings for false-heads include one coarse, tweed-like cotton cloth (30953 [1180g]) in which brown and white appear hit-or-miss. Now in two segments, this specimen consisted of a single web woven 24½ inches wide and more than 46 inches long. All of one end selvage and part of the other are intact and the loomstring ends of the two segments are tied together at one side. The weave is plain, one-over-one. The yarns include natural white, white and brown mixed (both in stock and ply, like the examples shown in Fig. 37), and a few solid brown used at random. Some of the brown yarns form a one-half inch weftwise stripe 14½ inches from one end. Most of the yarns, both warp and weft, are two-ply, Z-S spun, medium twist, and average one twenty-fourth inch in diameter. A few are soft twist. Some are finer. The warp count is 22 per inch; the weft count, 14. There are two loomstrings at each end. These consist of four or five ends of the weaving yarns twisted together with a soft Z-twist to produce a yarn about one-eighth inch in diameter. Ends of these, 9 to 14 inches in length, extend from the three remaining corners of cloth.

This is described as "A cloth found labelled: belongs to 1180? for covering the false head of the mummy?" (p. 36). It is from the same place as "the objects 1000 to 1087. At present the site is beneath the temple" (p. 27).

The other false-head covering is a heavy four-web cloth (29721 [1139b]). It is nearly square, 32 by 36 inches. Each of the component webs is approximately 16 by 18 inches. Two are orange-color cotton, one brown wool, and one red wool with a pattern in white. All have been sewed together with coarse white whipping stitches. Both orange squares, which are diagonally opposite, are approximately alike. Both are rep-type plain weave. Both have been piece dyed and the dye penetration is poor. One was woven of all white yarns; the other has some wefts which were mixed brown and white. The warp yarns are primarily two-ply, Z-S spun, medium twist, and average one forty-eighth inch in diameter. The weft yarns vary considerably. Some are like the warps, some are coarser and soft twist. The warp counts average 44; the weft counts, 17 per inch. Both webs have two loomstrings at each end, consisting of five to six ends of S-S spun,

hard twist cotton yarns twisted together Z-wise. The brown web is similar. The warp yarns differ in being of wool, hard twist, and about one-fiftieth inch in diameter. The wefts are the same. The weave is a one-over-one plain weave, except in the fill-in section where the wefts have been used doubled, with 42 warps and 16 wefts per inch. The brown is either natural or stock dyed, since flecks of white stock are present in a considerable number of the yarns. The loomstrings, two at each end, are coarse white cotton yarns each composed of five ends of two-ply yarn, Z-S spun, hard twist, and one thirty-second inch in diameter. The red and white web is basically a red plain weave cloth with the pattern appearing as white plain weave on the obverse face, all of the floats being on the reverse. The weave is the same, and both the patterning and the coloring are very similar to those of the red and white pouches (Fig. 10). White pinstripes cover about one-third of the length of the cloth, with the remainder in pattern. The red warp yarns are two-ply, Z-S spun, medium to soft twist, and one forty-eight inch in diameter. The wefts, all red, are a slightly different hue, soft twist, and slightly coarser. The white warps are similar to the red warps, but are of cotton, and are hard twist. The heading cords, made from these same white yarns, are like those of the brown web. The warp and weft counts are 54 and 14 per inch, respectively.

The sewing threads used for joining the webs are generally like those of the loomstrings, with two to four ends used together. In a few instances the loomstring ends have served as the sewing thread for sections of sewing near the junctions of end and side selvages. As put together, this is one specimen which displays an objectionable color combination.

The specimen is identified as part of the external furnishings of a mummy (1139, Skull P69) and is described as the "Head-cloth of the false head" (p. 28). It is from the same site as the preceding (p. 27).

SUMMARY

This group of fabrics shows no homogeneity, except perhaps in a lack of elaborate ornamentation. The prevalence of red is notable. Distinctive proportions, similar to those of present day scarves and kerchiefs, seem to be characteristic of the shawls and frontlets. The fabrics are soft and flexible. These characteristics are not shared by the false-head coverings, which tend to be coarse and harsh in texture.

GROUP VI: BANDS AND BORDERS

The specimens of this group are quite generally narrower than those classed as shawls. They have been identified as sashes, belts, and headbands. Presumably each was woven as a long narrow web. All have some type of ornamentation. The items grouped as bands show no evidence of having been joined to other cloths; each seems to have been complete in itself. Probably most of these served as belts or headbands. One may have been a sling. The only example classed as a border appears to have been used as a decorative edging which was sewed to another fabric. Although the indications are that each of these narrow cloths was woven as an independent web, most are fragments and in at least three cases, where only small sections remain, they may have been parts of large webs. The selvages which now appear as edge selvages may have been woven as parts of long kelim slots.

BANDS

Three styles of ornamentation are represented among the twelve specimens classed as bands. Four examples have plain central sections with borders crossing the ends. Three have intermittent patterning distributed throughout their lengths. Five show continuous patterning in allover or repeat designs.

Plain Bands with Decorative End Borders. Two of the specimens of this group (29668 [3256], 29541 [1090u]) are approximately alike in their layouts. They differ markedly in the quality of workmanship. These are the widest of the bands. Another (29884 [3270c]) is similar in plan but much narrower. The fourth item (29693 [3258]) is a variant. In this, the central plain section is braided, not woven. A patterned end section is woven as a narrow band formed into a loop.

One of the two pieces with similar layouts (29668 [3256]) now consists of three fragments. These include sections of plain weave undecorated cotton cloth, with a minimum length of 12 inches, and two tapestry end sections each seven inches long and four and one-fourth inches wide. The width of the plain section, although not intact, probably was about the same, since both the tapestry and plain parts were woven on the same set of warps. About half of the length of each of the tapestry sections has been divided, in the weaving, into three tabs each of which is approximately three and three-fourths inches long and one and one-half inches wide. Each tab has been narrowed toward the terminal end to a width of about one inch where tassel-like fringe, roughly five inches long, was added. The fringe is now attached to only one tab and a section of another; additional fringe sections are loose. This specimen is one of those shown in *Pachacamac* (1903, P1. 6, Fig. 15) and in this earlier illustration fringes or tassels are present on five of the six tabs, and more of the plain fabric is shown than is now intact. Uhle has described this as a "Short band or sash with wide ends of tapestry" (*ibid.,* p. 31). The plain fabric section is now brown. Both of the tapestry ends are polychrome but the two are not alike in either their design motives or coloring, although the pattern layouts are similar (Fig. 51a). The ground color of one end is principally rose-red with the pattern colors bright blue, gold-color, black, brown, two greens, maroon, white, bits of rust or mahogany color, and a dull purple. The other end has the ground in two colors, brown for the undivided area and shades of rose-red for the tabs. The pattern colors are: three blues, gold-color, maroon, dark brown, two pinks, bright rose, cream-color, white, mahogany-color, and green.

The weave is plain, one-over-one in the central part; two-over-one in the tapestry. The warp yarns are cotton and, although now brown, may have been cream-white originally, since all are badly charred. All are two-ply, Z-S spun, hard twist, and one-fiftieth inch in diameter. The weft of the unpatterned section is the same. The warp and weft counts are 60 and 32 per inch, respectively. The tapestry wefts are wool, generally two-ply, Z-S spun, soft twist, and one sixty-fourth inch in diameter. Although a few variants in degree of twist and diameter are present, these features are unusually constant for yarns in so great a variety of colors. Warp counts for both tapestry segments are 20 (times two), indicating that some drawing-in took place in

the weaving of the unpatterned section; weft counts average 100 per inch. No heading cords remain. The tips of all of the tabs, with sections of a narrow terminal border, have been destroyed and the bunches of fringe yarns have been inserted above this tiny border. This, together with the slovenly manner in which the fringes are attached, in contrast to the excellent workmanship shown in the weaving, indicates that these fringes are late additions, probably a substitute for some earlier type of end finish. The fringes are of red wool yarns, two-ply, Z-S spun, soft twist, and one forty-eighth inch in diameter. Although the red coloring has deteriorated to some extent, that of the fringe has a bluer tone than the red of the tapestry ground.

The Catalogue description, "Short sash with gaily-colored Gobelin ends, was held by one hand. (Of the mummy?)" (p. 140), creates some doubt as to the original use of the cloth. The specimen is one of the items from the "Continuation of the finds in the burial place Beneath the Temple (3251-3275)" (id.).

The other specimen of like form (29541 [1090u]) consists of one end of a poorly made cloth. The remaining warp length is 13½ inches, of which four and three-fourths inches is tapestry with the terminal end divided into three tabs, each about three and one-half inches long and two and three-eighths inches wide. All of the tapestry has a simple pattern of serrated diagonal bands (Fig. 51b). The other part of the web is unpatterned coarse cotton fabric. The whole web is woven in a one-over-one plain weave, except for a few places where the tapestry wefts have been paired. The average woven width of the tapestry section is seven inches, while the plain part has been narrowed in weaving until the width is only five inches. This narrowing does not appear to be planned shaping but the result of the change in the weaving from tapestry to non-tapestry without the usual shift from grouped to single warps. In the tapestry section there are approximately 14 warps and 32 wefts per inch; in the plain part, 18 warps and 8 wefts. The warp yarns are all natural white cotton, two-ply, Z-S spun, hard twist, and one thirty-second inch in diameter. The wefts of the un-patterned section, also natural white cotton, are coarse and nubby, single-ply, Z-spun, very soft twist (like roving), with an average but not constant diameter of three thirty-seconds inch. Some of these same wefts appear in the tapestry, together with a few yarns of pure white cotton. The latter are single-ply, crêpe twist, one-fiftieth inch in diameter, and have been used double. In addition there are wool wefts in taupe, faded red, dark brown, and gold-color, which are two-ply, with various degrees of twist and differing diameters, as well as other odds and ends of wool and cotton yarns, and a few black yarns made of hair. Two loomstrings remain in place, connecting the tips of the tabs. These are of unbleached white cotton, two-ply, Z-S spun, medium twist and one-sixteenth inch in diameter.

Attached to the loomstrings at the end of the tapestry, by long irregular whipping stitches, are two additional cords from which hang bunches of light brown and white cotton yarns about four and one-half inches long. The latter appear to have been the looped ends of warps for another web, set up for weaving a cloth about five inches wide. These are single-ply, Z-spun, crêpe twist yarns about one-fiftieth inch in diameter. Both this extraneous set of loomstrings and the sewing thread are of unbleached white cotton, three-ply, Z-S spun, hard twist, and one twenty-fourth inch in diameter. Both the ends of the warps being prepared for a second web, and the plain cloth at the opposite end of the specimen, have been trimmed off irregularly or torn, and the piece appears to have been cleaned since recovery.

Described as the "End of (a) scarf with Gobelin" (p. 21), this specimen is from the "Excavation some ten meters to the west of the foregoing ones, at the foot of an old half-terrace. (1088-1134)" (p. 20).

Two fragments of very fine tapestry (29884 [3270c]) classed as "small pieces of borders" (p. 141) appear to represent the polychrome ends of a plain monochrome cotton band, the whole having a layout similar to the above, but much narrower, with two in place of three tab ends. One fragment is about ten inches long and has a two-inch length of the plain cotton cloth at one end. The tapestry section is one inch wide with an interlocking fish design (Fig. 51c) in which either the undulations, the color juxtapositions, or both produce an effect of the fish being in motion. The tapestry has been narrowed, in weaving, to seven-eights inch at the beginning of the plain section and this has been narrowed to about one-half inch at the end of the fragment, where the fabric is badly charred. A one-fourth inch band with a goemetric pattern separates the fish design from the plain section and a like border is present at the opposite end of the tapestry

section. No end selvage remains and the tab ends, which probably extended beyond the one-fourth inch border, have disappeared.

The second fragment is ten and one-half inches long and one inch wide. It is almost all tapestry; less than one-eighth inch of the plain cotton part remains at one end of the strip, which, like the first fragment, has been narrowed to seven-eighths inch. The opposite end has been divided into two tabs. The tips of these have been destroyed. The major part of the pattern is like that of the other fragment. On the tabs an arrangement of opposed triangles has been added (Fig. 51c). Judging from other pieces, it seems probable that these tabs were finished with tassels or fringes and that the two fragments represent the terminal sections of a narrower plain band of unknown length.

For both fragments the warp yarns appear to be two-ply, Z-S spun, hard twist, and about one sixty-fourth inch in diameter, and either natural white or light brown cotton. All of the cotton yarns are now so brittle that they crumble with the slightest touch. The weft of the plain sections is similar to the warp but is medium twist and about one-fiftieth inch in diameter. The tapestry wefts are wool in rose-red, light blue, olive green, pink, light gold-color, cream white, taupe or gray, seal brown, and black. The yarns are two-ply and Z-S spun. They vary with the colors from soft to medium twist and are principally one-fiftieth inch in diameter; a few are coarser. The warp count for the tapestry is 28 per inch; in the narrower part of the plain section it is 52. The weave is one-over-one plain throughout, the narrowing being accomplished by weft manipulation rather than by grouping the warps or reducing their number. The weft counts for the cotton average 40; for the tapestry, 112 per inch. This is a very fine piece of weaving and represents a quite distinctive style of patterning among this group of fabrics, although its pattern layout is similar to the two preceding examples. Like the first of this group, the fabric is from the "Continuation of the finds in the burial place Beneath the Temple (3251-3275)" (p. 140).

The fourth specimen (29693 [3258]) has little in common with the others. It consists of a tapestry band, averaging seven-eighths inch in width, which has been woven to form a loop eight and one-half inches in circumference. Attached to this is a long flat braid about the same width as the tapestry. The braided section is now in several fragments but a length of 49 inches can be reconstructed. There is no indication of a second end finish.

Counting across the tapestry band there are ten warp yarns (about ten per inch). Presumably these warp yarns were passed directly around the two sticks which served as loom bars, rather than being attached to heading cords. The warps were then moved around the beams as the weaving progressed, the cloth being ring woven as a continuous piece. The warp actually consists of one spiraling yarn passing continuously around the ring which forms the tapestry loop at the end of the braid. The warp appears to have been made up of four ends of two-ply, Z-S spun, hard twist cotton yarn about one-fortieth inch in diameter softly Z-twisted together to produce a yarn about one-sixteenth inch in diameter. Some parts of the warps (although most are now black and powdery) and the major part of the wefts show a dull, medium shade of green-blue. A stepped diamond figure used in a simple repeat is dull gold-color on the edges, light red in the central part. The weft yarns are wool, two-ply, Z-S spun, soft twist, and one forty-eighth inch in diameter, with about 68 used per inch. All of the tapestry is very firmly woven and it seems probable that this loop formed a hand hold.

The yarns of the braid are red wool, slightly coarser and harder twist than the weft yarns. They have been inserted in pairs along a weftwise line, over one warp and a few of the wefts, providing twenty doubled ends for the braid. Each of these pairs crosses the complete width of the braid before reversing direction, producing the simplest of flat braids.

Described by Uhle as a "Sash with Gobelin knot (or bow)" (p. 140), this is listed in the same group as the preceding.

Bands with Intermittent Patterning. Of the three examples in this category, one (29666 [1079d]) has sections of combined damask, brocade, and embroidery set against a plain weave cotton ground. The other two (29686 [3180], 29697 [3187]) are tapestry woven, with plain and patterned sections. Two are com-

plete. One, the last mentioned, is incomplete. All are polychrome. (The identification tag has been lost from the band which is incomplete. Checking of both the Field and Museum Catalogues indicates that the number 29697 [3187], used throughout this report is correct. There is, however, a possibility that this is not the right number.)

The first of these (29666 [1079d]) is a single web 40½ inches long and seven-eighths inch wide. The ground is a one-over-one plain weave of fine natural white cotton yarns, two-ply, Z-S spun, hard twist, and one sixty-fourth inch in diameter, for the warp, and similar but medium twist for the weft. The pattern wefts are wool, chiefly brown and red (now mahogany color) with smaller areas of light green, yellow or light gold-color, green-blue and peach-color. These wool yarns are quite consistently two-ply, Z-S spun, medium or soft twist and one forty-eighth inch in diameter. There are seven sections of patterning (Fig. 52a). The central section, about eight inches long and showing highly conventional bird and animal figures, is the longest single unit. Two shorter units, with a similar bird pattern, have been arranged at either end of the central section, and a much smaller unit appears at each end of the band, one with a single bird, one with a star pattern. The major parts of these appear to have been woven in brocade weave and the details added with a needle after the completion of the particular part of the web. Between these areas are sets of narrow weftwise bands woven with wool wefts in plain and damask weaves.

The number of yarns per inch is constant for the warp but varies for the weft according to the weave and the type of weft.

Warp	Weft	
60	30	plain weave, cotton weft
60	44	plain weave, wool weft
60	88	damask weave, wool weft
60	52	alternate wool and cotton wefts, 26 each.

Ends of the loomstrings, now one to three inches long, extend beyond the edges of the cloth and appear to have been tied in some way which pulled the warp loops together. Closely set red wool yarn whipping stitches cover these warp loops and the loomstrings. There are two loomstrings at one end, each consisting of three ends of two-ply, Z-S spun, hard twist, natural white cotton yarn one forty-eighth inch in diameter. At the opposite end, a single loomstring has been used. This is made of four ends of a similar yarn, but medium twist and one-fiftieth inch in diameter. Four other ends of the same type of yarn have been laid along the single loomstring and secured to the web by whipping stitches, part of which have been destroyed.

This specimen is listed as "a narrow embroidered band" (p. 19), among the contents of "the remains of a working basket" (1079) (p. 18). It came from a "Four-headed (?!) grave in an adobe chamber. The mummies are partly those of children, and are apparently partly put in layers. The grave is half-way under the most northern of the lower terrace-walls of a temple-like building. (P55-57 belong here.) P55 belongs to the mummy from which nearly all objects come. This skull has the teeth ground off to a remarkable degree (probably from chewing cornmeal for the fabrication of chica). (1064-1084)" (p. 18). The general grouping is with the "Continuation of the Collections from Pachacamac, on the foot of the temple of Pachacamac" (p. 1).

The second band (29686 [3180]) is 69 inches long. It is one and five-eighths inches wide, except toward the ends, where the width has been narrowed to one and three-eighths inches. The terminal two inches of each end of the band has been divided into two tabs and tassels have been attached to the tips of the tabs. Details of the construction, in so far as they can be determined, are shown in Figure 55b. (Figs. 55b and 55a with a description of the specimen have been published previously, VanStan 1964 a.) Like the preceding, this band has fairly large pattern areas forming major design blocks and narrow weftwise bands spaced between the larger blocks. It differs in having tapestry, a one-over-one plain weave, used throughout, with the exception of very small areas of damask weave in the narrow bands. The ground is red; the patterns are

polychrome. Almost no design repetition is present (Fig. 55a). Uhle has shown this whole piece (1903, Pl. 6, Fig.9). He has described it as a "Woolen forehead band with patterns in various groups; . . . " (*ibid.* p. 31) and has noted the variety of patterns. In the Catalogue, the listing is "Fillet (?), which covered the artificial head of the mummy bale" (p. 135). The cloth has been mended and seems to have seen considerable use prior to adorning a mummy bale. The warp yarns are natural white cotton, two-ply, S-S spun, hard twist, and one forty-eighth inch in diameter. Most of the wefts are wool, two-ply, Z-S spun, medium twist, and one forty-eighth inch in diameter, but there are a number of exceptions. There are 23 warps per inch in the wider central part of the band. Weft counts average 88 per inch. Weft colors include cream-white, yellow, gold-color, brown, henna, pink, two light reds, maroon, purple, three blues, two greens, and black.

This band was one of the specimens found in the bale with a tapestry shroud (29492 [3179a,b]), one of the plain red shawls (29850 [3181] and one of the large brown shrouds (27873 [3182]) described above. It is from the "Excavations at burial place number one. Beneath the Pachacamac temple, continuation. (3179-3218)" (p. 135).

The third of these bands (29697 [3187]) is fragmentary. Like the preceding it has a red tapestry ground and the one end which remains has been divided into two tabs, one wider than the other, with tassels attached to the tips. The present length of the web, now in three segments, is 37 inches. The width is one-half inch. The tabs are one and one-half inches long; the width of one is five-sixteenths inch, of the other, three-sixteenths inch. Compared to the preceding, the cloth is coarse and thick. The warp yarns are brown cotton, two-ply, S-Z spun, medium twist, and one-fortieth inch in diameter. The weft is wool, two-ply, Z-S spun, soft twist, one-fiftieth inch in diameter. The warp count is 26 per inch; the weft count, 80. The three remaining full-length pattern areas differ in length. Two are two and one-half inches long, one is three and seven-eighths inches. All are now on separate cloth segments, but all show the same simple latchhook pattern (Fig. 52 b). The patterns on the tabs are step triangles, carefully handled and equilateral on one tab, varying on the other. The colors are brown, gold-color, green-blue with bits of green and tangerine. The tassels are red and apparently were in two or more shades. One has been constructed on the ends of the tapestry warps; the other has been sewed on with red wool yarns. The heads of the tassels are bound with cotton yarns which are covered by dark brown fibers wound around the heads with a few ends extending into the tassel fringe. These are fuzzy in appearance and show no evidence of spinning. Some of the red tassel yarns are like the wefts, others differ. A few of the cotton yarns used in the tassel tops are like the warps and may be warp or loomstring ends; others are coarser.

Bands with Continuous Patterns. Two pattern-weave fabrics (29696 [1176b], 30060 [1090b]), both of which have geometric patterns and are warp-face but have little else in common, and three tapestries (29911 [1090a], 29682 [1176c], 29687b [3214c]), all of which are polychrome kelim tapestries but differ in most other respects, make up this group.

One of the pattern-weave cloths (29696 [1176b]) is constructed with a spiral weft and would be tubular if the warps had not been interchanged between the two faces. The various colors have been brought to one surface or the other, as required for the pattern, and the weave appears as a one-over-one plain weave on the surface, the unused warps floating between the two surfaces. This technique has produced considerable bulk. The present band, which is only five-eighths inch wide, is three-sixteenths inch thick. The remaining length is 83½ inches, now in two pieces, rotted apart. The better preserved end of the longer segment has been cut; that of the shorter segment has warp ends extending one to five inches, and some of these have been twisted together to form two and three color cords. The same patterns (Fig. 52 c) appear on both surfaces of the cloth, but the colors differ. Included are red, which predominates, cream, gold-color, seal brown, and olive green. The yarns used for the warp are wool, two-ply, Z-S spun, medium to soft twists, with average diameters of one sixty-fourth inch. Some differences between colors may be noted; the green and gold-color yarns tend to be slightly finer and to have softer twists. The weft is natural brown cotton, two-ply, Z-S spun, medium twist and one sixty-fourth inch in diameter. Surface counts show seventy warps and eighteen wefts per inch. Except on the edges, where all of the warps are red, warps of two colors are

concealed while two others appear on the surfaces. This indicates that the total number of warps required for this pattern weaving would be four times the number showing on one surface or approximately 175 warps for the five-eighths inch width of the present band.

Uhle calls this band a "Thick, narrow frontlet" (p. 35) "Found with the mummy (Skull P74) (1176)" (*ibid.*). It is from the "Continuation of the excavation at the place, from which I obtained the objects 1000 to 1087. At present the site is beneath the temple" (p. 27). Although Uhle has classed this as a frontlet, it seems to belong more appropriately with this group of narrow bands than with the wider head coverings.

The second of the pattern-weave cloths (30060 [1090b]), which Uhle has designated only as a "Fragment of woven strip" among "Remnants of fabrics (1090)" (p. 21), may have been a head covering, or possibly a side section of a poncho. The length of the fragment is 24 inches. Its four and three-fourths inch woven width is approximately the same as that of the wider of the plain bands with decorative borders (29668 [3256], 29541 [1090u]). Although somewhat narrower, it is similar in several respects to examples classed with the patterned narrow shawls and frontlets (29787 [1141q], 30038 [1149d]); it is also warp striped and warp-face with both plain and patterned stripes, and has the patterning, in this case a single central stripe, woven in the same warp-float, color-exchange technique (Fig. 53). This cloth differs from the shawls in both coloring and texture and seems too firm and wiry for use as a head shawl. The colors are brick red (7-L-9), a medium green-blue (29-F-2), and a seal brown (16-A-2), in both the plain and patterned stripes. The plain stripes, woven in a one-over-two basket weave, vary in width from one-eighth to one-fourth inch. From the pattern stripe outward the color arrangement is red, brown, blue, brown, red, brown, on both sides, with an extra red, brown pair added on one edge, breaking the bilateral arrangement. The warp yarns are all wool, two-ply, Z-S spun, medium to hard twist, and one-fortieth inch in diameter, with the blues tending to show softer twists than the other warps. The weft yarns are natural white cotton, single-ply, S-spun, crêpe twist and one sixty-fourth inch in diameter. The fabric is warp-face, with 56 warps and 13 wefts per inch.

This is from the "Continuation of the excavation at Pachacamac. Excavation some ten meters to the west of the foregoing ones, at the foot of an old half-terrace. (1088-1134)" (p. 20).

Of the tapestry bands, one (29911 [1090a]), which is one of two pieces described as a "Narrow gobelin band, fragment" (p. 21), is from the same group as the above. Woven about one inch wide, the fragment is 30 inches long. The design is a series of interlocked, stepped latchhooks (Fig. 52 d). Although the motive does not change, differences in its length and width where the weft tension and battening have not been kept constant during the weaving have produced so much distortion that the appearance of the design is markedly different in two parts of the web (Fig. 54), and the woven width of the cloth varies from seven-eighths to one and three-eighths inches. These variances may have been due to the weaving having been done by more than one person, since the quality of the work, in other respects, is excellent. It seems unlikely that any one good weaver would have allowed so great a degree of distortion to occur, or so great a variation in the width of a fine narrow tapestry. The colors used are dark and light rose-reds and browns, gold-color in three values, a light orange-red, a dull gray-green, a blue-green, and a blue. The distribution of these colors is not constant, but the shifts do not coincide with the pattern variances.

The weave is one-over-one plain weave. The counts in the inch-wide sections are 25 for the warp and 100 for the weft. The warp is natural white cotton, two-ply, Z-S spun, hard twist, and one sixty-fourth inch in diameter. The wefts are wool, two-ply, Z-S spun, generally soft twist, and one-fiftieth inch in diameter. A few are medium twist and a few distinct differences in diameter can be noted which tend to be color related. The differences in yarn sizes have not contributed perceptibly to differences in the fabric width or to the pattern distortion.

Another of the tapestry bands (29682 [1176c]) is wider, about two and one-half inches. This consists of two fragments sewed together with coarse saddlers' stitches, producing a combined length of 11½ inches. One strip is seven and three-eighths by two and one-half inches; the other, four and one-half by two and one-fourth. No end selvages are present. Since only a small fragment of the width of the second piece is intact,

the narrower measurement probably represents the width of a drawn-in segment of weaving, not a separate warp setting. Uhle has shown this specimen in *Pachacamac* (Pl. 6, Fig. 12) and has described it as a "closed belt" *(ibid.,* p. 31) six inches long and and two and one-half inches wide, indicating that the two free ends were joined when the piece was recovered. In the Catalogue he describes it as a "Remnant of the border-like gobelin band which passed over 'b' " (p.35), the "thick, narrow frontlet" described above (29696 [1176b]). In Uhle's illustration, one unit of the design is shown. The others differ (Fig. 52 e) and parts are lacking. The cloth is a fine tapestry with fairly long kelim slots. The ground color is a dark red; the pattern colors are buff, gold-color, dull yellow, blue-green, dark brown, and black. The warp is natural white cotton, two-ply, Z-S spun, medium or soft twist depending on the color, and one sixty-fourth inch in diameter. There are 26 warps and 104 wefts per inch. The colors, yarn types, and counts all confirm Uhle's description of these as parts of a single web. The sewing yarns are red, a red which does not match the red of the tapestry. They are wool, two-ply, Z-S spun, very soft twist, and about one thirty-second inch in diameter. It seems obvious that this sewing was used in adapting the band to a secondary use since it does not join selvages and breaks into the pattern unit on one end.

The third tapestry band (29687b [3214c]) is a tiny fragment which Uhle has identified only as one of several "Small pieces of figured fabric,in poor condition (?); may possibly be of use" (p. 137). The fragment, woven three-fourths inch wide, is now five and one-half inches long with no end selvage intact. The pattern (Fig. 52 f) has some relationship to that of the preceding example but the general effect is quite different, due largely to the coloring; in this case, maroon, mahogany, olive green, a bluer green, light yellow, and black. The warps, now badly charred, appear to be cotton. They are two-ply, Z-S spun, hard twist, and one sixty-fourth inch in diameter. The wefts are wool, two-ply, Z-S spun, generally soft twist, and one forty-eighth inch in diameter, the degree of twist and the diameters varying slightly with the colors.

This specimen is from the "Excavations at Burial place number one. Beneath the Pachacamac temple, continuation. (3179-3218)" (p. 135).

BORDERS

Although it seems likely that a great many examples of independently woven border sections must be present among the scraps of textiles which Uhle recovered, only a single specimen is in the present group.

This small strip of tapestry (29909 [1090a]), now 17¾ by 1-5/8 inches, with no end selvage remaining, seems to have been woven as an independent web but the evidence is not conclusive. There is a central band one and three-eighths inches wide with a rose-red ground and this is bordered on each side with one-eighth inch strips of gold-color. Adjacent sections have been interlocked by means of alternating groups of the red and gold-color wefts passing around a common warp. Each of these weft groups extends from one-eighth to three-eighths inch. On one side of the band, the short section of the gold-color border which remains has a smooth outer edge; the border on the other side of the band has small tufts of one-eighth inch loop fringe which extend about one-fourth inch along the side selvage, at intervals of about one-half inch. The loops of this fringe remain intact in a small part of the length. Most have been torn open as if a scaffolding warp had been torn away. There are a few extraneous sewing stitches along the straight outer edge and a few like threads elsewhere in the fabric for which no purpose is apparent. The pattern, confined to the central band, is a simple repeat of a double bird motive (Fig. 52g). The individual figures differ in color but each is out-lined in black or seal brown. The cloth remnant is too short and the colors have deteriorated to such an extent that the repeat cannot be determined. The colors which can be distinguished are: pink, a light blue-green, a medium green-blue, gold-color and an additional hue, now a putty color. The rose-red of the ground outlines the birds' eyes and other dot-like details.

The fabric is fine and the quality of the weaving is excellent. The warp yarns are natural white cotton, two-ply, Z-S spun, medium twist and one forty-eighth inch in diameter. The wefts are wool, two-ply, Z-S

spun, soft and medium twists. Most have average diameters of one sixty-fourth inch; some are coarser. The whole piece is in a one-over-one plain weave with 36 warps and 116 wefts per inch.

This is the second of two pieces (29909, 29911) of "Narrow gobelin band, fragment" (1090a) among "Remnants of fabric (1090)" (p. 21) and, like the others of this group, is from the excavation" . . . some ten meters to the west of the foregoing ones, at the foot of an old half terrace " (p. 20).

SUMMARY

This small group of fabrics shows the production of a considerable variety of narrow patterned bands based on a very limited number of design layouts. Certain features seem to have been favored: Bilateral designs or designs having bilateral balance. Some, or all, of the ornamentation placed at the end, or ends, of the bands, either with or without fringe or tassels. Divisions separating the patterning into blocks. Red as the predominant color. Wool pattern and facing yarns, whether warp or weft; cotton for hidden yarns, except where muslin-like fabric forms the base for pattern sections.

Technically, the deliberate narrowing of some of the bands by shifts in the spacing of the warps and wefts, with no reduction in the total number of warps, and without warp grouping, is of considerable interest. This not only shows the use of a method of narrowing which could not be used on a loom with a reed, but points up the fact that two sections of one web, woven on the same warps, may have quite different warp as well as weft counts.

GROUP VII: SMALL AND
MINIATURE RECTANGULAR FABRICS

Classed in this category are a number of small-size rectangular cloths which are primarily single webs of cotton. Two distinct size groups are present. The average warp and weft dimensions for one group are roughly 16 and 14 inches; for the other, seven and three inches respectively. The designations *small* and *miniature* have been used for the two groups. The larger pieces probably served a variety of utilitarian purposes. There are indications that some were carrying cloths; others breech cloths, but none is sufficiently distinctive in shape, size, or proportions to show that it was planned and constructed for any one specific use. The miniature cloths show no evidence of use. They may have been garments, similar to the diminutive shirts or, in some cases, may have been the practice pieces of beginning weavers.

SMALL FABRICS

Excluding the miniatures, there are twelve cloths, eight unpatterned or striped and four patterned. One of the unpatterned specimens is made up of two webs. All of the others are single-web cloths. Most of the specimens are basically intact and complete warp and weft measurements are obtainable.

Unpatterned and Striped. Eight of these, including the one two-web specimen, appear to be strictly utilitarian and usually have been made of odds and ends of yarns spun from natural brown or cream-white cotton. Striping, when present, tends to be hit-or-miss rather than well planned, although some attempt at arrangement usually is evident. Three of this group (30443 [1090m], 30425 [1162c], 30947 a,b [1177b]) show a small amount of shaping produced by the drawing-in of the weft yarns. This is lacking from the other four single-web cloths (30255 [1090d], 30864 [1141q], 30266 [1162d], 30940 [1176e]) and from the one specimen made of two webs (30468 [1090q]). These are all cotton fabrics.

One all-white cloth (30443 [1090m]) which appears to have been shaped may have served as a child's breech cloth. Coarse heading cord extensions from opposite ends of the web are still tied together at one side, about two inches from the selvages. The others have been broken, but it is evident that these were tied also. This cloth, the smallest of the shaped pieces (Fig. 56 a), is 14 inches long, 13½ wide at one end, 12½ at the other, and 11 inches across the central part of the web. The narrowest part is the fill-in section, which may indicate that the apparent shaping was solely the result of poor workmanship. There has been no reduction in the number of warps in the narrow section. One end of the cloth has been woven in a one-over-two half-basket; the other end and the fill-in section, in a one-over-one plain weave. The count for the warp averages 19; for the weft, 13 (times two) and 14. The yarns of the warp and part of the weft are two-ply, Z-S spun, medium to hard twist, and one twenty-fourth inch in diameter. Other wefts are single-ply, hard to crêpe twist, and one thirty-second inch in diameter. There are two heading cords at each end. Each consists of four ends of the warp yarns used together. All extend about seven inches beyond the edge of the cloth.

Identified only as a small cloth (p. 21), this is from the "Excavation some ten meters to the west of the foregoing ones, at the foot of an old half-terrace" (p. 20).

A nearly square brown and white web (30425 [1162c]) is 21 inches long, 23 inches wide at the ends and 21½ across the midsection (Fig. 56 a). This also has been woven in a combination of one-over-one and one-over-two. The yarn counts average 42 for the warp; 15 and 14 (times two) per inch for the weft, producing a cloth which is nearly warp-face. Most of the warp yarns are fine, silky, cream-white cotton, two-ply, Z-S spun, hard to crêpe twist, and one-fiftieth inch in diameter; a few are much softer twist and coarser. The yarns of a single one-fourth inch warpwise brown stripe are two-ply, with one ply white and one brown, Z-S spun, soft twist, and one-fortieth inch in diameter. The weft yarns are of several types. They are all two-ply, Z-S spun; most twists are medium or soft; diameters vary from one-fortieth to one forty-eighth inch. A few are like the white warps. Some are all white; some have one ply white, one mixed brown and white; some

60

have both ply of mixed brown and white stock with different proportions of brown and white. Shadow stripes have resulted from the use of these mixed yarns in the weft and the relatively high warp count. While the placing of the one brown stripe in the warp, about six and one-half inches from one selvage, has been balanced roughly by a shift in the type of warp yarn about equidistant from the opposite selvage, weft changes show no plan or uniformity. Apparently when one type of yarn was used up another was substituted. There are two loomstrings at each end of the cloth and these extend from two to five inches beyond the cloth edges. For each of these cords, four ends of two-ply, Z-S spun, medium twist yarns, one forty-eighth inch in diameter, with one ply white, one mixed brown and white, have been soft twisted in a Z direction to produce a yarn about one-sixteenth inch in diameter.

Classed only as a "Small cotton cloth", this is one of the "Finds, of which it is not known for certain to which mummies they belong (1162)" (p. 33). It is from the same place as the 1000-1087 group. "At present the site is beneath the temple" (p. 27).

A comparatively long piece (30947a,b [1177b]) shows a very slight shaping (Fig. 56 a). Now in two sections and described as a "Cloth, which by mistake has been cut into two pieces" (p. 35), it is approximately 35 inches long, 15¼ inches wide at the ends and one-half inch narrower across the midsection. There are two heavy loomstrings at each end and the 8 to 12 inch ends of these have been knotted together at each side. This may have been used as a breech cloth. The fabric is brown and white cotton, woven in one-over-one plain weave, with 24 warps and 14 wefts per inch. The warp yarns are two-ply, Z-S spun, hard twist, and one thirty-second inch in diameter. Some are natural white; some show an admixture of brown in the stock. A few, which have a larger percentage of brown, are soft twist and have been used for a single edge stripe one and three-fourths inches wide. The weft yarns are like those of the warp, except that those which are soft twist have a smaller percentage of brown. The loomstrings are made up of five ends of the white warp yarns twisted together Z-wise.

This cloth is from the same excavation as the preceding (30425 [1162c]). It was "Found with a youthful mummy (Skull P75) (1777 and 1778)" (p. 35).

Of the four unshaped specimens (Fig. 56 b) the longest (30255 [1090d]) is 23½ by 11¾ inches and it differs from all of the others in having spaced warps, regularly spaced warp stripes, and a light reddish brown in the striping in addition to the usual natural shades of brown and white (Figs. 59,60).

All of the weave is one-over-one and all of the weaving yarns are single-ply. The brown warp yarns are S-spun, crêpe twist, and one sixty-fourth inch in diameter. The red-brown yarns differ in having a greater degree of crêping than the other brown yarns. The white yarns are Z-spun, medium twist; they average one thirty-second inch in diameter with each yarn showing considerable variation. The brown yarns have been set 44 to the inch; the red-brown, 48; and the white, 20. Each stripe has been separated from its neighbor by a one-sixteenth inch space. The weft yarns are all brown, Z-spun, crêpe twist, and one forty-eighth inch in diameter. There are two loomstrings at each end. Each pair is made of a single cord doubled back at the selvage into a second pick, with no extension on the looped side. At the opposite side the cord ends extend for about six inches, in this case, on diagonally opposite corners. These cords are white cotton, five-ply, Z-S spun, medium twist and one-sixteenth inch in diameter.

Classed as a "Small colored cotton cloth from a mummy" under the heading "Remnants of fabric (1090)" (p. 21), this is from the same excavation as the first of the small shaped cloths (30443 [1090m]).

The second of this group (30864 [1141q]) is almost square, 11 by 11½ inches. It has an odd putty color, which appears to have resulted from the bleaching of brown cotton occurring as a part of the general deterioration. However, it is possible that this is one of the less common shades of natural cotton. In the Catalogue Uhle mentions raw cotton found in the first cemetery of Pachacamac that was an "agreeable light brown color" and identifies some of the same lot as "lighter" and "white" (Nos. 3812 a-d) (Appendix) and in *Pachacamac* he adds, "Brown cotton is often found in the graves; new cotton of a light reddish color the writer saw at Lambayeque." (1903, p. 30, f.n. 2). The cloth is a well-made plain weave fabric with an inconspicuous fill-in section. Although it has the appearance of being square count, there are 34 warps

and 20 wefts per inch. Both the warp and the weft yarns are two-ply, Z-S spun. The warp is medium to hard twist and one thirty-second inch in diameter; the weft, medium twist and one twenty-fourth inch in diameter. Two heading cords have been used at each end of the web and these have been finished at one corner by knotting in a finger knot, with the cords pulled so tightly that a small amount of gathering is present. The other corners have been destroyed. Each cord consists of four to six ends of the warp yarn twisted together with a soft twist in a Z direction. The center and corners of the square have been stretched, in a manner which suggests use as a wrapping or carrying cloth. The specimen is one of "seven samples and remnants of fabric" (p. 29) from the "Internal furnishings" (p. 28) of a mummy (Skull P69), from the "Continuation of the excavations at the place from which I obtained the objects Numbers 1000 to 1087. At present the site is beneath the temple" (p. 27).

Another brown and white fabric (30266 [1162d]) measures 16¾ inches by 13½ inches. It is very poorly woven of yarn scraps and possibly was a beginner's piece. It has an asymmetrical warp stripe set-up combining narrow stripes of brown, cream-white or buff, and a bleached white, and a weftwise section of brown which appears to have been planned as a central band. The weave varies with the colors and the yarn types, between one-over-one, one-over-two, one-over-three, two-over-one, and two-over-three. The white warp yarns are single-ply, S-spun, crepe twist, and one forty-eighth inch in diameter. Some of the cream-white and brown warps differ only in being slightly finer. Some of these brown yarns appear to have been made into two- and three-ply, S-Z spun yarns which have been used in the warp also. The weft yarns are of two types: single-ply brown like that of the warp, used doubled and tripled in the central band, and coarse (one twenty-fourth inch in diameter), single-ply mixed brown and white, Z-spun, hard twist. All of the yarns are cotton. Counts average 32 and 18 (times two) for the warp; and for the weft, 9, 13 (times two), and 12 (times three). There are three heading cords at each end of the web, five-ply, S-Z spun, hard twist and one-sixteenth inch in diameter; these are primarily white but include a few brown fibers. At one end of the cloth the cord ends extend for about four inches beyond the selvage. The corners of the other end have been destroyed.

This is classed as "similar" to the second of the shaped cloths (30425 [1162c]), a "Small cotton cloth" (p. 33); it came from the same excavation.

The last of these small single webs, a brown and white cloth (30940 [1176e]) "folded like a pouch, and hung over the mummy bale" (p. 35), was one of several pieces found with a mummy (1176, Skull P74). This specimen is 14 by 16¾ inches, the woven length being less than the width (Fig. 56 b). Part has been woven one-over-one; part, one-over-two. The warp count is 26 per inch; the weft, nine or eight (times two). The warp yarns are two-ply, Z-S spun with both medium and hard twists present and diameters of one forty-eighth and one thirty-second inch. Some are all white; some have been spun from mixed brown and white stock; some have one ply white, one brown; while others have one ply white, one of mixed stock. The weft yarns are two-ply, Z-S spun. These include medium twist white yarns one-sixteenth to one-twelfth inch in diameter in which the twisting of the individual ply is so slight as to suggest that the ply were doubled in the roving stage. Similar yarns of mixed stock are present which are more constantly one-sixteenth inch in diameter. There are also some white yarns like those of the finer warps, which have been used paired. Only one heading cord is present at each end. For one, six ends of yarn like the coarser of the white warps have been used together; for the other, the yarns are like those of the warp which have one ply brown and one white. Short left-over ends of the heading cords extend beyond the selvages.

This, like the preceding, came from the "Continuation of the excavations at the place, from which I obtained the objects Numbers 1000 to 1087. At present the site is beneath the temple" (p. 27).

The only two-web specimen (30468 [1090q]) is a badly discolored all white, fine, sheer fabric which is in poor condition. Each of the webs is 16¾ by 8 inches (Fig. 56 c) and these have been joined along lengthwise selvages with whipping stitches. Both webs have been woven in a two-over-one half-basket. The texture of one is slightly firmer than the other. The warp counts of both are 23 (times two) per inch; the weft count for one web is 19, for the other, 16. The warp yarns are single-ply, S-spun, crêpe twist, and one-ninetieth

inch in diameter. The wefts differ only in being slightly finer, one ninety-sixth inch, and being spun more evenly. A single loomstring has been used at the ends of each web. For one web, these consist of four ends of the weaving yarn used together; for the other web, two ends. For part of the sewing joining the two webs, three ends of the warp yarn have been used together; for part, a two-ply, S-Z spun, medium twist yarn, one forty-eighth inch in diameter. The cloth appears to have been tied to, or around, something. Two diagonally opposite corners have disintegrated, but the other two show evidence of having been tied with added cords, two- and three-ply, Z-S spun, medium to soft twist, and about one twenty-fourth inch in diameter. Adhering to one face of one of the webs are small bunches of raw cotton.

Uhle has identified this as a "Small cloth found with the mummy of a child" (p. 21). It is from the same excavation as the first of the small cloths (30443 [1090m]).

Patterned. Four specimens may be classed as patterned (30427 [1090-l], 29773 [1141o], 29767 [1160b], 29768 [3193a]). The first of these has a block arrangement of brown and white with the pattern weave limited to the central block. The other three are monochrome cotton fabrics with narrow borders (Fig. 56 d). One piece (29768 [3193a]) is a fragment with the length incomplete.

The brown and white cloth (30427 [1090-l]) is a coarse cotton web with nine brown and white blocks and one extraneous weftwise stripe of brown. The piece is 21¾ by 18½ inches. The warp was set up with side sections, each approximately five inches wide, of white, the central part, about eight and one-half inches, of brown. Remnants of an additional set of warps of a second type of brown yarn are present in part of the brown area. Beginning at one end, there are white wefts for six and one-half inches, brown for nine inches, followed by two and one-half inches of white, one-half inch of brown, and the remainder of the length in white. The pattern, in a damask weave, is all in the central block where brown crosses brown. All other parts of the web have been woven in one-over-one or one-over-two plain weave. A reconstruction of the pattern weave is shown in Figure 57. In some parts of the pattern area, the finer warps have disappeared and these seem to have been removed rather than to have rotted away. Where these are absent, long weft floats extend under the warp floats, shown in the diagram, producing a honeycomb-like weave. The general quality of the weaving is poor but it does not have the characteristics of beginners' work.

The white and the coarser brown warp yarns are two-ply, Z-S spun, medium to hard twist, and one twenty-fourth inch in diameter. Some of the white yarns have a small amount of brown stock mixed with the white. The finer, supplementary warps are two-ply, Z-S spun, hard twist, and one-fortieth inch in diameter. These are darker than the coarser brown warps. Where the weave is one-over-one, the white wefts are like the white warps. Where the weave is one-over-two, the wefts are single-ply, crêpe twist, and one sixty-fourth inch in diameter. The brown wefts are like the coarser brown warps, except they all tend to be hard twist. There are 18 white warps per inch; also 18 brown, counting the supplementary yarns. Weft counts for the white are 9 and 11 (times two); for the brown, 11. There are three loomstrings at each end of the web. These consist of either three, four, or six ends of the white warp yarn twisted together Z-wise, with a soft to medium twist. Loose ends of the cords extend 5 to 14 inches. Bits of cotton sewing thread indicate that the cloth was sewed, possibly to the mummy bale. The random locations of the stitches suggest no other use. Most of these yarns are similar to the white warps and have been used double.

Another of the "Remnants of Fabrics (1090)", this is listed only as a "Small cloth" (p. 21) and is from the same excavation as the preceding (30468 [1090q]).

A badly discolored natural light brown or white cotton cloth with polychrome end borders (29773 [1141o]) is the smallest of this group of patterned cloths. It is 14¼ by 11¼ inches. Each border is one and one-fourth inches deep. The pattern, a simple repeat of a single geometric design (Fig. 58 a), may be classed as a double-face brocade. Each design unit appears to have been monochrome against a contrasting ground. Presumably all of the ground was rose-red. For the patterns, light yellow, green-blue, gold-color, brown, and maroon can be distinguished; any other colors which may have been present have deteriorated beyond recognition. The pattern motives on the two ends of the cloth are alike, except that those of one end are attenuated, allowing fewer repeats and, although the colors seem to be the same, the sequence differs.

The body of the web is a one-over-one plain weave with 26 warps and 19 wefts per inch. The warp yarns are two-ply, Z-S spun, very hard twist and one thirty-second inch in diameter. The wefts differ only in having soft twists. At the edges of the pattern section there are a few rows woven one-over-two; these produce the edging lines of the border and are partly in red wool and partly in cotton, like the wefts of the body of the web. The pattern yarns which remain are wool, two-ply, Z-S spun, and about one forty-eighth inch in diameter. The twists vary with the colors and range from very soft to medium. There are about 80 wefts per inch in the pattern section. Two loomstrings have been used at each end of the web and these have been finished off neatly at the side selvages. These are too brittle for probing, but appear to be made up of about four ends of the warp yarn.

This "Small piece of cloth with border" (p. 29) is listed among the "Internal furnishings (1141)" of a mummy (P69) (p. 27), the same mummy with which the second of the plain unshaped cloths (30864 [1141q]) was found.

Another specimen (29767 [1160b]) similar to the preceding, is a firm but light weight fabric with the body in plain weave and the borders in double-face brocade. The web is 16¾ by 17¼, each border about one and one-fourth inches deep. Like the preceding, the fabric is discolored and the cotton used in the body of the cloth may have been either natural white or light brown. The warp yarns are two-ply, Z-S spun, hard twist, and one sixty-fourth inch in diameter, and have been set 46 to the inch. The weft yarns of the body are cotton, two-ply, Z-S spun, hard twist, and one forty-eighth inch in diameter. These have been woven, 24 to the inch, in a one-over-one plain weave. The pattern yarns are two-ply, Z-S spun, soft to medium twists, one-fiftieth inch in diameter and are wool, except some cream-color yarns which are cotton. Wefts in the pattern section average 70 per inch. The design is a simple repeat of a single motive (Fig. 58 b), similar to the preceding but less complex. Again each unit is monochrome and each is set against a rose-red ground. The colors are now cream or light yellow, light and dark gold-color, and taupe or light brown. The lines forming the edgings of the borders are green-blue and cream in one instance, brown and rose-red in the others. These lines have been woven five to seven over one, using warp groupings basic to the weaving of the pattern. In both this and the preceding example the pattern weft yarns have been interlocked with each other wherever two colors meet. Except for this interlocking, the pattern weave would be reversible, with the colors interchanging. The web has three loomstrings at each end. Each consists of six ends of yarn, similar to the cotton weft, twisted together Z-wise. All of the ends have been turned back at the side selvages and finished neatly.

This cloth shows much less evidence of deterioration than the preceding, but does show signs of hard use. The cloth has been pulled diagonally and two diagonally opposite corners apparently have been tied together and untied until the threads have broken and the cloth has worn away. At both of these corners, the adjacent selvage edges have been reinforced with tight whipping stitches, for lengths of six to nine inches, with the edge of the cloth rolled back in some places.

In the Catalogue this specimen is listed as "Similar" to a "Cloth, [which] contained leaves" "Found with a mummy interred very deeply (1160)" (p. 32). It is from the same site as the preceding.

One other piece (29768 [3193a]), which is a fragment, may or may not belong with this group. Indications are that it was larger than the others, but closely related to the two preceding specimens in other respects. The present length of the cloth is ten inches; the woven width, 28 inches. The major part is an unpatterned natural white cotton. One end is intact. This has a border three-fourths inch deep in double-face brocade. Like the others, the pattern is in a simple repeat of a geometric figure (Fig. 58 c), the pattern in each block is monochrome against a rose-red ground and the contrasting weft yarns interlock where they meet along warpwise lines. It differs in having two adjacent repeats of the design motive in like colors and in having one narrow line at the top and lower edges of the border, in place of multiple lines. The colors of the blocks repeat in a four unit series: dull purple, gold-color, light yellow, and black.

The body of the fabric is a one-over-one plain weave with the warp of two-ply, Z-S spun, medium to hard twist yarn one-fortieth inch in diameter set 40 to the inch. The weft is similar but soft to medium

twist and one thirty-second inch in diameter. The weft count is 20 per inch. The pattern yarns are wool and, except for softer twists, they tend to be like the cotton wefts. These average 68 per inch. At the one remaining end of the web there are three heading cords and the ends of these, two to eight inches long, hang free at the one corner which is intact. The outer cord is made up of six ends of yarn similar to the warp, Z-twisted; each of the other two cords has been constructed of three ends in the same manner.

This cloth is described as a "Cotton band with narrow, embroidered border" (p. 136) and is from the "Excavations at burial place number one. Beneath the Pachacamac temple, continuation. (3179-3218)" (p. 135).

MINIATURE FABRICS

Seven toy-size webs, three plain white, one white with red stripes, and three patterned webs, make up this group. The unpatterned specimens (30589 [1090r], 30590 [1090r], 30591 [1090r], 30547 [3193d] appear to be beginners' work. The patterned pieces (29747 [1151d], 29838 [3214a], 29839 [3214a]) show evidence of more advanced weaving skills.

Unpatterned or striped. Three of these specimens (Fig. 56 e) are almost alike and have been listed as "Three small rags" among "Samples of fabric (1090)" (p. 21). Each piece is woven in a one-over-one plain weave of single-ply, crêpe twist, natural white cotton yarn, with the same type of yarn used for both the warp and the weft of each web. Each web has two loomstrings at each end, made of two or three ends of the respective weaving yarns twisted together. The first loomstring has been turned back into the second shed in some cases; in others the two cords are independent. Ends of irregular lengths extend beyond the selvages. All of the workmanship is poor, but in the weaving attention has been given to making the fill-in sections inconspicuous. Although the three webs are approximately alike, each differs slightly from the others. Additional details are shown below:

Specimen Number	Web Dimensions		Yarn Twist Directions	Average Yarn Diameters	Counts		Loomstrings	
	Warp	Weft			Warp	Weft	Ply	Twist
30589	8¼"	3"	S	1/32"	26	8	2	Z
30590	9"	2½"	S	1/32"	26	8	2	Z
30591	6¾"	3¼"	Z	1/24"	22	10	3	S

These specimens came from the disturbed soil *(Desmonte)* of the "Excavation ten meters to the west of the foregoing ones, at the foot of an old half-terrace " (p. 20).

The cloth with red stripes (30547 [3193d]) is the longest of this group (Fig. 56 e). It is 12 inches long and varies in width from two and one-half to three inches. Except for two central warpwise stripes of red, the yarns are natural white cotton, two-ply, Z-S spun, medium to hard twist, and one thirty-second inch in diameter. The stripes, one-eighth and one-fourth inch wide, are of wool yarns, two-ply, Z-S spun, soft to medium twist, and one-fortieth inch in diameter. Made in one-over-one plain weave the web is warp-face, with 42 white or 48 red warps per inch and an average of 16 wefts. The spacing of the wefts is very irregular, the selvages are uneven and the fill-in is conspicuous. There are two loomstrings at each end, the first turned back into the second pick, with the ends, three to eight and one-half inches long, hanging free at one side. These are made of six ends of yarn similar to the cotton warp, but finer (one forty-eighth inch in diameter), twisted Z-wise into a single medium twist yarn.

This "small piece with red stripes" (p. 136) is from the "Excavations at burial place number one. Beneath the Pachacamac temple, continuation (3179-3218) " (p. 135).

Patterned. One web showing an unusual bit of weaving (29747 [1151d]) may represent a pattern experiment, either by someone learning to do a different pattern weave, or by an experienced weaver working

out a new design arrangement. The whole web is eight by six inches, with the central part drawn in in the weaving to about five and one-half inches (Fig. 56 f). The warp was set up with alternate pairs of blue and white yarns, except for side selvages, one five-sixteenths and one seven-sixteenths inch wide, which are all white. The weave appears as a plain weave on the obverse face (Fig. 61 a), the yarns of unused colors floating on the undersurface of the cloth (Fig. 61 b), rather than forming parts of the pattern. A similar weave has been noted in several red and white pouches, a poncho and a false-head covering, but the blocking of the pattern differs in this example (Fig. 62). The unpatterned end sections of the web, one-half inch at one end, two and one-eighth at the other, have white wefts; the central patterned section, blue wefts. The white is a natural cream-white; the blue, now both soiled and faded, is about like Maerz and Paul 38-H-3. All of the yarns are cotton, with those of the same color alike in warp and weft. The white are two-ply, Z-S spun, medium to hard twist and one-fortieth inch in diameter. The blue differs in being hard twist and one forty-eighth inch in diameter. There are two heading cords at each end of the web, each consisting of four of the white yarns grouped together. These have been turned back at one side. Short ends extend and have been twisted together and knotted at one corner; at the diagonally opposite corners they are broken off at the edge of the web. Each cord is made up of four of the white warp yarns grouped together. The central part of the fabric is badly discolored, especially on the reverse face, as if something had been wrapped inside, with the cloth gathered up around it.

Identified only as a "Small piece of cloth" (p. 31) "Found with a mummy buried in an analogous manner: (1151)" *i. e.* "Found in the soil, which in ancient times was banked up as a substratum for the enlarged construction of the temple" (p. 30), it is from the "Continuation of the excavations from the place, from which I obtained the objects Numbers 1000-1087. At present the site is beneath the temple" (p. 27).

The other two very small webs are basically alike. Both are brown cotton fabrics with narrow end borders in double-face brocade. One (29838 [3214a]) is eight by three and three-eighths inches; the other (29839 [3214a]), six and one-fourth by three and three-eighths inches (Fig. 56 f). The body of each web is one-over-one plain weave with both the warp and weft of two-ply, Z-S spun, hard twist yarn, one forty-eighth inch in diameter. The longer web has 40 warps and 19 wefts per inch; the shorter, 52 and 18, respectively. The first has one seven-sixteenths inch border in cream and black (a true black, neither brownish nor blueish) edged with brown and, at the opposite end, a three-eighths inch border in gold-color and black edged with rose-red. Both borders of the shorter web are like the latter in coloring; one is three-eighths inch; one, one-half inch deep. The wefts used in the borders are wool, two-ply, Z-S spun, and one forty-eighth inch in diameter, the twist varying from soft to hard in the yarns of different colors. The wefts average about 96 per inch in the borders. The same geometric motive (Fig. 58 d), repeated in alternating colors, appears in all of the borders. Both this motive and the technique used in reproducing it are very similar to those of the small cloths with narrow borders (Fig. 58 a-c), although no weft interlocking is present.

Each web has two heading cords at both ends. The yarns are like the warps. For the longer web, two yarns have been twisted together in a Z direction; for the shorter web, three. These appear to have been turned back at one end, left free at the others.

Listed as "Two very small cloths with border" (p. 137), these are from the same excavation as the miniature cloth with red stripes (30547 [3193d]).

SUMMARY

Small fabrics of a utilitarian nature appear to have been woven either with or without decoration and frequently were made of miscellaneous, probably left-over, fibers or yarns. This is shown most clearly by the combining of brown and white, mixed in the stock, during the spinning, or in the weaving; the combinations of non-matching types of monochrome yarns; and adjustments made in the weave to compensate for the differences in yarn sizes. Decoration, when present, generally is limited to types which would not inter-

fere with the utilitarian value of the fabric. Pattern weave is generally confined to small areas. Weft inter-locking, in the double-face brocade borders, serves to provide added security for these yarns, as if added durability was wanted.

Some shaping is present. All is of the type produced by the drawing in of the wefts and it is probable that this was unintentional. No attempt seems to have been made to produce high quality textiles. In some cases, loomstrings were planned to serve the dual purpose of holding the warps during weaving and providing tying cords at the corners of the finished fabric.

The miniature cloths tend to be replicas of the other small cloths, except in their proportions. One blue and white pattern-weave piece presents one of the distinctive Peruvian weaves in a pattern arrangement which differs from other examples of the same weave.

GROUP VIII: LARGE CLOTHS OF UNKNOWN USES

A few fairly large cloths, and fragments of others which seem to have had generous dimensions, do not fit into any of the above classifications. They do not constitute an homogeneous group but show a variety of styles and textures. With two exceptions, these fabrics may be classed in one of three distinct style groups: (1) Two-web cloths, with one web the counterpart of the other. These are all firm cotton fabrics with their decoration limited to repeat patterns of two or three small figures placed to form a rectangular block adjacent to one side and close to an end. (2) Sheer fabrics of two or more matching webs sewed together along warpwise selvages and having some type of added ornamentation. (3) "Patchwork" cloths made up of many small independent webs generally joined at both end and side selvages. One of the two odd pieces is a coarse brown and white cotton cloth; the other, a cotton fragment with a narrow blue end border.

TWO COUNTERPART WEBS

Only one cloth of this style is completely intact (29756 [3193b]). There are two others in which parts of the two webs are still joined (29760a,b [3258b], 29757 [1182e]) and the same style of distinctive patterning (Fig. 65) is present. A fourth specimen, a fragment of one web (30153 [1090v]), has been placed in this category on the basis of its like patterning, as has another fragment listed as part of one of the preceding (29760a,b [3258b]) but not a part of the same cloth. The grounds of all of these cloths are of natural white cotton yarns, always two-ply, Z-S spun, and hard twist, woven in one-over-one plain weaves. The patterning is limited to four to six rows of figures about one inch high arranged in a simple repeat, with two colors in alternate positions. These form a block or border which starts at the outer side selvage and extends part way across each web near one end. The cloths, seamed at the center, are about a yard wide, and the one example which is intact is a yard and a quarter long.

Each of the two webs of the complete specimen (29756 [3193b]) is 45 by 18½ inches and these have been seamed together with firm whipping stitches along two lengthwise selvages. The patterning, a combination of brocade and embroidery (VanStan, 1967), forms a block, five and one-half by nine and one-half inches, adjacent to each of the outer side selvages and six and one-half inches from an end selvage (Fig. 65 a). Each block consists of four rows of small figures (Fig. 66 a). Although approximately alike, the two blocks of patterning are not identical and probably represent the work of different craftsmen (Figs. 63 and 64). In the ground fabric, both webs have 54 warps and 28 wefts per inch. The cotton yarns of both warp and weft are one forty-eighth inch in diameter. The pattern yarns are wool. Except for having softer twists, they are similar to the cotton yarns. There are two colors, a dark brown and a faded rose-red. Generally the two colors have been arranged alternately, one motive brown with red details; the next red with brown details. The major parts of the patterning appear to have been woven in, as brocade, the minor details added with a needle sometime subsequent to the completion of the woven-in parts of each motive, but probably prior to the completion of the cloth. Wherever the pattern is present, weft counts double, since pattern yarns alternate with the cotton wefts. Each web has been constructed with three loomstrings at each end, made of three to seven ends of the cotton weaving yarns used together. In each case, the outer cord is heavier than the others. At three of the outer corners of the cloth the loomstring ends have been braided into a simple three-strand braid and secured with a knot about one inch from the cloth. The ends are free at the fourth corner, apparently having become unbraided. All have been finished neatly at the seamline. Most of the yarns used for sewing the seam are like the cotton weaving yarns; a few are similar but medium twist. All have been used double. The sewing has pulled loose at one end. At the other, it continues along one end selvage, securing the end of a loomstring.

This cloth is in excellent condition and there is no evidence of any ornamentation other than the two

blocks of patterning. Ends of bast fiber yarns, which probably were used to attach the cloth to a mummy bale, indicate that, although differing from the shrouds, this also served as a part of the wrapping of the mummy.

Uhle has called this a "Cotton cloth with embroidered ornaments" (p. 136). It is from the "Excavations at burial place number one. Beneath the Pachacamac temple, continuation. (3179-3218)" (p. 135).

The second of these two-web cloths (Fig. 65 b) is the larger of two separate fragments which have the same number (29760a,b [3258b]). The remaining length of this larger specimen is 30 inches; the woven width of one web, 17 inches. A section of a second web, attached to this with whipping stitches, is 24 by 4½ inches. The pattern block, made up of five rows of small figures, is 8 by 11½ inches and 7 inches from one end selvage. There are two similar motives (Fig. 66 b), the larger three-fourths inch high. Again, the pattern colors are brown and rose-red, used in alternate positions in adjacent motives, and the technique is a brocade-embroidery combination (VanStan, 1967, Fig. 6). The ground fabric is badly discolored. The web with the complete width intact has 48 warps and 28 wefts per inch; the other, 50 and 30, respectively. All of the cotton weaving yarns are one forty-eighth inch in diameter. The wool yarns are similar, but soft twist and one thirty-second inch in diameter. There are three loomstrings at each of the two web ends which are intact. These consist of two to four ends of the cotton weaving yarns used together. On one web, they are arranged three, two, three; on the other, four, three, four. All of the ends have been finished neatly at the corners. The same yarns, doubled, have been used for the whipping stitches which are about one-eighth inch apart.

The extraneous fragment classed under this same number (29760a,b [3258b]) is a similar piece of cloth 13½ by 13¼ inches. Part of one side selvage remains and the design block begins near this side and extends to the edge of the fragment. No end selvage has been saved. One end has been cut three inches from the design block and finished with a rolled hem sewed with tight whipping stitches. Five rows of figures are present, with the cloth destroyed close to the top row. Three small motives have been used (Fig. 66 c), one of which matches one of those of the other cloth of the same number. These have been spaced more openly and less evenly than the other set and appear to have been put in with a needle, as embroidery, rather than being woven in alternately with the cotton wefts. All of the yarns, including those used for hemming, are like the corresponding yarns of the other cloth. The only yarn difference that can be noted is that the red is slightly darker and some of the red yarns have medium twists. Fading and discoloration may conceal other color differences. There are 44 warps and 28 wefts per inch in the ground fabrics.

These are classed as "Samples of stuff, remnants of decorated (ornamented) stuffs" from the "Continuation of the finds in the burial place Beneath the temple (3251-3275)" (p. 140).

One two-web fragment, which still has the selvages joined with whipping stitches, has parts of both design blocks intact (Fig. 65 c). This specimen (29757 [1182e]), now 18 by 37 inches, presumably was one end of a large cloth (Fig. 65 c). The woven width of one web is 18½ inches; the other web may have been one-fourth to one-half inch wider, judging from the remaining patterning. The pattern block, 9 by 14½ inches, is 6½ inches from the one remaining end selvage, on each web. Two motives (Fig. 66 d) have been arranged in five rows. A brief description of this textile and a photograph of a section of one web are included in an earlier paper (VanStan, 1964b, Figs. 1 b and 2 b). One figure is almost the same as one of the preceding two pieces; it differs in having the main outlines woven with double lines connected with tiny cross-bars, in place of solid lines. These figures are also slightly larger and the colors are brighter. Like the others they are red and brown, used alternately for the dominant areas of each figure. Although the fabric is badly charred, the colors are generally clear, rather than faded and discolored. One of the two webs has two rows of the figures inverted and has a few bits of yellow added in some of the motives. Most of the ornamentation seems to have been woven in as brocade, but there is some evidence that certain sections were sewed in. The warp yarns are one forty-eighth inch in diameter; the cotton wefts, one sixty-fourth inch and the counts 68 and 24, respectively, for both webs. The wool yarns used for the patterns are similar but soft twist and one forty-eighth inch in diameter or slightly coarser. Both of the remaining end selvages have

three heading cords, the outer one heavier than the others. These appear to have been made of two, four, and six ends of the warp yarns twisted together Z-wise. The cord ends, at the two corners which are intact, have been sewed down with the whipping stitches of the seaming. Three ends of the warp yarn have been used together for this sewing.

Uhle has identified this as a "Remnant of an embroidered cloth" among "Other objects accompanying the mummy (1182)" (p.36). (Numbers 1180 to 1183 were "Found with a mummy" but the skull number is not given in the Catalogue.) It is from the "Continuation of the excavations, at the place from which I obtained the objects Numbers 1000 to 1087. At present the site is beneath the temple" (p. 27).

The last of these cloths with blocks of small figures is a fragment 19½ by 15½ inches (30153 [1090v]). It is a corner of a web and has a rolled hem along one end near the design block (Fig. 65 d), which suggests some secondary use. The small figures (Fig. 66 e) have been arranged in six rows making the block 14½ inches warpwise and, if the design block was completed as indicated by the remaining sequence, 17½ inches weftwise. The block is adjacent to the remaining side selvage and 5½ inches from the end selvage. The motives are widely spaced and inaccurately placed. The larger figure (central in the diagram) appears only twice, at the upper corner near the selvage (VanStan, 1967, Fig. 8). The same colors, rose-red and brown, have been used in the same manner, except that in the very small bird figure only one color has been used, first red, then brown. Most of these designs seem to have been woven in, although there is a possibility that some of the small details were sewed. This cloth is finer than the other similar specimens. It is cleaner, and somewhat less discolored. Fading is evident. The cotton yarns of both warp and weft are one sixty-fourth inch in diameter. There are 72 warps and 38 wefts per inch. The pattern yarns are wool, similar to the others, but soft twist and one forty-eighth inch in diameter. Three loomstrings are present at the one end selvage. All consist of multiple ends of the warp yarns, eight for the outer cord, four for each of the others, the individual ends being doubled back at the side selvage.

This specimen, a "Small embroidered piece of fabric" from the disturbed ground, is another of the "Remnants of fabrics (1090)" (p. 21) from the" . . . Excavations some ten meters to the west of the foregoing ones at the floor of an old half-terrace. (1088-1134)" (p. 20).

SHEER FABRICS WITH ADDED ORNAMENTATION

Only two examples fall in this category. Both are fine cotton cloths woven of single-ply, crêpe twist yarns in a one-over-one plain weave, with the same yarns used for warp and weft. One (30207 [2032]) has an allover tie-dye pattern; the other (29917 [1090i]) has a narrow tapestry border sewed to each end.

The first of these (30207 [2032]) consists of one web and bits of another sewed to one side selvage. The one web, covered with typical tie-dye "circles" is 47 inches long and 22½ inches wide. Most parts of the selvage edges are intact but the cloth has been trimmed along one side. In some places the selvage has been cut off; elsewhere small bits of another web, sewed to the first with fine whipping stitches, have been left. These scraps match the other web and the dyed patterning extends onto both, showing that the joining of the two webs preceded the dyeing (Fig. 68). The sewed-on scraps are present intermittently along the entire length of the web, indicating that the second web equalled the first in length. Although badly discolored, the fabric appears to have been a natural cream white. The dyed parts are all brown. Both end selvages of the one web are present, but no heading cords. Remaining warp loops suggest that a single cord was removed, either a true heading cord or a scaffolding weft which served a like purpose. The presence of bisected pattern circles along these edges supports the case for the latter, the dyeing probably having been done while additional webs were attached to the ends. All of the yarns are S-spun. They vary considerably in diameter, averaging about one sixty-fourth inch. The wide spacing of the yarns, about 16 per inch for both warp and weft, has produced an open, gauze-like texture. A considerable amount of yarn slippage has taken place and the yarns appear to have been spaced irregularly in the weaving, producing wide discrepancies in the counts.

The two corners of the cloth, on the side where no sewing is present, have been pulled into sharp points and one, now in bad condition, seems to have been tied into a knot. For the sewing, the yarns are like the weaving yarns, used either single or double. No pattern or design is discernible in the arrangement of the tie-dye circles, although their distribution suggests something other than a simple polka dot arrangement.

This specimen is described in the Catalogue as a "Cotton cloth, figured by dyeing after being woven" (p. 89) from the "Excavations in the first burial place (Pachacamac)" (p. 82).

The second of these sheer fabrics (29917 [1090i]) shows weaving of the same type; of somewhat better quality. The body consists of two webs of monochrome natural white cotton cloth seamed together along side selvages. The yarns, also S-spun, average one sixty-fourth inch in diameter and, although there is considerable size variation, the changes in diameter are more gradual than in the yarns of the preceding specimen, producing a somewhat smoother appearance in the cloth. The yarn counts are higher, 37 warps and 27 wefts per inch for one web; 37 and 24, respectively, for the other. One web, with parts of all selvages present, is 54½ by 18½ inches. The other, now in two sections, probably was the same length, since parts of both ends are still sewed to the other web. The woven width is 18 inches. One heavy loomstring, made up of six ends of yarn similar to the weaving yarn twisted together in a Z direction, is present at each end of each web. The two webs are joined with whipping stitches. Two ends of the weaving yarn, usually twisted together with a soft Z-twist, have been used for sewing. Bands of polychrome tapestry, one inch wide, have been sewed to each end of the cloth. At one side these extend four to five and one-half inches beyond the side selvage where they have been cut. Light cords threaded through these tapestry ends appear to have been used for tying, and seem to have been a late addition. The other two corners have disintegrated. The patterning of the tapestry band consists of a block pattern which cannot be completely reconstructed. The colors which are preserved are dark and light brown, black, two reds and two gold-colors, cream-white and blue-green. The warp yarns are two-ply, S-S spun white cotton, medium twist, and one-fiftieth inch in diameter, set 20 to the inch. The wefts are wool, two-ply, Z-S spun, soft to medium twist and one sixty-fourth to one forty-eighth inch in diameter according to color. The weft counts vary from 96 to 118 per inch.

Identified as a "Small piece of cloth with a fragment of border" among the "Remnants of fabrics (1090)" (p. 21), it is from the same excavation as the last specimen of the preceding group.

PATCHWORK WEAVING

O'Neale's term *patchwork* (1933), used for this group, does not imply cutting and sewing but the use of numerous small independent webs fastened together by means of common weft (sometimes warp) yarns or by sewing along abutting selvage edges. There are five examples of this style. Two of these (29880 [1162b], 29781 [3785]), appear to be parts of one cloth, which consisted of pattern-dyed, five-inch squares and long, narrow, unpatterned strips joined together. Another (30214 [1770r]) is made up of one-inch squares, each woven in one of four colors. The remaining part of another specimen (30226 [1149d]) shows contrasting strips, each about three and one-half inches wide, sewed together along their side selvages. The last of the group (29991a [1272f]) consists of a series of blocks woven as step-triangles, two of which fit together to make a rectangle approximately two and one-half by three inches, these being joined to produce the larger cloth (Fig. 67). The assumption that these were fabrics of considerable size is based on the knowledge of the dimensions of similar fabrics or on the expanse required for the completion of the designs. Neither is an infallable criterion.

The pattern-dyed parts of the two specimens (29880 [1162b], 29781 [3785]) which appear to constitute segments of a single cloth are of considerable interest, since they show evidence of the *plangi* type of resist dyeing in some of the squares and, in others, another type in which the light-dark relationship is the reverse of tie-dye patterning. A photograph of some of the squares, showing the different value contrasts, has been published, and the technique discussed in detail in an earlier report (VanStan 1963). A reconstruc-

tion, using all of the fragments from both specimens and retaining the established color sequences *(ibid.,* Fig. 1), shows the size of the cloth to have been at least 55 by 46½ inches, with three lengthwise strips of plain red wool fabric, each five and three-fourths inches wide (Fig. 67 a), separated by two 15-inch pattern strips. Each of the pattern strips was three blocks wide and eleven or more blocks long. All of the square blocks have like patterns, a simple diagonal line with one of the hollow circular figures typical to cloth tie-dye on each side of the line (Fig. 67 b). Each block has two colors and six different combinations appear, five of which have the usual light patterns against darker grounds: cream-color on light green-blue, gold-color on dark green-blue, cream on navy, gold-color on red, and red on purple. The sixth is red on gold-color and could not have been produced by the usual tie-dye method, but may have been obtained by using a batik-like process. The squares have been arranged in a regular color sequence with diagonal empha-sis. The pattern of one of the specimens is shown in *Expedition* (VanStan 1961b, p. 36). Each square, woven with four selvages, has been dyed as an independent web. After dyeing, these were attached end-to end, by means of a common weft yarn inserted alternately through the warp loops, usually in groups of three. Three of the strips of squares were then sewed together with whipping stitches along the side selvages and these,in turn, were sewed to the plain red strips in the same manner. All of the cloth is wool and both warp and weft yarns are two-ply, Z-S spun, soft to medium twists, and with diameters of one forty-eighth to one thirty-second inch depending on color. Warp counts average 56 per inch for all of the webs; average weft counts are 24 in the squares and 22 in the plain bands. A one-over-one plain weave has been used in all of the webs, with wefts doubled in the fill-in sections in a few cases. The appearance is one of like texture throughout. Heading cords remain in one end only of eight of the small squares. These show two cords made of four to six ends of the weaving yarns grouped together. For the red strips, no heading cords are present. One end shows the remains of a few warp loops, two others have been sewed with a very tight knot stitch in brown cotton thread which has been oversewed with very closely set whipping stitches of red wool matching the weaving yarns. The long lengthwise seams are sewed with red, gold-color or purple yarns, like the weaving yarns, used either singly or in pairs.

Uhle has described one of the fragments (29880 [1162b]) as a "piece of stuff, which has been figured by being dyed after the weaving" among the "Finds for which it is not certain to which mummies they be-long (1162)" (p. 33). This is from the "Continuation of the excavations at the place, from which I obtained the objects Numbers 1000 to 1087. At present the site is beneath the temple" (p.27). The other specimen (29781 [3785]), described as a "fragment of cloth dyed and patterned after being woven. A kind of stuff mostly found together with the most ancient objects. Pachacamac first cemetery," is listed in the Appendix with "Objects found without number, preliminary list . . . I give in the following list, the objects with all that I clearly know still about them" (unnumbered pages, following p. 143).

One specimen (30214 [1770r]) which is made up of a series of one-inch squares (Fig. 67 c), each of which is cream-white, dark blue, dark brown, or light brown (or beige), now has a maximum size of 16½ by 11 inches, with all or parts of only 89 of the squares remaining. Since the design shows part of a large re-versed diagonal pattern, *(Expedition, op. cit.,* p. 35, lower left), it seems that this is only a small part of the original cloth. Each of the squares has four selvages and is woven in a two-over-one basket weave with 48 (times two) warps and 48 wefts per inch. The squares have been joined end to end, in some cases with a common weft yarn, which appears to have been threaded in with a needle; more frequently they are sewed with fine whipping stitches, similar to those used for all of the warpwise joinings. Most of the sewing thread matches the brown weaving yarns.

This is described as a "Small piece of stuff, consisting of small squares sewn together" (p. 79) and is one of a number of "different kinds of remains of cloth; 1770a-u" (p. 78), from "Pachacamac, continuation (first burial place) 1735-1779" (p. 76).

Another cotton cloth (30226 [1149d] now consists of parts of four strips, all loosely woven in a one-over-one plain weave, which have been sewed together with whipping stitches along the side selvages. Both outer strips are a medium blue. One has been woven about three and one-half inches wide; the other, of

which two small fragments remain, appears to have been about the same width (Fig. 67e). The two central webs are both light browns. They differ somewhat and it seems probable that one was cream-white originally, the other brown. Each of these has been woven about four inches wide (Fig. 67 f). The maximum length of the cloth is now about 22 inches, with no evidence of an end selvage on any of the webs. The present width, about 13 inches, may have been expanded by any number of sewed-on webs, although the outer edge of the one blue web which is intact shows no evidence of sewing. All of the weaving yarns are single-ply, crêpe twist. They are S-spun, with the exception of about three-fifths of the warps of the cream-white web, which are Z-spun. The blue and brown yarns are about one sixty-fourth inch in diameter; the cream-white are slightly finer. The warp counts are 32 for the blue, 26 for the brown and 30 for the cream-white. The weft counts are 23, 20, and 20, respectively. The sewing threads are either the S-spun weaving yarns, or two-ply, S-Z spun, soft twist yarns one thirty-second inch in diameter.

Uhle has described this cloth as one of two "Samples of weaving" among "Other objects belonging to the find (1149d)" "From a burial-place at the east-front of the construction, where the graves are almost beneath the terraces. These finds were obtained in an analogous manner as were those from the north-front (skull P69) (1146-1149)" (p. 30).

Four small sections of a woolen patchwork cloth (29991a [1272f]) may represent a cloth of almost any size. All of the remnants (shown in *Expedition, op. cit.,* p. 35, lower right) are made up of small step-triangles with selvages on all edges. Each is monochrome, red, green, brown, or a light gold-color which probably was cream-white originally. Each triangle is roughly two and one-half inches on each side, with three steps forming the hypotenuse (Fig. 67 d). With one block inverted, two triangles, a green and a brown, or a red and a gold-color, fit together to form a rectangle approximately two and one-half by three inches; however, there is considerable size variation, with some of the blocks almost square. The rectangles have been joined end-to-end, the resulting strips joined side-to-side. Generally all of the abutting warp selvages have been joined by means of a common weft yarn threaded through groups of warp loops (Fig. 7), while the adjacent side selvages have been sewed with whipping stitches. The rectangles of different colors alternate, with red meeting green and brown meeting gold-color throughout, but the relative positions of the strips have been reversed on the two larger fragments. At the sides, red is joined to brown in one fragment, to green in the other. Whether this arrangement was accidental, perhaps the result of carelessness; was part of a pattern sequence, now lost; or indicates that the fragments represent parts of two similar but not identical cloths, cannot be determined. All or parts of 30 squares are present. The longest length represented is seven squares; the greatest width, five squares. The longer piece is two squares wide and remaining thread ends indicate that other pieces were attached at one side and one end. The wider piece is four squares in length and yarn ends indicate that other pieces were attached to at least three of the four edges. The remains of what may have been loomstrings are present across one end of one of the component strips of the longer piece. Double brown wool yarns appear in the first five picks of the base of a green triangle and one end of this yarn continues across the end of the adjacent brown triangle which is part of the same rectangular block. The manner in which this has been handled suggests that the warps for the green triangle were set up and the weaving started before the warping was done for the companion brown triangle. All of the weaving is in a one-over-one plain weave. The cloth is warp face with the warp count 70 per inch; the weft count, 20. The yarns used for the warp and weft of each triangle match. All are two-ply, Z-S spun about one-fiftieth inch in diameter. Most are medium twist. Variations between yarns of different colors are present, but none is markedly different from the others. The yarns of the loomstrings are darker, coarser, and softer twist than the brown weaving yarns. The sewing yarns are all brown, and several shades are present. All are two-ply, Z-S spun; twists are usually soft; diameters average one-fiftieth inch with some finer, some coarser. In a few places on the long seams the thread has been used double and the stitches on these seams tend to be coarser and the sewing more conspicuous, especially on the longer remnant.

In the *Field Catalogue,* Uhle has described this as "Fragments of a cloth made of woven step triangles put together" among "different pieces of weaving" (p. 47), from the "Continuation of the Pachacamac collection" (p. 38).

ODD FABRICS

One coarse brown and white tweed-like fabric (30421 [3190]) is similar to others classed with the shrouds, but there are no grounds for calling this example a shroud. The cloth is a single web 57 by 22 inches made of a variety of brown and white cotton yarns (Fig. 69) in a one-over-one plain weave. The use of yarns having a preponderance of brown or of white in sections of various widths, in both the warp and the weft, has produced an irregular plaid. Except for brown side selvages and one dark stripe on each side near the selvage, no evidence of planned striping or color arrangement is present, and even in these cases there is no correspondence between the widths of the stripes. Although browner and whiter sections are present in both warp and weft, those of the warp are more conspicuous, due to the excess of warps over wefts. The average warp count is 25 per inch; the weft count, 12. Although some variations in count are present, both the frequency and range are less than would be anticipated with so great a variety of yarns. The warps, with few exceptions, are two-ply, Z-S spun. Twists range from soft to very hard and diameters from one twenty-fourth to one forty-eighth inch. Frequently the ply of a single yarn differ in their diameters. The brown and white are mixed in both stock and ply. The browns range from a very light golden hue to a rich dark chocolate color. The same yarn descriptions apply to the weft. In one small area, a span of about three inches, the wefts have been doubled, an adjustment made to meet a difference in yarn diameters. The loomstrings, two at each end, are made up of five ends of the weaving yarns, soft twisted, Z-wise (Fig. 69b). At each end of the web a continuous cord forms the loomstrings and each has been turned back leaving a loop about eight and one-half inches long, at one side of the cloth, and ends which extend ten and one-half and 13½ inches at the opposite sides (diagonally opposite corners). The original doubling back of the yarns to form the cord can be seen in these ends. Each has two loops and one cut end, indicating that the loom-string lengths were prepared to provide these extensions at the corners of the cloth. Except for a few holes which appear to have been gnawed, the fabric is in excellent condition. It shows no evidence of any kind of use.

The catalogue identification is "Cotton cloths" with the notation, "Nos. 3188 to 3195 probably from a mummy" (p. 136). The specimen is from the "Excavations at burial place number one. Beneath the Pachacamac temple, continuation. (3179-3218)" (p. 135).

The last of this group (29771 [3258a]) is a soiled and discolored rag consisting of parts of two webs sewed together at the side selvages with whipping stitches. The present length of the fragment is 26 inches; the width, 34¾ inches. One of the component webs is 17½ inches wide; the other, 17¼. The wider web has all of one end selvage and contiguous parts of the side selvages intact. The other has a considerable length of one side selvage, still sewed to the first web, with one corner and part of the end selvage present, as well as a section of the second side selvage. Adjacent to the end selvages is a narrow brocaded border. This is completely intact on one web and a three-inch segment remains on the other. All of the body of the cloth is cotton in a one-over-one plain weave. The only patterning is the brocade border, one-half inch deep, at the end. In so far as they have been preserved, both webs are alike and the pattern of the border, a simple herringbone design in green-blue wool yarns, has been matched carefully at the seamline. The body of the specimen, now a light brown, is woven of single-ply, S-spun, crêpe twist yarns which vary in diameter from one twenty-fourth to one sixty-fourth inch. This wide variation in diameters occurs within single yarns of both warp and weft and seems to have been intentional, since rhythmic repeats have produced an interesting texture change in the fabric of both webs, a texture similar to that of many modern raw silk fabrics. The counts average 24 and 22 per inch for the warp and weft, respectively. The cloth, although not particularly fine, is of excellent quality with good workmanship evident throughout the two webs. The two border sections are alike, a simple brocade, reversible, but not technically doubleface. The pattern yarns, all wefts, are wool in a medium green-blue, two-ply, Z-S spun, very soft twist, and one thirty-second inch in diameter. These alternate with the cotton tabby yarns of the weft, starting adjacent to a single heading cord. This heading cord consists of six ends of the cotton weaving yarn twisted together with a hard Z-twist. The same

type is present on both webs. All of the remaining ends have been finished off neatly at both the outer corner and the seamline. The sewing thread is two-ply, S-Z spun cotton, medium to hard twist, and one twenty-fourth inch in diameter. In a few places this has been used double. The color, also light brown, differs slightly from the cotton fabric. Either may have been natural white originally.

This specimen is one of three "Samples of stuff, remnants of decorated (ornamented) stuffs, 3258a,b,c," and is from the "Continuation of the finds in the burial place Beneath the Temple (3251-3275)" (p. 140). The second of the two-web cloths with block designs (29760a,b [3258b] is also one of the three "Samples of stuff.").

SUMMARY

A tendency to use patterns fixed within quite narrow limits, in respect to both motives and coloring, on cloths of similar size and style is evident, as is the use of similar cloths for more than one purpose. Patterns frequently classed as embroidery, probably were largely woven-in as the cloth was constructed, only small details being sewed in after the completion of all or part of the weaving. Tie-dyeing of the *plangi* type was used on both large and small webs and these webs were joined by sewing either before or after dyeing. Some other resist-dye technique, probably similar to batik, also was used to produce *plangi* type designs with inverted coloring. Cotton and wool fabrics, both sheer and closely woven, appear with *plangi* patterning. Patchwork weaving served as a design producing technique with large numbers of very small webs joined to provide cloths of unknown dimensions. Loomstrings were removed following the weaving or the ends finished off close to the corners of the fabrics, in some cases; in others, long and usually heavy cords served as parts of the finished fabric, apparently being planned for specific purposes, in advance of the warping. The texture interest of cloth woven with thick-and-thin yarns was recognized.

GROUP IX: FRAGMENTS

There are twenty-six scraps of fabric which are too small or ragged to be classified in any of the above categories. Most are specimens which Uhle identified as "Samples of fabric." All show some type of ornamentation. Included are seven specimens with stripes, three which are either tapestry or tapestry-like, fourteen which are brocades or embroideries, and two tiny scraps showing painting and tie-dye. Since these are all fragments the extent of their decoration may have been much greater than is indicated, or the nature of any additional ornamentation may have differed from that of the remaining sections. It seems probable, also, that many had fairly large undecorated areas which have not been preserved.

STRIPED FABRICS

All except one of the striped pieces are basically warp-face plain weaves with warp stripes. Four are entirely plain weave with the striping marked only by contrasts in color. In the other three, the stripes are in pattern weaves as well as contrasting colors. One of these differs from the others, in being weft-face with weft stripes. Two of the plain weave fragments show edge striping only. So far as can be judged from the fragments, all of the other striping was distributed over the width of each fabric.

Plain weaves. The two specimens in this category which have edge striping (29796 [1748g] 29797 [1748h]) are approximately alike and very similar to the fabric of one of the poncho-shirt fragments (29857 [1182g]). Both have cream-white or light brown cotton grounds with multiple stripes. The outer stripes are comparatively wide and of red and/or rose color; while the inner stripes are narrower and in contrasting colors. The striping of the first (29796 [1748g]), a fragment 17½ by 10½ inches, begins with 4 warps of the ground color at the side selvage, followed by 4 red, 6 rose, 24 red, 42 rose, 10 teal blue, 4 brown, 12 of the ground color, and 12 brown, making a striped section one and three-eighths inches wide. The cloth is a firm rep with 70 warps and 20 wefts per inch. The warps of the ground section are two-ply, Z-S spun, very hard twist, and one-fiftieth inch in diameter. The wefts differ only in being hard twist and one forty-eighth inch in diameter. The other warp yarns are wool, two-ply, Z-S spun, hard twist, and average one sixty-fourth inch in diameter, except the rose, which is slightly coarser. An 11 inch length of one side selvage is intact.

The second piece (29797 [1748h]), now 17 by 10 inches with a selvage along all of one side, has a striped section one inch wide with less complex coloring than the other. There are 4 ground yarns at the selvage, then 38 rose, 12 black, 10 of the ground color, 10 black. The fabric is slightly lighter weight than the preceding, but otherwise like it in texture. The warp count is 68; the weft count, 20 per inch. The cotton yarns differ from those of the other fabric only in having hard twists for the warp and medium for the weft. The rose and black yarns are wool and are like the other wool yarns, except that the red is medium twist.

Sewing thread ends remain along the selvages of both pieces at widely spaced intervals (one and one-half to three inches). These are henna colored cotton consisting of four ends of two-ply, Z-S spun, hard twist yarn one-fiftieth inch in diameter, Z-twisted into a cord. These stitches provide the only indications that these two fragments may have been used together. Both are listed under the heading "Small pieces of cloth" (p. 77) (There is a double listing of the numbers 1748a-h in the Catalogue. The first set refers to "Many small square pieces of cloth, dyed and figured after being woven" To add to the confusion, the second of the present specimens [1748h] is numbered 1768 c or e on the reverse of the tag, a *Field Catalogue* number which differs from that on the obverse of the tag and is listed with a differing Museum number.) Presumably both belong to the group excavated at "Pachacamac, continuation (first burial place) 1735-1779" (p. 76).

Another of the plain weaves (29795 [1748e]) has "Roman stripe" coloring. It is a fragment five by five

and one-half inches which appears in the same double entry as the above. There is no key to the original form, except that the striping was adjacent to one side selvage. A three-fourth inch length of this one selvage remains, to which a similar fragment of selvage, only one-eighth inch wide, is sewed with saddlers' stitch. The cloth has a series of stripes varying in width from one-fourth to three-eighths inch, each separated from the next by a pair of contrasting pin stripes. The fragment shows 12 of the wider stripes and 22 pin stripes. At the selvage there is a one-fourth inch section of light brown followed by a one-sixteenth inch stripe of red, then three-eighths inch of dark brown. The light brown is present also in a five-eighths inch width at the opposite edge of the fragment, with no narrow stripe between this and an adjacent three-eighths inch stripe of red. While the light brown appears to be part of the stripe sequence in this small fragment, it may be all that remains of an area of ground color. The same brown is present in one of the central stripes and has been used for some of the pin stripes. Three red stripes are equidistant from each other but the colors separating these differ and no regular color sequence is present. Additional colors are medium brown, gold-color, green-blue, white, olive green, black, and henna. The yarns of the warp are wool, two-ply, Z-S spun. Twists and diameters vary with the colors, ranging from soft to hard, and from one sixty-fourth to one forty-eighth inch. The wefts are like the lighter brown warps, hard twist and one-fiftieth inch in diameter. The warp count averages 96 per inch; the weft count, 15. Sewing yarns, which have been used three together, appear to be the same as the lighter brown weaving yarns.

One ragged scrap of heavy woolen fabric (30856 [1155d]), shows a sequence of dark and light stripes, each roughly three and one-half inches wide. Each is made up of a number of narrower stripes, now all in shades of cream, tan, and brown. The lighter-colored have pin stripes only. In these, cream alternates with tan and with dark brown, the cream and brown groups dividing the width of each light stripe into four equal parts. The darker stripes are slightly wider and more complex. In these the tan is absent and a medium brown has been added. In both cases the arrangement is bilateral. The remaining cloth, 22 by 17 inches, has no end selvages and some of the wefts appear to have been removed from parts of both ends. One short length of side selvage is present and the light stripe at this side is narrower than the others. The weave is a two-over-two basket with 33 (times two) warps and 8 (times two) wefts per inch. The warp yarns are two-ply, Z-S spun, about one forty-eighth inch in diameter. Some of the cream-color yarns are hard twist; some are soft twist. The dark brown are hard twist; the lighter brown, soft twist. Others vary between these extremes. These variations suggest that differences in the coloring, which are no longer discernible, probably were present. The wefts are like the warps and, in most cases, one of each of the basket weave pairs is light brown, one cream-color. A few of the cream-color yarns of the warp are cotton, otherwise both warps and wefts are wool.

The specimen is in poor condition. It has been darned, and worn through the darned sections. Parts of one side and of a long central slit crossing a darned section have been rolled back and sewed with coarse whipping stitches. Various types of wool and cotton yarns have been used for the sewing, which obviously has been added at different times. There is no key to either the original or subsequent use of the fabric. It is listed as a "Sample of weaving" among "Other objects found with the mummy No. 1152 and 1153 (1155-1157)" under the heading "Found with one or more mummies, which were interred equally high up (skulls P72, etc.) (1152, 1153, 1155-1157)" (p. 31), and is from the "Continuation of the excavations at the place, from which I obtained the objects Nos. 1000 to 1087. At present the site is beneath the temple" (p. 27).

Pattern-weave Stripes. One fabric in this group (29854 [1141q]) is now a fragment 14 by 5¼ inches with a single side selvage intact. The ground is red, broken at one-fourth inch intervals by groups of three contrasting pin stripes or a pattern stripe. The outer lines of the pin stripes and the ground areas of the patterned stripes are brown. The colors are badly deteriorated but the inner pin stripes appear to have been gold-color, white, blue-green, or maroon. The simple pattern probably was a small lozenge in white. The warp yarns are wool, two-ply, Z-S spun, soft twist, and one sixty-fourth inch in diameter, except the white, which is cotton and hard twist. The weft is also white cotton, but slightly coarser than that used in the warp. The warp count averages 56 per inch; the weft 20.

This is one of "seven samples and remnants of fabric" part of the "internal furnishings (1141)" of a mummy (Skull P69) (p. 28) "from the continuation of the excavation beneath the temple" (p. 27). The fragment is similar to another from the same group (29787 [1141q]) classed with Scarves and Shawls.

A badly charred specimen (29726 [3788]) consists of a fragment of a patterned web 19½ by 24½ inches, with a tiny piece of a plain natural color cotton fabric, three-eighths by four and one-half inches, sewed to an end selvage. The major web has a brown ground with a cream-white all-over pattern. Both the pattern and technique are like those described above and shown in Fig. 19a,b. The patterned area is divided by a single plain red warpwise stripe one and one-half inches wide, which probably was equidistant from the two side selvages. Only one side selvage is intact and the edge of the red stripe is 12¾ inches from this edge. The cloth is very similar to the central web of one of the poncho shirts (33003 [3210]) and stitch holes along the remaining side selvage indicate that another web was joined to this side. The brown and red warp yarns are wool, two-ply, Z-S spun, and hard twist. The brown is one forty-eighth inch in diameter; the red, one-fiftieth. The pattern warps are natural white cotton, matching the brown warps in other respects. The wefts are brown wool and are like the brown warps, except for having diameters of one-fortieth inch. The warp count averages 62 per inch in both the plain and patterned sections; the weft count, 16. Except for the pattern floats on the reverse of the fabric, the weave is one-over-one and appears as a plain weave on the obverse face in the pattern as well as the ground areas. Two heading cords are present where the end selvage is intact. Each of these consists of four ends of two-ply, Z-S spun, hard twist, natural white cotton yarns twisted together in a Z direction to form a cord one-sixteenth inch in diameter. The added bit of cotton fabric is similar to the other web in texture. It is plain weave, warp-face, made of yarns like the pattern warps of the larger web. An end selvage of this has been placed on top of the brown cloth, over-lapping about one-fourth inch. This has been sewed down with diagonal stitches, with thread similar to the cotton weaving yarns, used three together.

This specimen has been described as a "Rag found in the excavations Beneath the Temple of Pachacamac. Labeled 1138" (Appendix, following p. 143). The number 1138 refers to "Internal objects of the mummy (1138)" from the "Continuations of the excavations at the place from which I obtained the objects Nos. 1000 – 1087. At present the site is beneath the temple" (p. 27).

The single weft-face striped fabric (30045 [1090t]) is a badly deteriorated cloth with coarse cotton warps set 15 to the inch and fine wool wefts averaging 92 per inch in the plain-weave sections. The warps are three-ply, Z-S spun, soft and medium twists, and one-fiftieth to one sixty-fourth inch in diameter. The warps appear to have been natural white; the wefts of the ground areas, light brown, with medium and dark brown, two shades of red, and white in the stripes. The fragment, now 22 by 18½ inches, consists of two parts, probably parts of different webs, which have been joined end to end and along parts of one side. One has parts of one end and both side selvages intact; the other, parts of one end and one side selvage. Although it is possible that both segments were originally sections of a single web, this cannot be determined by remaining evidence. One fragment has a plain brown band one and three-eighths inches deep next to the end selvage, an inch-wide red and white and medium brown pattern band, a one-and-three fourth inch light red, light and dark brown pattern band, and the beginning of a third band, all spaced about two inches apart with the plain light brown ground areas between. The other fragment shows a similar sequence. The plain brown band at the end selvage is narrower and a second of the wider pattern bands is present. The narrower bands of both fragments have a stylized bird pattern; the others, a bird, fish combination. There are two loomstrings at each of the two end selvages. Each consists of two of the warp yarns used together.

All of the edges of the fabric have been sewed. The two side selvages were joined with simple whipping stitches, the thread continuing in one place to become a darning thread used to mend a hole. The opposite side appears to have been closed at some time, but subsequently has been reinforced along the open edges with various types of stitches and darning, most in brown wool yarns. The two end selvages are sewed with both saddler's and whipping stitches with brown wool and white cotton. Both these and the cut ends have

had sections of needleknitting in brown wool. Along the cut edges, these seem to have covered closely-set, tight whipping stitches of white cotton. There are a number of patches of darning in different types of yarn. Some evidence suggests that near the end of its span of service the cloth served as a deep bag. The open edge shows the most recent reinforcing, and the largest additional patches of darning are opposite these at the part which may have been the bottom of a bag. However, the sewing along this "bottom" edge is the least secure and there is no proof that the second side of the "bag" was closed, although sewing is present and there are bits of another web attached to one of the cut ends.

This specimen is listed as a "Fragment of Stuff" (p. 21) from the "Continuation of the excavation at Pachacamac. Excavation some ten meters to the west of the foregoing ones, at the foot of an old half-terrace (1088-1134)" (p. 20).

TAPESTRY AND TAPESTRY-LIKE

Of the three fragments in this group, one is a part of a cloth which must have been a very beautiful tapestry in its original state. It shows parts of a repeated geometric pattern and a border. The other two fragments have the general appearance of tapestry but are not tapestry woven.

Tapestry. The tapestry fragment (29683 [1141q]) now measures 8½ by 15¼ inches. The latter seems to represent the original width of the cloth, with parts of two side selvages remaining, although it is possible that one or both of these were kelim slots. The design is a comparatively simple diamond figure with a pattern derived from a bird's head used as a border. Notable is the extreme care with which each unit of the patterning has been fitted into the allotted space (Fig. 70a). The weaving is kelim tapestry, with a considerable use of the figure-eight technique and the interlocking of a weft around a warp of the adjacent pattern block, at intervals of approximately one-fourth inch, where slots would have been overlong as a result of the vertical pattern lines. The colors, which are badly deteriorated, appear to have included one or two reds, a light gold-color, a soft green, and black. The arrangement of these colors has given the fairly simple design an appearance of complexity. In the weaving of the tapestry, four of the warp yarns have been grouped together. These are cotton, two-ply, Z-S spun, hard twist, and one forty-eighth inch in diameter. The weft yarns are wool, two-ply, Z-S spun; twists vary from soft to hard and diameters from one-fiftieth to one sixty-fourth inch depending on the color. There are 16 (times four) warps and an average of 50 wefts per inch.

Remains of two sets of whipping stitches, one white, one brown, are present along one tapestry selvage. The white sewing thread is cotton, two-ply, Z-S spun, medium twist, and one thirty-second inch in diameter; the brown is similar, but finer. Both have been used double. The quality of the sewing does not correspond to that of the weaving and appears to have been added during some period of re-use.

This specimen is one of the "Seven samples" from the same group as one of the preceding striped cloths (29854 [1141q]).

Tapestry-like. Another of the "Seven samples" is a small fragment of polychrome cloth (29667 [1141q]) which looks like tapestry but is either brocade or embroidery (the technique which Bird calls *reinforced tapestry*). (Bennett and Bird, 1965, p. 210). The specimen is irregular in shape with maximum dimensions of four and one-half by two and three-fourths inches. A one-inch length of side selvage is intact. The fragment shows a rather bold, angular design (Fig. 70b), in two or more shades of red, or rose, a light gold-color, a green-blue, and black wool yarns. These are set against a cotton ground which presumably was cream-white originally. The ground fabric is a simple one-over-one plain weave of cotton yarns, two-ply, Z-S spun, medium to hard twist, averaging one-fiftieth inch in diameter, with 63 warps and about 24 wefts per inch. Wool weft yarns, two-ply, Z-S spun, soft to medium twist, and one forty-eighth inch in diameter have been used for the pattern. These pass over and under groups of three warp yarns, generally with six courses of wool between the cotton ground wefts. The ground fabric is exposed in a few small areas between seg-

ments of the pattern. In these areas the cotton wefts are closer together than elsewhere, due to the pressure exerted by the greater bulk of the yarns in adjacent positions. The major pattern areas of this small cloth give every indication of the pattern yarns having been introduced as the cloth was woven. In two instances there is yarn-splitting of the type which would have occurred if the yarns were inserted with a needle, a method which might have been used during the weaving as well as after its completion.

A second tapestry-like specimen (29889 [1155b]) is similar to the above, but even more closely related to the tapestries. The somewhat larger fragment, four and one-half by five and one-half inches, shows blocks of a stylized cat motive (Fig. 70,c). One block is red and gold-color, the adjacent black (or dark brown) and light green-blue. Any other hues which may have been present have deteriorated beyond the point of identification. Both outer edges, at the sides of the fragment, appear as selvages, but it is impossible to determine whether or not these represent the side selvages of the original fabric. Tabby wefts are present in this cloth, as in the preceding, but occur between every ten or twelve pattern wefts. These have become very brittle and some have disintegrated. Both the warps and the tabby wefts are of unbleached white cotton, two-ply, Z-S spun, medium twist, and one forty-eighth inch in diameter. All of the pattern yarns are wefts and are of wool. All appear to have been two-ply, soft to medium twists, and about one-fiftieth inch in diameter, with some Z-S spun, some S-Z. There are 54 warps, 12 cotton wefts, and about 120 pattern wefts per inch. The cotton yarns are woven one-over-one; where the wool is introduced, three warps cross one weft. Between the pattern sections there are two intervening warpwise strips of all-cotton fabric about one-fourth inch wide near one side of the fragment, and two picks cross one end weftwise. Short unwoven warp ends extend beyond the latter.

Uhle has identified this as a "Small piece of Gobelin" among "Other objects found with the mummies interred equally high up (Skulls P72 etc.)" (p. 31) in the "soil banked up as a substratum for the enlarged construction of the temple" (p. 30).

BROCADES AND EMBROIDERIES

The majority of the cloths of this group have the appearance of embroideries. Technically they differ from the two preceding examples chiefly in the comparatively small areas of the surfaces which are covered by the patterning and by the relatively large number of tabby wefts. If embroidery is defined as needle-work added to a prefabricated cloth, most of the present ornamentation must be classified as brocade, although many of the distinctions are debatable (VanStan, 1967). Certain of these patterns may be considered to be "solid" in the sense that pattern delineation takes the form of a series of small areas of solid color, as in tapestry weaving. The pattern blocks appear as plain weave with the same pattern on both faces of the cloth and corresponding areas in like colors. Considerable areas of ground fabric, invariably monochrome cotton in plain weave, surround these blocks and small bits are present within the pattern units. The wool colors tend to be predominantly brown and rose-red, with details in gold-color and green-blue. There are nine examples of fabrics having these reversible block patterns. Yarn details for these are shown in Table 4. A second type has diagonal patterns which cover a restricted area quite completely. This patterning differs on the two faces of the cloth and is not reversible. Four specimens fall in this category. In addition to these, there is one distinctly different example, which appears to have had all of the design produced as needlework. This has a small repeat pattern in a widely spaced diapered arrangement.

Reversible Block Patterns. One of the cloths of this type (29654 [3791g]) consists of a strip, 12¼ by 1 5/8 inches, cut from a larger fabric. No selvage remains. The major part of the remnant is covered quite solidly by two repeats of two motives (Fig. 71a). At one end of this patterning there is a three-sixteenths inch band of two-color twill (Fig. 25c) followed by two and one-fourth inches of fine cotton plain-weave fabric like the ground of the pattern areas. The cotton is a light orange color. The ground is a one-over-one plain weave; the pattern, three-over-one. The pattern, made with wool wefts of several colors, is tapestry-like

in appearance and was put in as the cloth was woven, except for parts of the diagonal outlines of the figures which are in stem stitch. The latter probably were added section by section as the weaving progressed, rather than after the cloth had been removed from the loom.

Uhle has shown this cloth in *Pachacamac* (1903, Pl. 6, Fig. 2) and has described it, together with others of similar type, at some length (*ibid.*, p. 30). In the Catalogue, it is listed as one of several "Pieces of tissue of cotton with embroidered figures" and as "one of the parts of the outer wrapper of a mummy bale, found beneath the temple of Pachacamac (falsely labelled 1079e)" (Appendix).

Another fabric from the same group (29653 [3791f]), a strip 3 1/8 by 13 inches, also has been cut from a larger cloth. This has two repeats of a squirrel-like figure (Fig. 71b) which Uhle has shown in *Pachacamac* (1903, Pl. 6, Fig. 3). Each figure is two and one-half inches high and has been placed three inches from the other figure. A one-inch length of side selvage remains, with the first motive three inches from this selvage. The ground color is a very light reddish brown. The cloth is firm and the cotton yarns curve outward along the edges of each figure, indicating that the wefts were added as the weaving progressed rather than after the weaving was complete. One figure is rose-red; the other, brown. Both have details in gold-color and green-blue. The technique is the same as that of the preceding, with one or two pattern yarns between the tabby shots. The cotton ground is a one-over-one plain weave; the pattern sections, three-over-one.

Four additional pieces from the same *Field Catalogue* group display the same technique. Two of these (29652a [3791e] , 29652b [3791d]) have animal figures and enclosing borders which are almost alike (Fig. 71c). Both appear to be single motives cut from larger fabrics and both show the remains of coarse stitches at the edges as if they had been sewed onto another cloth. The first of these is three and one-half by five and three-fourths inches and has a one-half-inch length of side selvage intact. The ground, now discolored, probably was natural white. The animal figure is rose-red with brown outlines. The second fragment is three and one-half by five and one-fourth inches. The ground color of this is darker than the other and the animal figure is brown with red outlines. In both, the vertical axis of the figure is warpwise. Presumably animal figures of this type are the ones to which Uhle has referred in discussing the "embroidered figures" (1903, p. 30) but he shows no illustrations. The other two include segments of larger design units which cannot be reconstructed. One of these fragments (29657 [3791i]) has a light reddish-orange ground color. The ground of the other (29658 [3791h]) is discolored and may have been either white or putty-color. The first of these is a ragged strip 2¾ by 13¾ inches. Although much of the pattern has disappeared, the parts which remain, especially the straight, warpwise lines, show more of the characteristics of embroidery than any of the others of this group of block patterns. The same colors are present with green added. Rose-red and brown appear to have predominated, although much of the color has disappeared. One warpwise edge of the fragment has been rolled and sewed with tight whipping stitches in matching cotton yarn, then over-sewed in finer, light tan yarn, partly in whipping stitch and partly in knot stitch. There are also remains of random stitches in coarse white cotton yarn. The second piece, another ragged strip is 10½ by 2¾ inches. This shows the edge of a pattern which appears to have been one of the enclosing frames of a rectangular block. It is larger in size than any of the above, more than six and three-fourths inches warpwise, and consists of a row of bird figures rather than the double-headed bird of the other frames (Fig. 71c, d).

A slightly larger fragment (29650 [3792]), 10½ by 7½ inches, with one side selvage partially intact, shows animal figures forming a row with the human figures placed in adjacent rows. The animal figures are in enclosing rectangles like the above, but are somewhat more complex (Fig. 71d). The human figures are comparatively simple (Fig. 71e) and differ only slightly from one shown in *Pachacamac* (1903, Fig. 32). All of the figures are horizontal when the warps are vertical. The ground fabric, which may have been either brown or cream-white, is very firm. To compensate for the added bulk of the pattern yarns, some of the cotton wefts were terminated near the edges of the pattern blocks. Some seem to have been turned back, others just clipped off. Replacements were added on the opposite edge of the figure. As a result, these

motives show considerable warpwise bulging but little weftwise. The condition of the fabric does not allow for accurate checking of the paths of individual yarns. Uhle describes this as, "Rags of a tissue of cotton with similarly embroidered figures. Found in the excavations Beneath the Temple of Pachacamac. Labelled 1138" (Appendix).

A similar piece (29659 [3792a]) from the next *Field Catalogue* grouping is a poorly preserved scrap, four by three and one-half inches, which includes a part of one of the more complex of the animal figures enclosed in a border (the type shown in Fig. 71d). This is one of the finest of the cloths of this type. Uhle has classified it as a "Similar small fabric" (Appendix).

The patterning of another fragment (29759 [1182f]), although related technically, differs markedly from the others. In this there is an increased number of colors and a reduction in both the size and complexity of the motive. While the same warp-weft relationships are present it seems probable that the whole or most of the patterning was produced as needlework (VanStan, 1967, Fig. 7). This specimen is 16 by 7½ inches and has parts of one side selvage and an adjacent end selvage intact. Two repeats of a rectangular block (Fig. 71f) about one and one-eighth by one and seven-eighths inches, with a geometric design, have been placed near one end selvage. A photograph of this specimen has been shown in an earlier publication (VanStan, 1964b, Fig. 3a). At the end selvage there are three heading cords made up of four or eight of the warp yarns used together. At the one remaining corner, the ends of two of the cords are paired and turned back to form the third cord.

In the Catalogue, this is called an "other piece" of "embroidered cloth" among the "Other objects accompanying the mummy (1182)" (p. 36).

Uhle classified all of this group of fabrics as embroideries, and commented on an error in the classification, as a tapestry, of a similar example from Ancon (1903, p. 30, f.n. 1). Present analyses indicate that Uhle's classification was also in error, most of the patterns having been added while the cloth was in process of construction. However, Uhle may have considered all needlework to have been embroidery, whether it was worked on bare warps while the cloth was in process of construction, or on cloth which had been made and removed from the loom. This would follow along the same line as his classification of tapestry as not woven (1903, p. 29). In this case, the difference would be one of terminology rather than a distinction between two techniques.

Diagonal patterns, non-reversible. Like the preceding, all of this group have plain weave monochrome cotton grounds with the patterns produced by supplementary weftwise wool yarns in contrasting colors. In these, both the motives and the colors have been arranged to form diagonal bands within the patterned areas and the delineation is characteristically in diagonal lines with lattice-like fill-in sections.

Two of the specimens of this group (30321a [1149a] , 30321b [1149b] are essentially alike although more than one web is represented. The grounds are dark brown of two-ply cotton yarn, Z-S spun, hard twist, one forty-eighth inch in diameter, with warp counts averaging 37 and weft counts 24. The pattern yarns, gold-color and red, have been used to produce an interlocking bird pattern in a band two and one-fourth inches deep, edged top and bottom with one-half inch bands of a simple latchhook pattern (Fig. 73). On the reverse of the fabric the pattern is nearly obliterated by the long weft floats (Fig. 74). The wool yarns are two-ply, Z-S spun, medium to very soft twist, and one thirty-second inch in diameter, with a few single-ply Z spun, crêpe twist, gold-color yarns used paired in the narrow bands of both specimens. As in standard brocades, these wool yarns alternate with the tabby wefts and cross the complete width of the design section, instead of turning back at the edge of each color block. A woven gold-color wool fringe one inch deep, half heading and half fringe ends, overlaps the lower edge of each band covering the end selvage. Each has been attached with long running stitches in matching yarn.

The first specimen (30321a [1149a]) is three and one-half by ten and three-eighths inches. The plain brown cotton fabric has been trimmed off close to the top of the border. One section of side selvage is intact and ends of sewing stitches are present along this side. For these, three ends of cotton yarn like the weaving yarns have been used. The one remaining end selvage has three heading cords, each made up of two or three ends of cotton yarn, like the warp, twisted in a Z direction.

The second specimen (30321b [1149b]) is composed of parts of the borders from one end of a two-web fragment. The two webs have been sewed together along the side selvages to produce a continuous border. One segment is four and one-fourth by ten and one-half inches, including one end selvage and a one-inch length of the plain brown fabric above the border. Parts of the side selvages are present with the remains of coarse whipping stitches in thread like that used in the preceding specimen. A one-inch length of one side is still attached to the second web, a piece four by eight and one-half inches. This also has bits of the plain brown fabric, one side selvage, and one end selvage remaining. The heading cords of both webs are like those of the other specimen.

Both of these specimens are described simply as "Party-colored fabrics; two pieces" among "Other objects belonging to the find: (1149)" which came "From a burial-place at the east-front of the construction, where the graves were almost beneath the terraces. These finds were obtained in an analogous manner as were those from the north-front. (Skull P69) (1146-1149)" (p. 30).

Differing markedly in appearance is a specimen with a diagonal interlocking fish design (29761 [1141q]). The patterning, divided into two sections, covers the entire fragment (Fig. 72). In contrast to the preceding, the pattern yarns change course at the end of each color block, sometimes skipping across diagonally to another pattern block, but generally interlocking with the yarn of the adjacent color where the two meet on the reverse face of the fabric. The lattice-like characteristic of the weave is also more pronounced. Back-stitching, common to embroidery, appears in limited use, where small color accents were added. The fragment, six and one-half by ten inches, is charred and brittle. The yarns are cotton and wool, as in the other examples. There are 60 warps and 32 wefts per inch in the cotton ground. Wool pattern wefts, alternating with the cotton, double the weft counts in the pattern areas. The cotton yarns, both warp and weft, are two-ply, Z-S spun, hard twist, and one-fiftieth inch in diameter. All are now dark brown. The wool yarns, all wefts, can be seen to have included a dark brown, gold-color, a rose or mahogany color, and a green. These are two-ply, Z-S spun and about one twenty-fourth inch in diameter. The degree of twist differs with the color, varying from very soft to medium.

This fragment is another of the "Seven samples and remnants of fabric" (p. 29).

The design of the last specimen in this category (30176 [3793]) is not of the interlocking type. It consists of a series of small rectangles or parallelograms, into each of which a cat figure has been fitted. These blocks, generally placed end-to-end, form reversing diagonal bands. The bands, alternately red with blue-green accents, and brown with red accents, cover almost all of the remaining fragments (Fig. 75). In the weaving the characteristic lattice-like effect is marked. All of the patterning appears to be in a brocade technique (VanStan, 1967). Even small blue-green accents in the red bands and red accents in the brown bands seem to have been put in as the cloth was woven. The pattern yarns turn back at the edge of each color unit, except at the corners of some of the small rectangles, but no yarn interlocking is present (Fig. 76). The cloth consists of two fragments, each approximately 8 by 12 inches. Both probably were parts of a patterned strip about 12 inches wide, since the remains of narrow bands of different patterning are present at the sides of each scrap. These are overlapped along warpwise edges and sewed together with coarse diagonal stitches. A small rolled-up bit of cotton fabric of similar texture has been sewed to one edge and bits of other sewing, including two short sections of knot stitch, are present along other edges, indicating that the last use of the fragments, prior to serving a funereal purpose, was in a made-over form. The ground fabric is cotton, probably originally unbleached white, woven in a one-over-one plain weave with 68 warps and 32 wefts per inch. Both warp and weft yarns are two-ply, Z-S spun, hard twist, and one sixty-fourth inch in diameter. The pattern yarns are wool, two-ply, Z-S spun, soft twist, and about one forty-eighth inch in diameter. These alternate with the tabby wefts, making 64 wefts per inch where the patterning is present.

Uhle has described this specimen as a "Rag of tissue of cotton, with embroidered design. (More geometrical, but of the same manufacture.) Found beneath the temple of Pachacamac" (Appendix). The reference in parentheses seems to refer to items 29650 [3792] and 29659 [3792a], described above among examples with reversible designs.

A Small Repeat Pattern. A single badly charred specimen (29664 [3222a]), is the only example in this category. The fragment, about 16 by 11 inches, has a small animal figure distributed evenly over the surface. A photograph of part of this specimen has been published in *Expedition* (VanStan 1964 b, Fig. 6, p. 35). Several fabrics with small repeat patterns are present among the large cloths, but none shows the diapered repeat of a single motive or the clear evidence of a pattern produced in stitchery found in this one fragment. The cotton ground color is brown. Each of the remaining motives (Fig. 78) is in one of three colors. These are arranged to form diagonal rows in a sequence of green, russet, brown, russet (Fig. 77). The russet-color rows are alternately lighter and darker values, which may indicate that a fourth color was present originally, in place of two shades of one color. The ground fabric is a one-over-one plain weave with 40 warps and 28 wefts per inch. The wool embroidery yarns are parallel to the weft in the pattern and alternate with the cotton wefts. The cotton yarns are two-ply, Z-S spun, hard twist, and one forty-eighth inch in diameter; the wool, two-ply, Z-S spun, very soft twist, and one-fortieth inch in diameter.

This is listed as "A small piece of embroidered fabric." It is "From the burial place number one, Beneath the Temple of Pachacamac" (p. 138).

PAINTED AND TIE-DYE

Two scraps, small enough to have been overlooked in cataloguing, are of sufficient technical interest to be worth reporting.

The largest is a fragment five and one-half by two and one-half inches and is of unbleached white cotton with a painted pattern, in red and dark brown, on one face of the cloth. The two colors meet along a diagonal line. In the red area, which is the larger, two unpainted hollow, round-cornered "squares," which are typical to tie-dye patterning rather than painting, show the natural color of the cotton yarns. None of the paint has penetrated to the reverse face of the cloth. The weave is a two-over-one half basket. The yarns are all single-ply, S-spun, hard to crêpe twist; the warps are one-fiftieth inch in diameter, the wefts one sixty-fourth inch. There are 28 (times two) warps per inch and 26 wefts.

The smaller fragment is a frayed bit of tie-dye fabric two and one-fourth inches long and about one and one-half inches wide. The warp loops are present at both ends of the cloth and part of one scaffolding weft remains, although, except in the central part, most of the wefts have disappeared. In the center of the scrap there is a single cream-white tie-dye circle against a soft green-blue ground. The yarns are all wool, two-ply, Z-S spun, soft twist, and one forty-eighth inch in diameter, with about 56 warps and 20 wefts used per inch. The indications are that this was a section of a patchwork tie-dye cloth.

SUMMARY

Represented in this heterogeneous group of scraps are a variety of techniques and patterns which seemed to Uhle to be of sufficient interest to make their preservation worthwhile. Included are a few features which are not represented in the preceding groups. Notable among these are: Two styles of striping, the multicolored "Roman" style, and the alternating wide dark and light stripes composed of numerous narrow stripes which are all in shades of brown or cream-white. The closely related tapestry-like, brocade and embroidery techniques used in the production of polychrome designs against plain weave monochrome ground fabrics, with patterning characteristically in wool, the ground in cotton yarns. The clear distinctions between reversible and non-reversible fabrics, related to the styles of patterning. Small profile animal figures enclosed in frames of conventional bird figures, cut from larger fabrics, presumably for re-use.

Confirmation of the re-use of fabrics is seen also in other specimens. There is one example of overlapping of selvages, when joining two webs, in place of the usual edge to edge method, which may represent a

diverse practice rather than expediency in this particular case. The variety of shades of natural cottons is noteworthy and, in the light of Uhle's comments, invites further investigation.

CONCLUSIONS

Conclusions concerning these textiles as a group, can be little more than summary statements until studies of the remainder of the collection have been made. The total number of specimens reported, about 160 from a collection numbering 996 by rough count, represents less than one-sixth of the textiles from "Beneath the temple." Even the exact number of items included is debatable. In some cases two or more different specimens are labelled as one, and some which are labelled separately have proved to be segments of a single cloth. A listing of the headings and subheadings from the Catalogue, with a numerical distribution of the textiles of the present group according to the categories used in this study (Table 5), shows some of the problems involved in following Uhle's classifications. His *Gravefield I,* and *first gravefield* or *first burial place beneath the temple,* are confusing and *Field Catalogue* number sequences with different headings sometimes overlap, indicating the need for further comparisons of all of Uhle's correspondence, reports, photographs, notes, maps and diagrams, and the cross references to skeletal, ceramic, and other non-textile materials before final conclusions are drawn.

The present study includes all of the textiles found with a specific mummy in only three cases: 1149, 1151, and 3179-3186. There is one additional lot, 3188-3195, "probably from a mummy." These show no patterns of conformity.

The first lot [1149] includes four specimens, all fragments. Two of these (30321a,b [1149a,b]) are essentially alike: both have non-reversible diagonal patterns that appear to have formed borders on plain cotton fabrics (pp. 82-83).* Another, a small piece of patchwork weaving (30226 [1149d]), consists of parts of four sheer unpatterned cotton webs seamed together along warpwise selvages (pp. 72-73). The fourth item is a scrap of red wool fabric with warp striping (30038 [1149d]), classed with the narrow shawls and frontlets (pp. 48-49).

The second lot (1151) contains only two specimens, and Uhle has questioned their association. Both are whole pieces rather than fragments, and show evidence of non-funereal use. One is a miniature blue and white cotton cloth with an unusual pattern weave (29747 [1151d]) (pp. 65-66); the other, a deep figured pouch with a handle of double cloth (30119 [1151e]), a pouch which shows evidence of extensive use prior to its deposit with a burial (pp. 8-9).

The third lot (3179-3186), which has been reported previously (VanStan, 1964a), consists of textiles of five distinctive types: a large tapestry shroud with king-like figures (29492a,b [3179a,b]) and a somewhat similar fragment listed as "another piece," both polychrome tapestries woven in long narrow strips ornamented with a single figure used in a simple repeat (pp. 43-44); a tapestry belt or headband (29686 [3180]) distinguished by the variety of designs which it displays (pp. 55-56); a narrow red wool shawl (29850 [3181]), with its four selvages intact (p. 47); and a large heavy brown wool shroud made of three webs with red and blue stripes at one of the outer side selvages (29873 [3182]) (p. 40). Except for the tapestry shroud and the similar fragment, these pieces are complete and well preserved. They may or may not have served some earlier purpose.

The artifacts (3188-3195) labelled "probably from a mummy" include seven textiles. One of these (29772 [3189]) is a large, fine, sheer cotton poncho-shirt with narrow red and brown borders at the lower edge and needleknitted reinforcements, one red and one brown, at the front and back of the neck opening adjacent to the seam endings (pp. 21-22). The other specimens consist of: a coarse brown and white tweed-like cotton cloth (30421 [3190]) of unknown use (p. 74); a fragment of cotton cloth (29768 [3193a]) with a narrow end border consisting of small rectangular blocks with a simple geometric pattern repeated in different colors (pp. 64-65); a complete large, two-web cloth with counterpart designs (29756 [3193b]) (pp. 68-69); two red wool belt-like pouches with woven cotton tapes for tying (29730 [3193c], 29731 [3193c]) (p. 13); a miniature white cotton fabric with two red warpwise stripes (30547 [3193d]) (p. 65). All of the specimens of this group are in good condition and show no evidence of wear or other non-funerary use.

*In this chapter, page references in parenthesis are to pages in this Monograph.

There are four additional burials for which more than half of the textiles listed are included in the present study.

Those "Found with one or more mummies, (skulls P72 etc.) (1152, 1153, 1155-1157, and 1161)" include, under the heading "Other objects found with the mummy No. 1152 and 1153 (1155-1157)" the remnants of a large poncho-shirt (29875 [1155a]) which is a sheer cotton crêpe garment with a narrow, sewed-on tapestry border (pp. 22-24); two fragments of weaving, one of which is a bit of tapestry-like fabric (29889 [1155b]) (pp. 78-79); the other, a ragged scrap of heavy striped woolen cloth in basket weave (30856 [1155d]) (p. 77); and a piece of pattern-weave textile, believed to have been a figured bag-like pouch (30865 [1155g]) (p. 12). The latter is described as "from a child mummy accompanying the large mummy." Another "sample of fabric" (1155h) from this group is lacking. "Additional objects" found with another of these mummies (1161) include four pouches, a pouch band and a "red fillet." One pouch (1161p) and the pouch band (1161t) are missing. The other three pouches are all of the patterned bag-like type and all are poorly preserved. One (30126 [1161u] (p. 8) is square; the other two (30106 [1161s]) (pp. 10-11), (30080 [1161r]) (pp. 11-12) are broad and shallow and both show evidence of hard usage. The "red fillet" (29844 [1161q] is a monochrome, plain weave, wool scarf or narrow shawl, which is soft in texture and fairly well preserved (p. 48).

"Found with a mummy interred very deeply" (1160) are two pouches (29805 [1160c] , 30736 [1160d]) (pp. 4-5). Both are deep, narrow, cotton bag-like pouches "for implements"; one is monochrome, one striped. Both are in good condition. There is also one small rectangular fabric (29767 [1160b] (p. 64), plain-weave cotton except for narrow end borders of brocade. This has seen hard use. A "cloth containing leaves" (1160a) is missing.

Textiles "found with the mummy (skull P74) (1176)" including a "wrapper of the mummy" (30933 [1176d]), which is a two-web cloth of mixed brown and white cotton yarns (pp. 38-39); the remains of two "frontlets" classed with the bands and borders, one a thick pattern-weave band (19696 [1176b]) (pp. 56-57), the other a wider tapestry band (29682 [1176c]) (pp. 57-58) which passed over the preceding. There is also one small rectangular cloth (30940 [1176e])(p. 62) of brown and white cotton. Lacking are a "braided circle for the forehead" (1176a) and a "long narrow cloth" (1176f).

The fourth lot is a comparatively large one, "Found with a mummy (1180-1183)." Of the textiles, the "External objects: (1180)" consist of sixteen pouches, one large poncho-shirt, two "wrappers," and a covering for the false head. One pouch and one "wrapper with the false head" are lacking. Twelve of the pouches are of the small, undecorated bag-like variety (1180i, k-u) (pp 3-4). One is a shallow bag-like fringed pouch (30801 [1180h]) (pp. 5-6). Three are of the belt-like type. Two of these are undecorated cotton (30838 [1180f], 30835 [1180g]) (pp. 6-7); one is a patterned red and white wool and cotton (29729 [1180e]) (pp. 13-14). The large shirt (30935 [1180a]) (pp. 19-20), which is wide with small arm-holes, is made of coarse, unbleached, white cotton fabric. It has no ornamentation. The two wrappers include a large cotton shroud or "inner white wrapping" (30954a,b [1180c]) (pp. 37-38) and a large, heavy brown wool, three-web shroud with a red and blue striped border along one side (29874 [1180d]) (pp. 39-40). The false-head covering (30953 [1180g]) is a large mixed brown and white, cotton cloth (p. 50). All of these items are in fairly good condition.

The "Internal objects: (1181)" include only two textiles. One, a "red woollen frontlet, fragment" (29847 [1181a]), is a monochrome, plain-weave woolen scarf-like cloth (p. 48). The other, "the remains of a gobelin frontlet," is missing.

Among "Other objects accompanying the mummy (1182)" are two pouches, of which one (1181c) is lacking; parts of two poncho-shirts; a piece of tapestry; two fragments classed as one piece, which appear to be mummy wrappings; one large cloth of unknown use; and an unidentifiable fragment. Listed, also, is a "twisted cord," which is lacking. One pouch (29792 [1182d]) is a narrow, deep, patterned bag in poor condition (pp. 8, 9-10). The poncho-shirt (29497 [1182a]) (pp. 24-25) is red wool with warp stripes in pattern-weave. It appears to be a made-over garment. Two ragged pieces of cloth (29857 [1182g])

(pp. 28-30) show evidence of having been parts of one of the webs from another two-web poncho-shirt. These pieces were re-used for some unknown purpose. Th e fabric is warp-face white cotton with colored side borders. The piece of tapestry (29680 [1182b]) is a fragment which Uhle has classed as a loin cloth. It is polychrome, with attached sections of plain white cotton fabric (pp. 33-34). The two separate pieces of cloth, both unbleached white cotton fragments which appear to have been used as shrouds, differ from one another. One (30955a [1182g]) is a sleazy basketweave fabric; the other (30955b [1182g]) is a firm, warp-face one-over-one plain weave, (p. 38). Both are undecorated. The large cloth of unknown use (29757 [1182e]) is part of one of the cotton cloths with two counterpart webs each having small repeat patterns in an outer corner (pp. 68, 69, 70). The fragment (29759 [1182f]) has a plain cotton ground with two small rectangular polychrome blocks embroidered near the one remaining corner (p. 82). Both this and the preceding are well made fabrics.

Listed separately, although presumably part of the same lot, are seven "nets, found with it (1183)." All of these (1183a-g) are lacking. It seems probable that six of the specimens are among those described in an article on hairnets by Singer (1936), although no specimen numbers have been given.

As with the complete grave lots, these partial lots show no conformity in respect to the variety of the textiles, their quality, their condition, or the number included with each burial. Likewise, the nature of the ornamentation occurring in the few patterned textiles of each lot shows no clear-cut adherance of the individual grave lots to the decorative styles which Uhle outlined.

In many cases the burials which Uhle found had been disturbed prior to his excavations. Uhle did find stratifications in some instances, and used these as the bases for the design classifications by means of which he determined his style sequence. Following this, he used the similarities of form and decorative designs as his key to classification. Obviously this latter method is not applicable to the textiles which lack decorative designs. While classifications for ceramic and other more durable materials have been expanded to include various structural characteristics, most of the undecorated textile items can be classified only through references to associated artifacts.

It seems necessary that other criteria be found, that features other than ornamentation, such as size, relative proportions (which Uhle has mentioned in reference to poncho-shirts [1903, p. 37]), details of texture, yarn, and weave, types of edge finishes and methods used in joining one web to another, be investigated. The use of color also provides other possible criteria. Not only the number and range of hues, but their absence or prevalence, and the ways in which they have been arranged or combined may prove to be useful. While no divisions of this type can be made at present for Pachacamac textiles, certain features can be noted for future checking against the remainder of this collection.

Monochrome textiles are prevalent. These are predominantly natural cream-white cotton; natural brown cottons are present and there are yarn-dyed red and brown wools, piece-dyed orange and blue cottons.

The use of natural brown and white cottons, intermixed in the stock, in the spinning, or in weaving is represented in tweeds, stripes, plaids, and in pattern weaving. Wool yarns are used frequently as pattern yarns, in fabrics having the non-pattern yarns of cotton; for example, the wefts in many brocades and tapestries, and the warps in warp-face pattern stripes. Most of the basic weaves are represented: plain, with variations, including tapestry, warp-face, spaced warps, as well as the basket weaves; damask; brocade, both single and double-face; pseudo or two-color twills; gauze. Patchwork weaving is also present and there are two distinctive types of pattern weave. Of the latter, the "two-color" threading with warps in alternate colors woven to produce a pattern in plain weave on the obverse face of the fabric, seems to have quite limited distribution. The other, the "dotted weave," a weave which gives a lattice-like effect when used as an outline, seems to have had great popularity in the Central Coastal area. Tie-dye was used, and probably also another type of resist patterning. A very limited amount of shaping during weaving is evident, principally gradual narrowing. There is also the warpwise bisection of one web for part of the length, in the tying tapes of some of the pouches, and similar dividing into two or three sections at the ends of belts or headbands.

A few special applications may be noted: ring weaving in bags and tiny shirts; warp fringe made from the central section of the warp, used in bags; leaving of long heavy loomstring ends and sometimes reinforcing these for tying; and the use of numerous methods for flush finishing of heading cord ends.

Sewing, both decorative and utilitarian, is present. It was used for seaming, hemming, and to secure pleats. It provided reinforcing and decorative edge finishes and in addition was used for both embroidery and mending.

Certain standardizations seem to have been present in respect to methods of spinning, selection of yarns for specific uses, the sizes and proportions of specific articles, as well as in the layout for the ornamentation of certain garments and other textiles, including color selection and arrangement as well as type and location of patterning. In all of these a degree of flexibility, rather than rigid following of rules, can be noted.

Much re-use of the fabrics is evident with both made-over types and darning, the made-overs frequently showing worn cloths of fine quality put together in a slovenly manner. Also evident is a wide range in the quality of the fabrics, indicating the presence of the work of master craftsmen, weaving which is fair to good in quality, as well as beginners' work and that done hastily or carelessly by experienced weavers. Some color combinations are pleasing, others are in poor taste by today's standards.

Little use of texture contrasts within individual monochrome textiles is present. There is a wide range of texture contrasts between various independent fabrics; between the grounds and borders, or other decorative areas, of many single webs; and, frequently, where color contrasts are present. Texture contrasts between webs joined by sewing are common, especially where decorative bands and borders have been added. A tendency to make considerable use of the minor color contrasts of natural fibers, as well as the stronger brown with white, is apparent.

The styles of these cloths, both as fabrics and as made-up garments or accessories, while tending to repetition in some cases, show an extensive variety of both techniques and designs. The tendency to repetition, for example, among the bag-like and the belt-like pouches, and in the use of "two-color" and "dotted-weave," suggests the presence of a certain craft unification, perhaps following local fashions without discarding the more basic established practices. Does this mean that a unified or typical local pattern or patterns of textile construction and use can be expected for a specific time and place? Can minor variations be attributed to the interpretations of individual weavers or craftsmen? Or are these cumulative differences appearing with the "handing down" process, either through the passage of time or increased distance from a center or focal point?

If local patterns are present, did these appear as "themes with variations" based on individual choices, perhaps within quite narrow limits? Or, were such patterns rigidly fixed on the basis of social status, locale of residence, or other personal affiliation of an individual owner?

Does a lack of uniformity indicate an accumulation of artifacts over an extended period of time? Or, in the case of a religious gathering ground, such as Pachacamac is believed to have been, the result of a congregation of pilgrims with the products of their home areas intermixed with the materials of local origin? Or, does this show the result of the interplay of many forces in an advanced urban civilization where trade, with its turmoil of interests in "new" and different things, would invite the end of any static design era?

As yet these questions cannot be answered for pre-Hispanic Pachacamac, but it seems most probable that all of these factors may have played a part in contributing to the variety of the textile remains from Pachacamac's past.

REFERENCES CITED

Bennett, Wendell C., and Junius B. Bird

1964 *Andean Culture History.* The Natural History Press. Garden City, New York.

Harcourt, Raoul d'

1934 *Les Textiles Anciens du Pérou et Leurs Techniques.* Les Editions d'Art et d'Histoire, Paris.
1962 *Textiles of Ancient Peru and Their Techniques.* University of Washington Press, Seattle.

Jijón y Caamaño, J.

1949 *Maranga: Contribución al Conocimiento de los aborigenes del Valle del Rimac, Peru.* La Prensa Catolica, Quito.

Maerz, A., and M. R. Paul

1950 *A Dictionary of Color.* McGraw-Hill, New York.

O'Neale, Lila M.

1933 A Peruvian Multicolored Patchwork. *American Anthropologist,* Vol. 35, No. 1, pp. 87-94. Menasha, Wisconsin.
1937 Textiles of the Early Nazca Period. *Archaeological Explorations in Peru. Part III. Anthropology Memoirs, Field Museum.* Vol. II, No. 3. Chicago.

O'Neale, Lila M., and Bonnie Jean Clark

1948 Textile Periods in Ancient Peru III: The Gauze Weaves. *University of California Publications in American Archaeology and Ethnology,* Vol. 40, No. 4, pp. 143-222. Berkeley.

Reiss, Wilhelm, and Alphons Stübel

1880-1887 *The Necropolis of Ancon in Peru,* 3 volumes. Asher & Company, Berlin.

Singer, Ernestine Wieder

1936 The Techniques of Certain Peruvian Hairnets. *Revista del Museo Nacional.* Vol. 5, No. 1, pp. 16-24. Lima, Peru.

Strong, William Duncan, Gordon R. Willey, and John M. Corbett

1943 *Archaeological Studies in Peru, 1941-1942.* Columbia University Press. New York.

Uhle, Max

1896-97 *Field Catalogue, Notes and Report,* 3 volumes MS, unpublished, on file in the University Museum Library of the University of Pennsylvania, Philadelphia.

1903 *Pachacamac.* The Department of Archaeology of the University of Pennsylvania, Philadelphia.

VanStan, Ina

1961 a Miniature Peruvian Shirts with Horizontal Openings. *American Antiquity.* Vol. 26, No. 4, pp. 524-531. Salt Lake City.

1961 b Ancient Peruvian Textile Arts: Patchwork and Tie-dye from Pachacamac. *Expedition: The Bulletin of the University Museum of the University of Pennsylvania.* Vol. 3, No. 4, pp. 34-37. Philadelphia.

1963 A Problematic Example of Peruvian Resist-Dyeing. *American Antiquity.* Vol. 29, No. 2, pp. 166-173. Salt Lake City.

1964 a The Fabrics from a Peruvian Mummy Bale Found Beneath the Pachacamac Temple. *Bulletin de Liaison du Centre International d'Etude des Textiles Anciens.* No. 19, pp. 20-37. Lyon.

1964 b Rags and Tatters: Among the Textiles of Peru. *Expedition: The Bulletin of the University Museum of the University of Pennsylvania.* Vol. 6, No. 4, pp. 34-39. Philadelphia.

1965 A Triangular Scarflike Cloth from Pachacamac, Peru. *American Antiquity.* Vol. 30, No. 4, pp. 428-433. Salt Lake City.

1967 Brocades or Embroideries? Seventeen Textiles from Pachacamac, Peru. *The Bulletin of the Needle and Bobbin Club.* Vol. 50, Nos. 1 and 2, pp. 5-30. New York.

Table 1

Yarn Detail, Undecorated Cotton Bag-like Pouches

Style	Specimen Number	Woven Dimensions		Yarn*				Twist**				Count	
				Diameter		Ply		Degree		Direction			
		Warp	Weft	Warp	Weft	Warp	Weft	Warp	Weft	Warp	Weft	Warp	Weft
Square	30735 [1180k]	12"	6"	1/32"	1/32"	2	2	Hard	Hard – medium	Z-S	Z-S	26	15
	30737 [1177g]	12 1/4"	7 1/4"	1/32"	1/24"	2	2	Hard	Soft	Z-S	Z-S	40	14
	30738 [1180o]	14 1/4"	6 1/2"	1/32"	1/24"	2	2	Hard	Hard	Z-S	Z-S	28	14
	30739 [1137e]	11 1/2"	5 5/8"	1/32"	1/24"	2	2	Very Hard	Medium	Z-S	Z-S	26	15
	30741 [971k]	13"	7 3/8"	1/48"	1/48"	2	2	Very Hard	Very Hard	Z-S	Z-S	48	22
	30742 [1180u]	11 1/2"	6 1/4"	1/32"	1/32"	2	2	Hard	Hard	Z-S	Z-S	28	15
	30743 [1180n]	14"	7 7/8"	1/48"	1/32"	2	2	Medium	Medium	Z-S	Z-S	38	17
	30744 [1180t]	11 3/4"	6 3/8"	1/32"	1/32"	2	2	Hard	Hard	Z-S	Z-S	34	15
	30745 [1180i]	12 3/4"	6 1/2"	1/32"	1/32"	2	2	Medium	Soft	Z-S	Z-S	24	14
	30746 [1180r]	11 1/2"	6 1/8"	1/32"	1/32"	2	2	Medium	Soft	Z-S	Z-S	32	14
	30747 [1180-l]	12 1/4"	7 1/8"	1/32"	1/32"	2	2	Medium	Soft	Z-S	Z-S	30	17
	30748 [1180m]	12 1/4"	6 1/4"	1/32"	1/32"–1/48"	2	2	Medium	Medium	Z-S	Z-S	26	13
	30749 [1180p]	12"	6 1/8"	1/32"	1/48"	2	2	Medium	Hard	Z-S	Z-S	24	16
	30750 [1180q]	13 3/4"	6 3/4"	1/32"	1/48"	2	2	Medium	Hard	Z-S	Z-S	32	18
	30751 [1180s]	14"	6 3/4"	1/48"–1/32"	1/48"	2	2	Medium	Soft	Z-S	Z-S	30	12-22
	30754 [1177f]	11 1/2"	6 1/2"	1/32"	1/48"	2	2	Medium	Hard	Z-S	Z-S	34	12
	30760 [3776]	7 1/2"	4"	1/24"	1/32"	2	2	Soft	Medium	Z-S	Z-S	30	9
	30793 [3216]	10"	6 1/8"	1/64"	1/48"	2	2	Hard	Hard	Z-S	Z-S	66	14
Deep	30736 [1160d]	22 3/4"	5 1/4"	1/24"	1/32"	2	S	Medium	Very Hard	Z	Z-S	32	11(2)
	29805 [1160c]	22"	4 3/4"	1/24"	1/32"	2	S	Medium	Very Hard	Z-S	Z	30	9(2)
Fringed	30801 [1180h]	12"(woven) 21"(warp)	12 1/2"	1/32"	1/32"	2	2	Very Hard	Hard – Very Hard	Z-S	Z-S	24	12
	30815 [1137d]	12"(woven) 23"(warp)	13 3/4"	1/32"	1/32"	2	2	Very Hard	Medium	Z-S	Z-S	28	15

* *Yarns for major areas only, others are present in parts of these specimens.*

** *Considerable variation is present within individual yarns.*

Table 2

Yarn Detail, Undecorated Cotton Belt-like Pouches

Specimen Number	Woven Dimensions		Yarn*								Count	
	Warp	Weft	Diameter		Ply		Twist**					
							Degree		Direction			
			Warp	Weft	Warp	Weft	Warp	Weft	Warp	Weft	Warp	Weft
30827 [1162f]	22"	6-1/2"	1/48"	1/48"	2	2	Hard	Hard	Z-S	Z-S	50	13 (2)
30831 [1177d]	19"	5-1/4"	1/24"	1/48"	2	S	Hard	Hard	Z-S	Z	34	10 (2)
				1/32"		S		Medium		Z		12 (2)
30832 [3775]	19"	7-1/2"	1/24"	1/24"	2	2	Hard	Hard	Z-S	Z-S	42	11
30834 [1162e]	21"	9-1/2"	1/48"	1/48"	2	2	Hard	Hard	Z-S	Z-S	48	20
30835 [1180g]	25"	8"	1/32"	1/48"	2	S	Hard	Hard	Z-S	Z	36	15 (2)
30836 [1177e]	19-1/2"	5"	1/24"	1/16"	2	2	Hard	Medium	Z-S	Z-S	38	9
30838 [1180f]	25"	9"	1/24"	1/24"	2	2	Hard	Medium	Z-S	Z-S	34	15
30840 [1137c]	19-1/2"	6"	1/24"	1/24"	2	2	Medium	Medium	Z-S	Z-S	26	12

*Yarns for major areas only, others are present in parts of these specimens.

**Considerable variation is present within individual yarns.

Table 3

Yarn Detail, Red and White Patterned Belt-like Pouches

Specimen Number	Woven Dimensions		Yarn*											
	Warp	Weft	Diameter		Ply		Twist**				Count		Fiber	Color
							Degree		Direction					
			Warp	Weft	Warp	Weft	Warp	Weft	Warp	Weft	Warp	Weft		
29728 [1137b]	19 1/2"	6"	1/32"	1/48"-1/24"	2	2	Medium-hard	Hard,soft	Z-S	Z-S	28	14	Wool	Red
			1/32"-1/24"		2		Hard		Z-S		40		Cotton	White
29729 [1180e]	26"	8 3/4"	1/24"	1/32"	2	2	Hard	Soft	Z-S	Z-S	34	16	Wool	Red
			1/24"		2		Hard		Z-S		28		Cotton	White
29730 [3193c]	24"	7 1/2"	1/48"	1/32"	2	2	Medium	Soft	Z-S	Z-S	48	16	Wool	Red
			1/32"		2		Hard		Z-S		48		Cotton	White
29731 [3193c]	24"	7 3/4"	1/32"	1/32"	2	2	Hard	Medium	Z-S	Z-S	28	14	Wool	Red
			1/32"		2		Hard		Z-S		28		Cotton	White
29734 [3211c]	26"	6"	1/32"	1/24"	2	2	Medium-hard	Soft	Z-S	Z-S	48	16	Wool	Red
			1/48"		2		Hard		Z-S		54		Cotton	White
29735 [3211c]	22 1/2"	5 1/4"	1/32"	1/24"	2	2	Medium-hard	Very soft	Z-S	Z-S	36	14	Wool	Red
			1/32"		2		Hard		Z-S		48		Cotton	White

*Yarns for major areas only, others are present in parts of these specimens.

**Considerable variation is present within individual yarns.

Table 4

Yarn Detail for Nine Brocaded or Embroidered Textiles with Reversible Block Patterns

Specimen Numbers	Cotton Yarns of Ground Fabric*						Wool Yarns of Pattern (all weftwise)**			
	Diameter		Degree of Twist		No. per inch		Diameter	Twist		No. per inch***
	Warp	Weft	Warp	Weft	Warp	Weft		Direction	Degree	
29654 [3791g]	1/64"	1/64"	Medium	Medium	75	44	1/50"	Z-S	Soft	108
29653 [3791f]	1/48"	1/48"	Hard	Hard	76	28	1/48"	Z-S	Medium – soft	82
29652a [3791e]	1/48"	1/48"	Hard	Hard	52	24	1/48"	Z-S	Soft	64
29652b [3791d]	1/48"	1/48"	Hard	Hard	50	26	1/48"	Z-S	Soft – very soft	60
29657 [3791i]	1/48"	1/48"	Hard	Hard	64	20	1/48"	Z-S	Medium – soft	80
29658 [3791h]	1/64"	1/48"	Hard	Hard	68	28	1/50"	Z-S	Soft – very soft	76
29650 [3792]	1/48"	1/48"	Hard	Hard	80	28	1/50"	Z-S,S-Z	Very soft	104
29659 [3792a]	1/50"	1/50"	Hard	Hard	48	32	1/48"	Z-S	Soft – very soft	96
29759 [1182f]	1/64"	1/64"	Hard	Hard	46	30	1/48"	Z-S	Soft – very soft	80

*All are two-ply, Z-S spun.
**All are two-ply.
***Apparent count discrepancies between cotton and wool weft counts are due to spreading of cotton wefts and the number of wool wefts used between pairs of cotton wefts.

Table 5

Distribution of the Specimens of Each Category According to the Locale of Their Recovery.

Field Catalogue Locale Designation	Field Catalogue Subheadings	I Pouches	II Poncho-Shirts	III Odd Made-up Fabrics	IV Shrouds	V Shawls etc.	VI Bands and Borders	VII Small Fabrics	VIII Large Cloths	IX Fragments
Continuation of the Collection from Pachacamac, on the foot of the temple of Pachacamac. Nos. 906-1087.	Found with a mummy (P38) (954a-i)	1								
	Found on the mummy, near which the two vessels, in shape of a mountain-cat were found. (Skull with jawbone P40) See p. 7 - from a very deep grave. Nos. 971 a-y.	1								
	Four-headed (?!) grave in an adobe chamber. The mummies are partly those of children, and are apparently partly put in layers. The grave is half-way under the most northern of the lower terrace-walls of a temple-like building. (P55-57 belong here.) P55 belongs to the mummy from which nearly all objects come. This mummy has the teeth ground off in a remarkable degree (probably from chewing corn meal for the fabrication of chica). (1068-1084)				2		1			
	Found with a mummy interred very deep (Skull P 58; near P59). (1085)				1					
Continuation of the excavation at Pachacamac. Excavation some 10 meters to the west of the foregoing ones, at the foot of an old half-terrace. (1088-1134),	[Remnants of fabric (1090)] **		2	1			4	7	2	1
	[Miniature poncho (1093b)] **		1							
	Found with a mummy (1097-1103) Cotton cloths (1097)				1					
	Cloths for frontlets (?) (1099)					4				
	Found with a mummy, which was in rotten condition: (1104)		1							
	Found with the mummy No. 971 & seq.: (1122)		1							
Continuation of the excavations at the place from which I obtained the objects Nos. 1000-1087. At present the site is beneath the temple.	Found with a mummy (skull P68) (following 1137 and 1138)	5								
	External objects of the mummy: (1137)									
	Internal objects of the mummy: (1138). See 3775, 3776, 3788.		1							
	Furnishings of a mummy (skull P69) was photographed together with P68 (1139-1141)									
	External furnishings: (1139)					1				
	Internal furnishings: (1141)					1		2		4
	From a burial-place at the east-front of the construction, where the graves are almost beneath the terraces. These finds were obtained in an analogous manner as were those from the north-front (skull P69) (1146-1149). Other objects belonging to the find: (1149)					1		1	1	2
	Found with a mummy buried in an analogous manner: (1151) (Analogous to: Found in the soil, which in ancient times was banked up as a substratum for the enlarged construction of the temple.)	1						1		
	Found with one or more mummies, which were interred equally high up (skulls P72 etc.) (1152, 1153, 1155-1157, and 1161)									
	Other objects found with the mummy No. 1152 and 1153 (1155-1157)	1	1							
	Found with a mummy, interred very deeply (1160)	2								
	Additional objects found with mummy, interred further up (1161)	3				1				
	Finds, of which it is not certain to which mummies they belong (1162)	2						1		
	Found with the mummy (skull P74) (1176)				1		2	2	1	2
	Found with a youthful mummy (skull P75) (1177 and 1178) [1177]	4						1		
	Objects found inside the mummy-bale (1178)		1							

The following is a rotated tabular catalogue. Column headers are blank; numeric values are given per row.

Description											
Found with a mummy (1180-1183)											
External objects: (1180)	16	1	2	1	1				1		1
Internal objects: (1181)		1		1							
Other objects accompanying the mummy (1182)	1	2	1 or 2	1				1		1	1
Continuation of the Pachacamac Collection.											
Two long pouches (1232 a,b), from the mummy of photograph No. 344 (1213)	1										
From an excavation in the large gravefield										1	
Different pieces of weaving [1272]							1				
Finds from a second entire gravefield superficially rifled, of about the same age as the first worked, eminently old. (1330-1350).											

Pachacamac, continuation (first burial place). (1735-1779).											
Two strips of cloth found with the mummy 1748 a,b		1 or 2	1								3
Small pieces of cloth 1748 e-h		1	1	1						1	
Different kinds of remains of cloth; (1770 a-u)		1		1							
Excavations in the first burial place, Pachacamac. (1794-2084).											
***										1	
Excavations at burial place number one. Beneath the Pachacamac temple, continuation. (3179-3218).											
(numbers 3179-3186 belong to a mummy)			2 or 3	1	1						
[Thick, figured, narrow ribbon, which was wrapped around the mummy of a child]					1 (Tag lost)						
3188-3195, probably from a mummy	2	1	1	1	2			2 or 3			
3197-3217 from one tomb	3	4	1	2	2						
From the burial place number one. Beneath the temple of Pachacamac.											
[Small piece of embroidered fabric] [3222] **									1		
Continuation of the finds in the first burial place Beneath the Temple. (3251-3275).											
3251-3261 from one mummy				2	2					2	
[Other] **			1	1							
Beneath the temple of Pachacamac. ****											
A large pouch of the mummy bale 1138. (*3775)	1										
A small pouch of a mummy bale, also 1138 (*3776)	1										
Pachacamac, first cemetery.											
A kind of stuff mostly found together with the most ancient stuffs. (3785)				1					1		
Beneath the temple of Pachacamac.											
Labelled 1138 (3788)											1
Formed parts formerly outer wrapper of a mummy bale. Falsely labelled 1079e. (3791 a-i)											6
Rags of tissue of cotton. Labelled 1138 (3792, 3792a)											2
Rag of tissue of cotton. (3793)											1

* Uhle's notation, "Formed parts formally outer wrapper of a mummy bale, found Beneath the Temple of Pachacamac. Falsely Labelled 1079e." (Appendix)

** Square brackets are used for objects where no subheading has been supplied and previous heading does not apply, according to notations in Catalogue.

*** Catalogue shows other headings and subheadings which do not apply to present group of textiles.

**** Beginning of the "Appendix to the Collection."

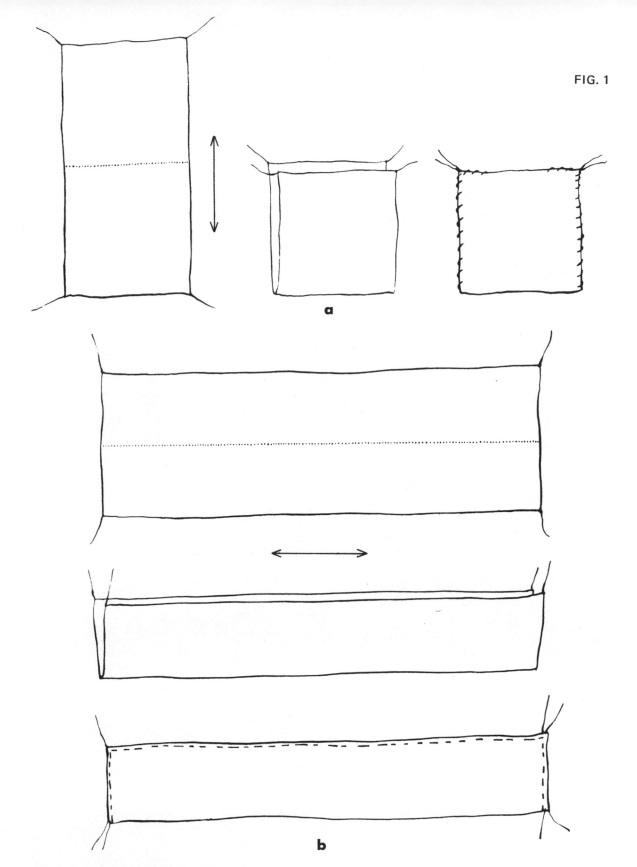

FIG. 1

The basic methods of pouch construction.

 a. Undecorated bag-like type.

 b. Belt-like type.

FIG. 2

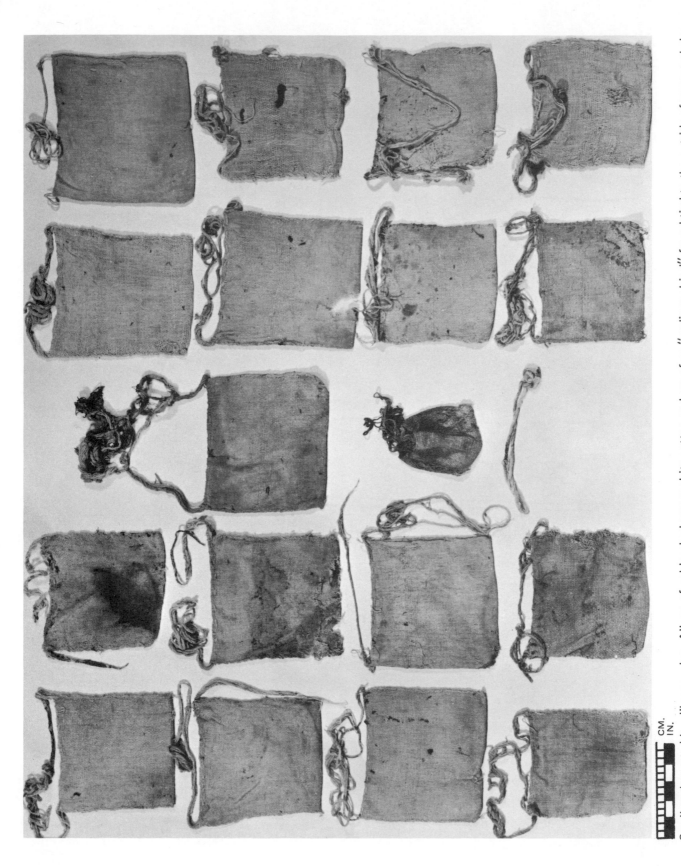

Small undecorated bag-like pouches. All are of unbleached creamwhite cotton and are of an "ordinary kind" found tied to the outside of mummy bales. Top row, left to right: 30748 [1180m], 30749 [1180p], 30738 [1180o], 30743 [1180n]. Second row: 30745 [1180i], 30750 [1180q], 30737 [1177g], 30751 [1180s], 30735 [1180k]. Third row: 30747 [1180-l], 30741 [971k], 30760 [3776], 30746 [1180r], 30744 [1180t]. Bottom row: 30739 [1137e], 30754 [1177f], 30793 [3216], 30742 [1180u].

CM.
IN.

FIG. 3

Two deep bags (left, 30736 [1160d]; right, 29805 [1160c]) and two of a shallow, fringed variety (top, 30815 [1137d]; bottom, 30801 [1180h]). Made of undyed cotton yarns, these are cream-white except for the simple brown stripes in one example.

CM.
IN.

FIG. 4

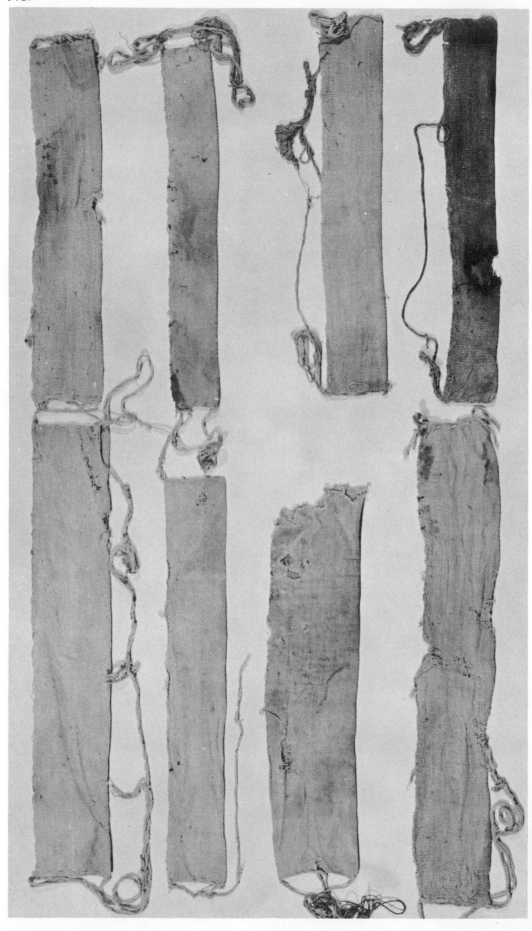

Belt-like, undecorated cotton pouches from mummy bales. Top row, left to right: 30838 [1180f], 30832 [3775]. Second row: 30827 [1162f], 30831 [1177d]. Third row: 30834 [1162e], 30840 [1137c]. Bottom row: 30835 [1180g], 30836 [1177e].

CM.
IN.

FIG. 5

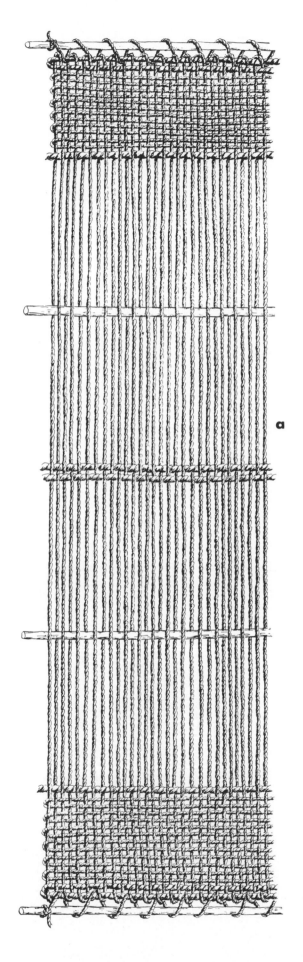

a

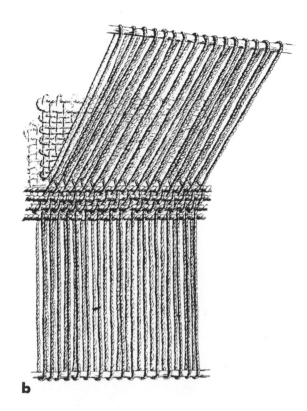

b

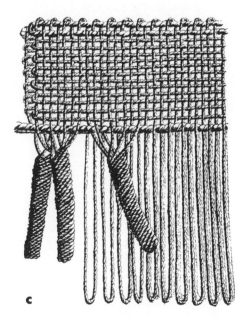

c

Method of the fringe construction of the two shallow, undecorated bag-like pouches.

 a. Fabric on the loom, with heavy cords and sticks in place.

 b. Fringe loops drawn out over sticks.

 c. Twisting of the loops to form the cord fringes.

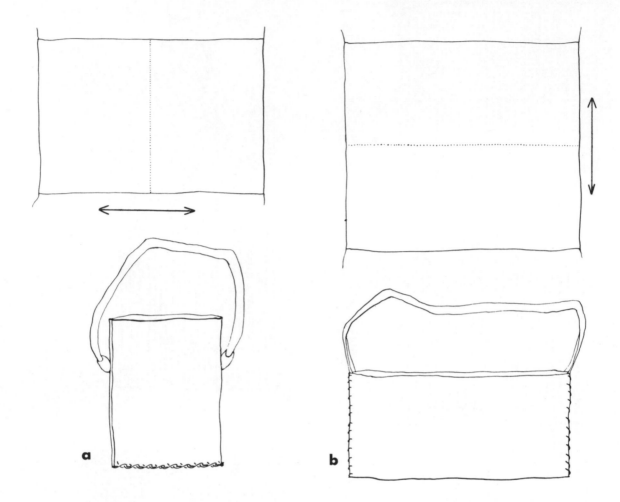

Fig. 6. The basic method of construction and position of the handles in the bag-like figured pouches.

 a. Deep bag.

 b. Shallow bags.

Fig. 7. Method of joining warp loops in ring or tubular weaving. Specimen 30119 [1151e].

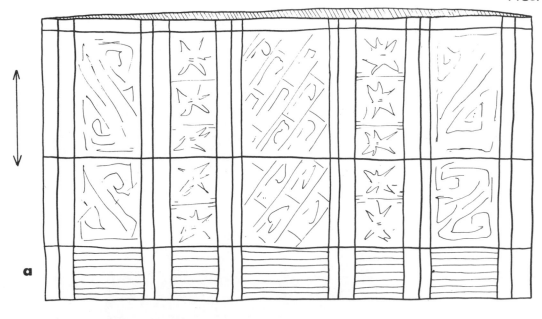

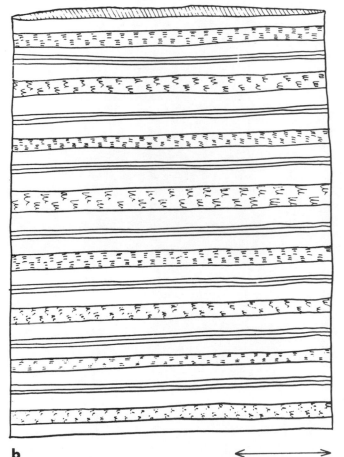

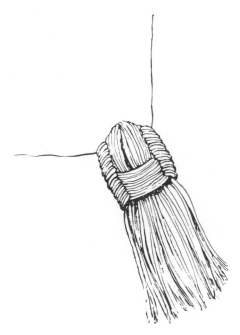

Fig. 9. Needleknitted binding of the tassel heads. Specimen 30106 [1161s].

Fig. 8. General layouts of the patterning of the figured, bag-like pouches.

 a. Shallow bag.

 b. Deep bag. Specimen 30119 [1151e].

FIG. 10

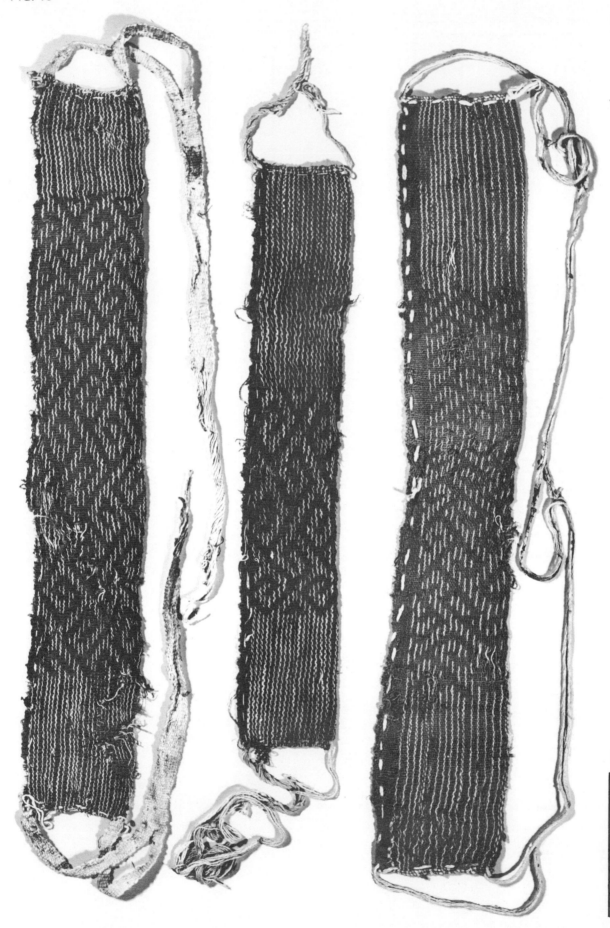

Three red and white patterned belt-like pouches. These are fairly well preserved and the reds fall in the orange-to-red category (Maerz and Paul, 1950, p. 3). Top: 29730 [3193c] has two shades, 6-D-10 and 7-J-5. Center: 29729 [1180e] matches 5-K-8. Bottom: 29728 [1137b] matches 5-K-5.

CM.
IN.

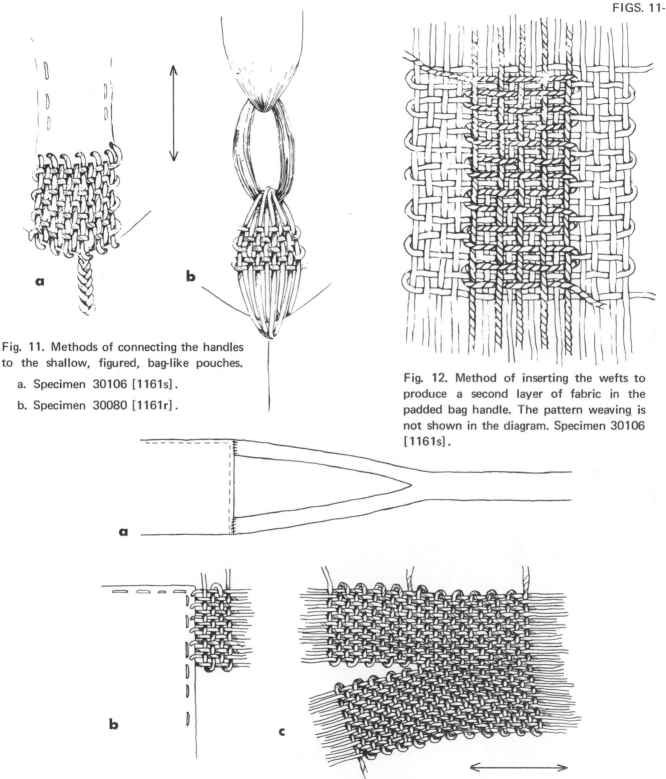

Fig. 11. Methods of connecting the handles to the shallow, figured, bag-like pouches.

 a. Specimen 30106 [1161s].

 b. Specimen 30080 [1161r].

Fig. 12. Method of inserting the wefts to produce a second layer of fabric in the padded bag handle. The pattern weaving is not shown in the diagram. Specimen 30106 [1161s].

Fig. 13. Form and method of weaving the tapes of some of the figured, belt-like pouches.

 a. General form of pouch end with attached tape.

 b. Detail of method used in starting the tape construction at a corner of the pouch.

 c. Detail of the weaving of the two sections of the tape into a single unit.

a

b

Fig. 14. The basic shirt types.

 a. The common poncho-shirt style, with vertical neck and arm apertures.

 b. A tubular style with horizontal openings for arms and neck.

Fig. 15. The miniature shirts; a-d, Poncho-shirt style; e-g, Tubular style with horizontal neck and arm apertures.

 a. 30740 [1137e].

 b. 29831 [3214b].

 c. 29832 [3214b].

 d. 30727 [1122n].

 e. 30707 [1090c].

 f. 30732 [1104-l].

 g. 30731 [1093b].

CM.
IN.

FIG. 16

Three poncho-shirt variations, all undecorated garments.

a. A standard two-web type. Specimen 30935 [1180a].

b. A similar style with sleeves added. Specimen 30293 [1090g].

c. A method used to reduce the width of an excessively wide garment. Specimen 30284 [1178g].

FIG. 17

Four types of poncho-shirt ornamentation.

a. Narrow woven-on edge border and sewed reinforcements at the front and back points of the neck opening. Specimen 29772 [3189].

b. A sewed-on border at the lower edge. Specimen 29875 [1155a].

c. Two-web construction, warp striping. Specimen 29497 [1182a].

d. Three-web construction, with stripes and allover patterning. Specimen 33003 [3210].

FIG. 18

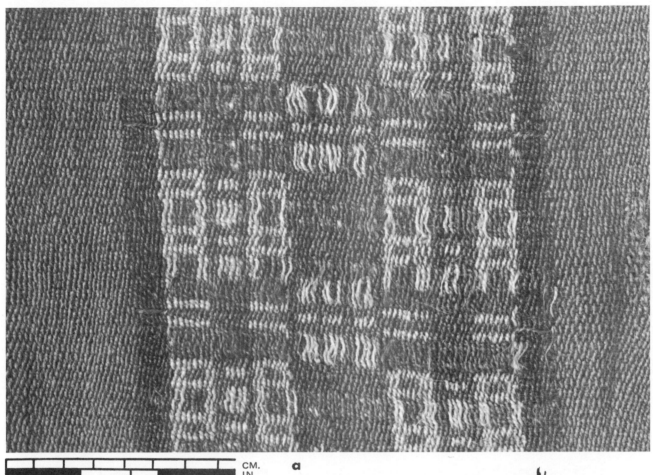

CM.
IN.

Details of a large poncho-shirt. Specimen 29497 [1182a].

a. Part of a pattern stripe.

b. A knot stitch, used to secure a rolled hem.

FIG. 19

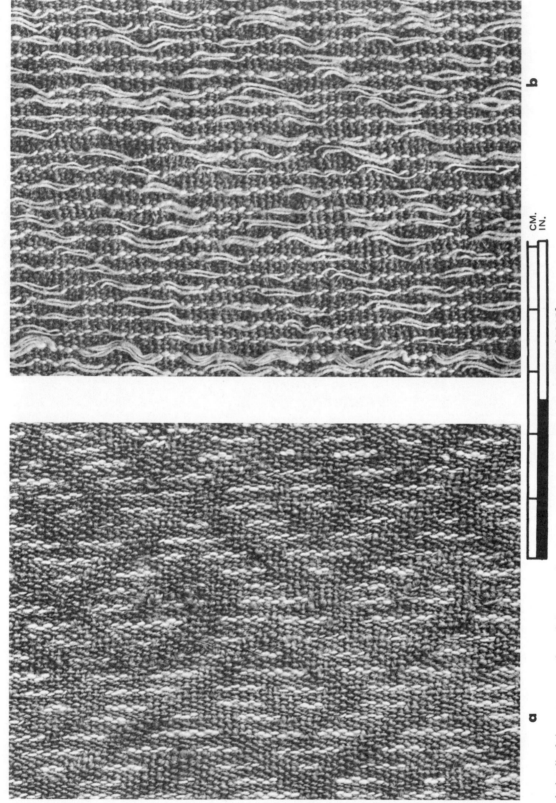

A detail of the pattern section of the central web of a three-web poncho-shirt, 33003 [3210].

a. Obverse.

b. Reverse.

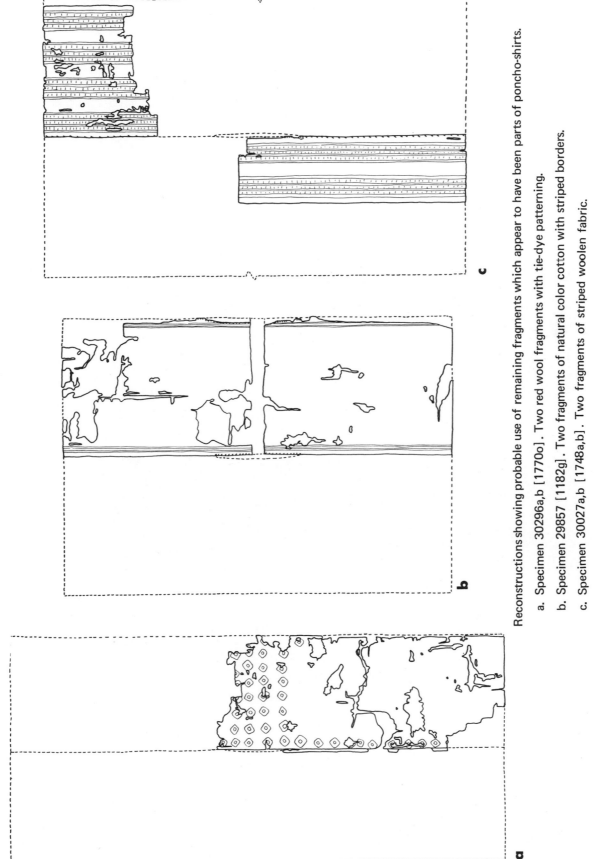

FIG. 20

Reconstructions showing probable use of remaining fragments which appear to have been parts of poncho-shirts.

a. Specimen 30296a,b [1770o]. Two red wool fragments with tie-dye patterning.

b. Specimen 29857 [1182g]. Two fragments of natural color cotton with striped borders.

c. Specimen 30027a,b [1748a,b]. Two fragments of striped woolen fabric.

FIG. 21

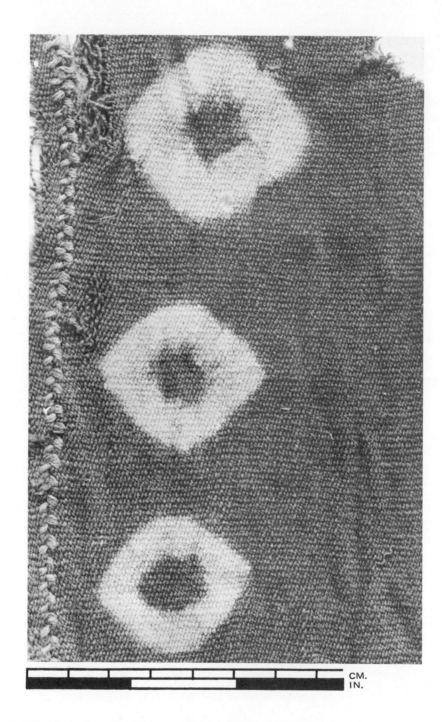

CM.
IN.

Details of tie-dye patterning and a seam sewed with saddlers' stitch. One of two red wool fragments, 30296a [1770o], believed to have been parts of a poncho-shirt.

FIG. 22

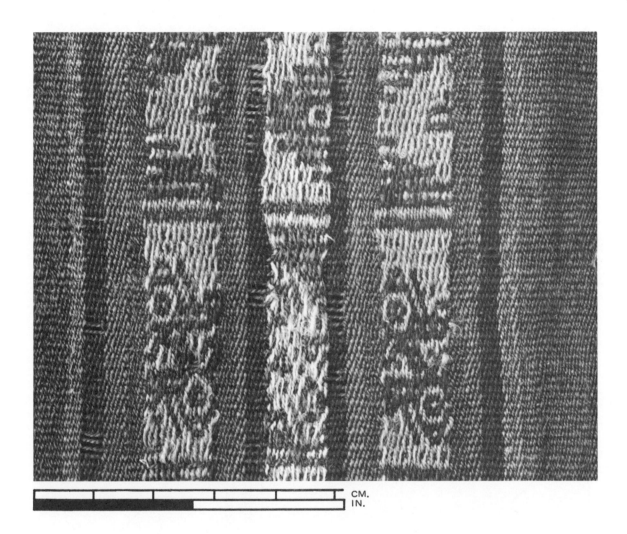

CM.
IN.

A section of a pattern stripe of one of two pieces of fabric, 30027a [1748a], which may have been parts of a poncho-shirt. These were found with a mummy.

FIG. 23

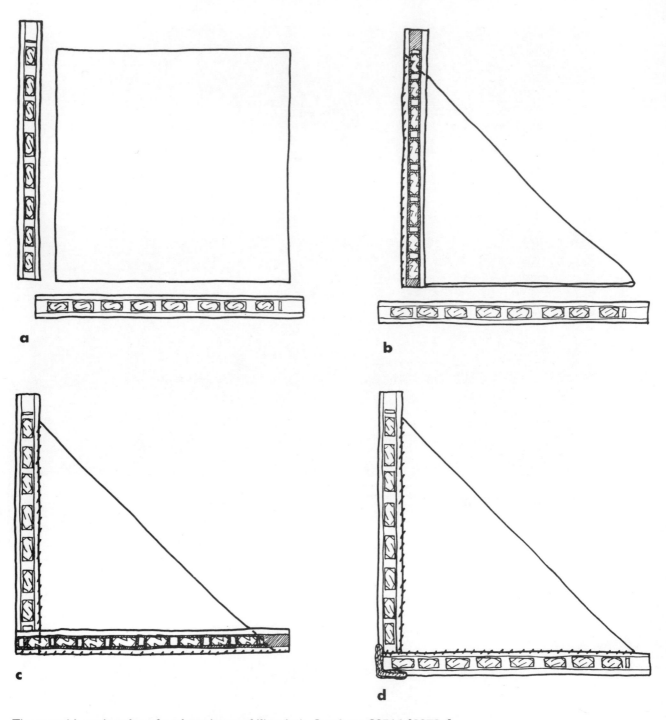

The assembly and sewing of a triangular scarf-like cloth. Specimen 29714 [3270d].

 a. The individual webs — a gauze weave square and two sections of patterned banding.

 b. The folded square with one band attached.

 c. The first band turned out; the second sewed in place.

 d. The finished piece, with needleknitted corner.

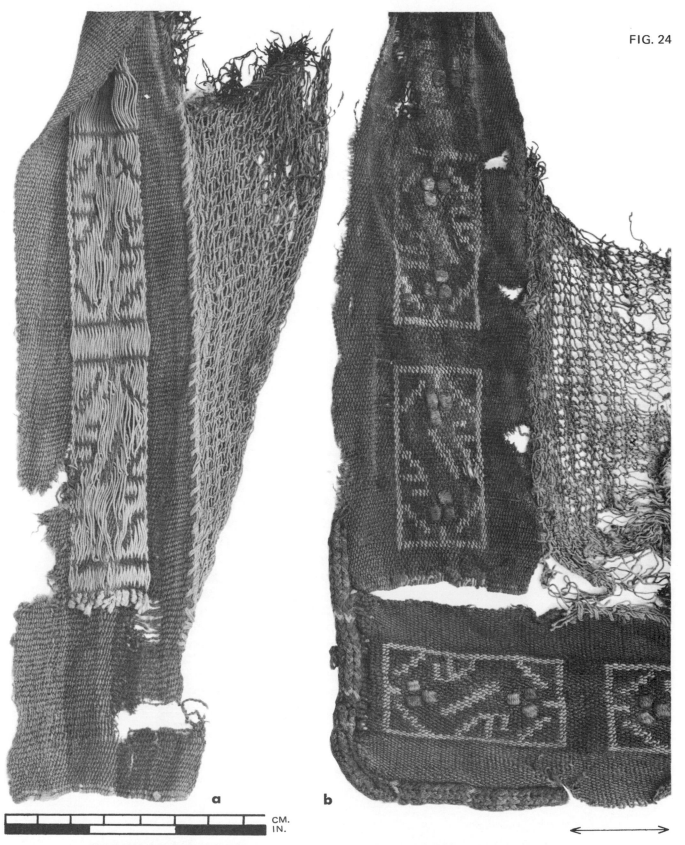

FIG. 24

CM.
IN.

Parts of two corners of the triangular scarf-like cloth 29714 [3270d].

a. The reverse face of one of the acute-angle corners and an end of one of the two bands.

b. The obverse face of the right-angle corner.

FIG. 25

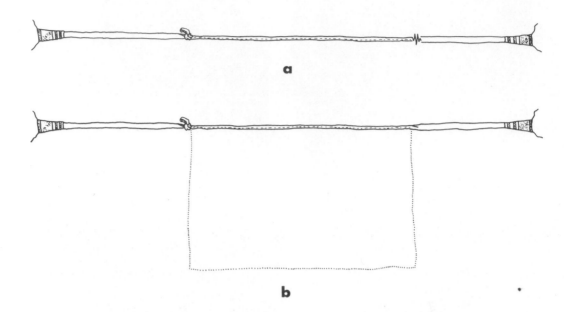

a

b

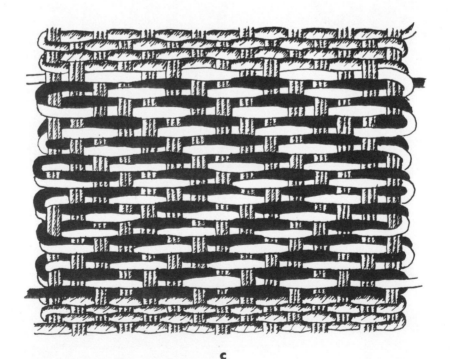

c

Diagrams of an apron-like cloth. Specimen 29568 [1345].

a. The remaining band, now in two segments.

b. A reconstruction, based on Uhle's description, remaining sewing, and cloth and yarn fragments.

c. A detail of the weave of sections of the end borders of the band.

FIG. 26

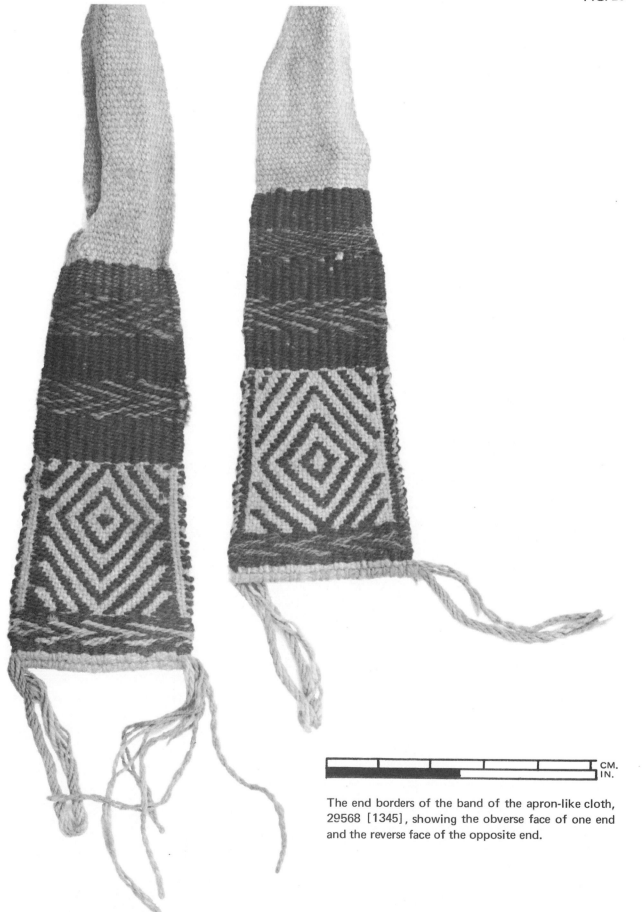

The end borders of the band of the apron-like cloth, 29568 [1345], showing the obverse face of one end and the reverse face of the opposite end.

FIG. 27

A piece of tapestry with attached fragments of plain white cloth, designated as a "loin cloth." Specimen 29680 [1182b].

Fig. 27 (left). A reconstruction from the remaining fragments.

Fig. 28 (below). A photographic detail of the upper left corner.

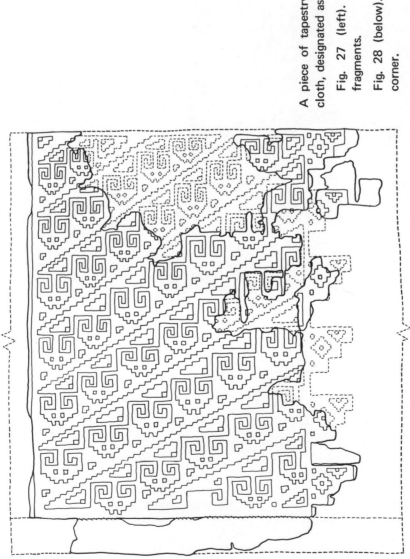

FIG. 28

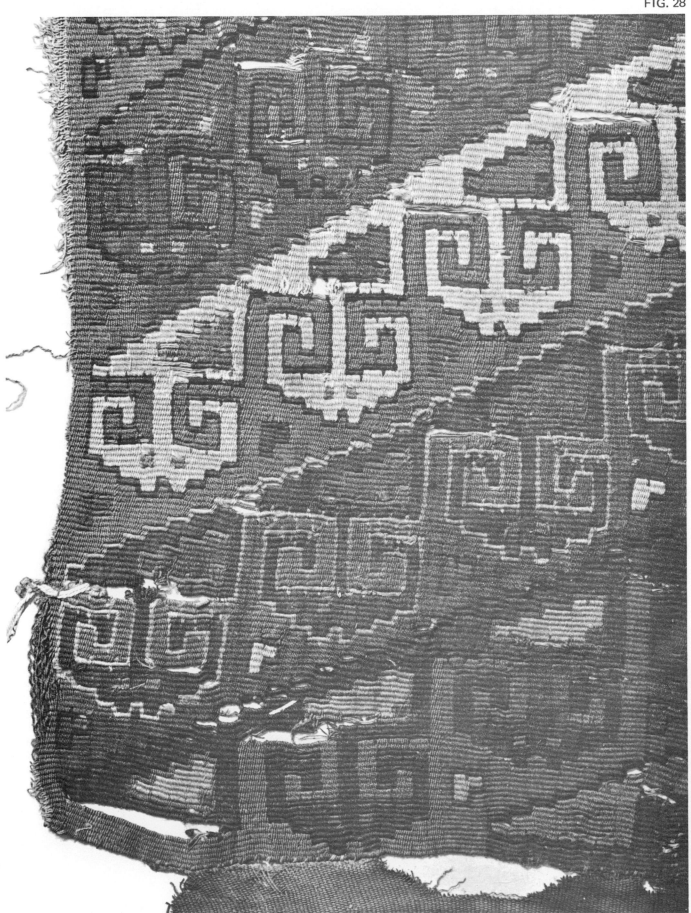

FIG. 29

A specimen in which needleknitting has been added to finish the selvage edges of a brocade border. Specimen 30174 [1090s].

Fig. 29 (left). A diagram of the part remaining.

Fig. 30 (below). Part of the brocaded border with its reversed-diagonal pattern arrangement.

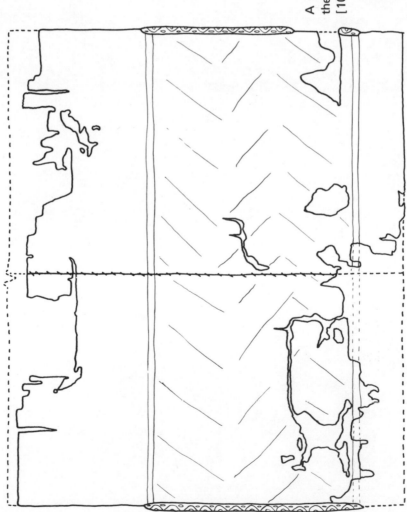

FIG. 30

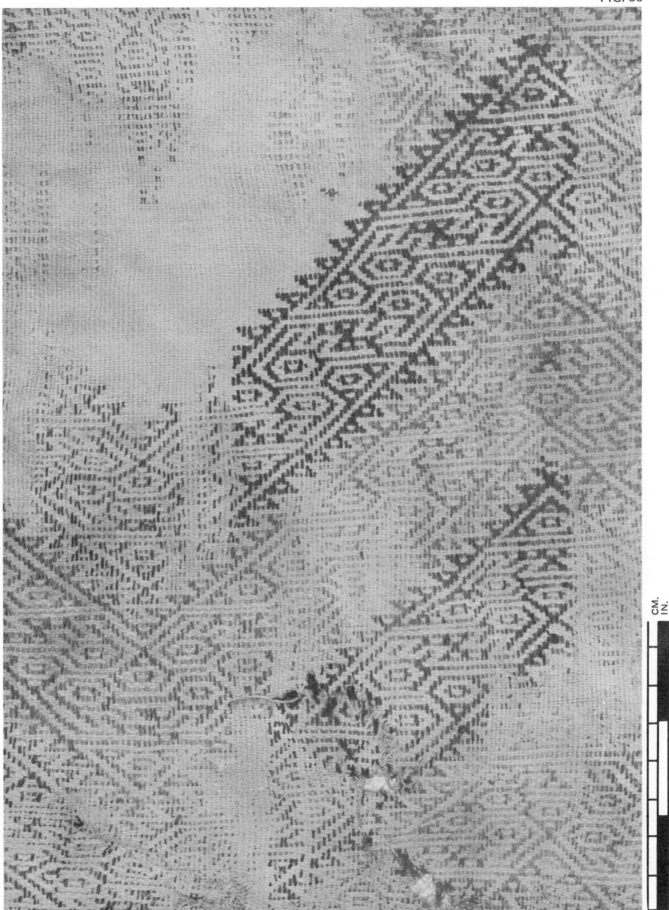

FIG. 31

CM.
IN.

b

A cotton tie-dye cloth with a plain sewed-on section. Specimen 30211b [1770n].
a. A diagram of the remaining part of the specimen.
b. A detail of the patterning in which the undulations resulting from the tie-dye processes are preserved.

a

FIG. 32

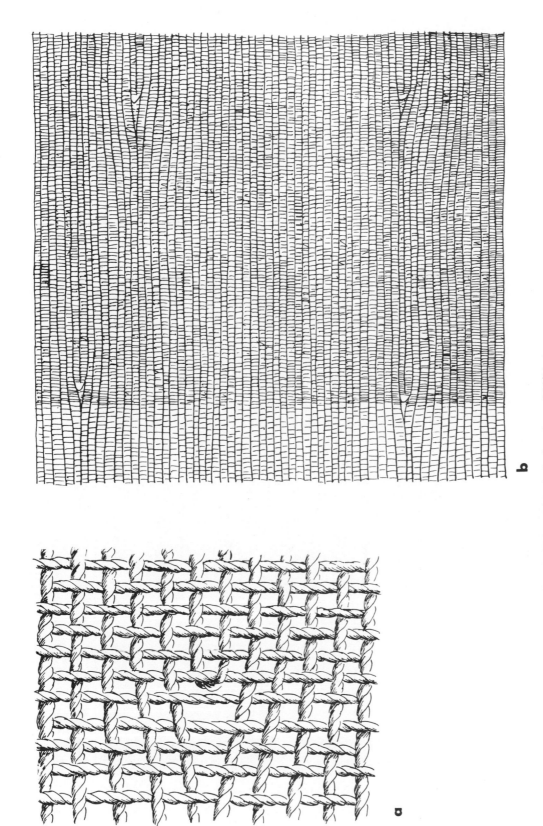

Diagrams of extra wefts inserted along one side of a large white cloth. Specimen 30954a,b [1180c].

a. A detail of the construction.

b. The general distribution of the turned-back wefts.

FIG. 33

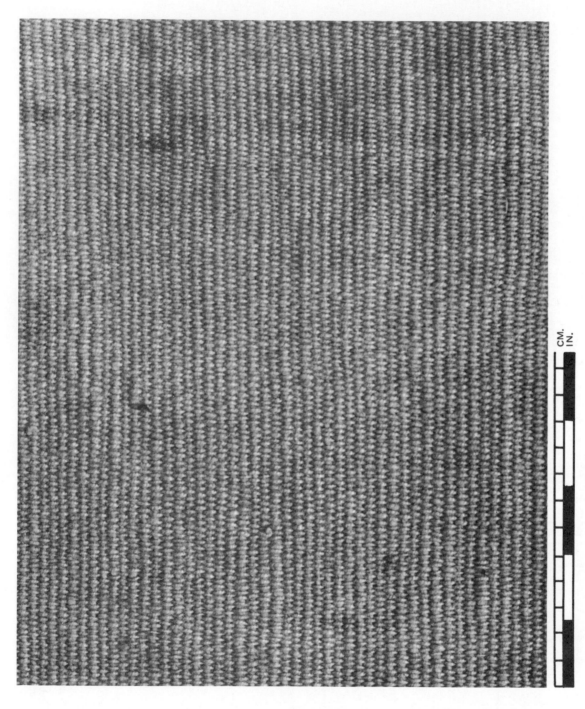

CM.
IN.

Enlarged photograph of Specimen 30954a [1180c].

This and the three following figures (Figs. 34, 35, 36) show the contrasts between the textures of four of the cotton cloths used for shrouds.

FIG. 34

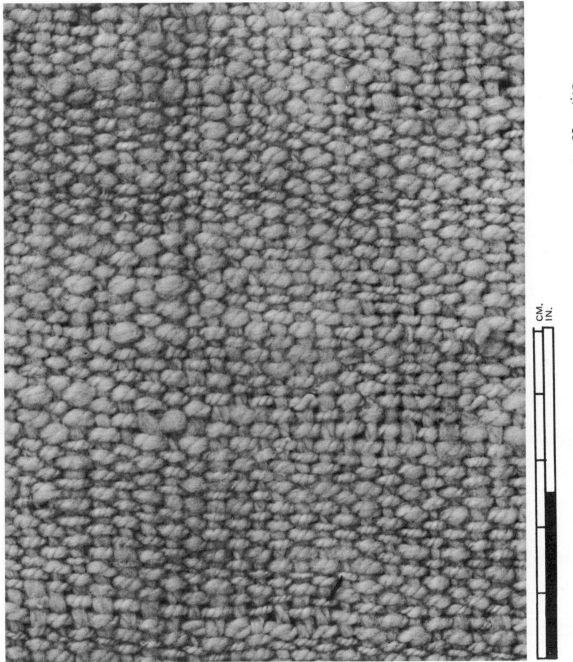

CM.
IN.

Photograph of a section of Specimen 30934 [1097c] enlarged to show texture contrast. See Fig. 33 caption.

FIG. 35

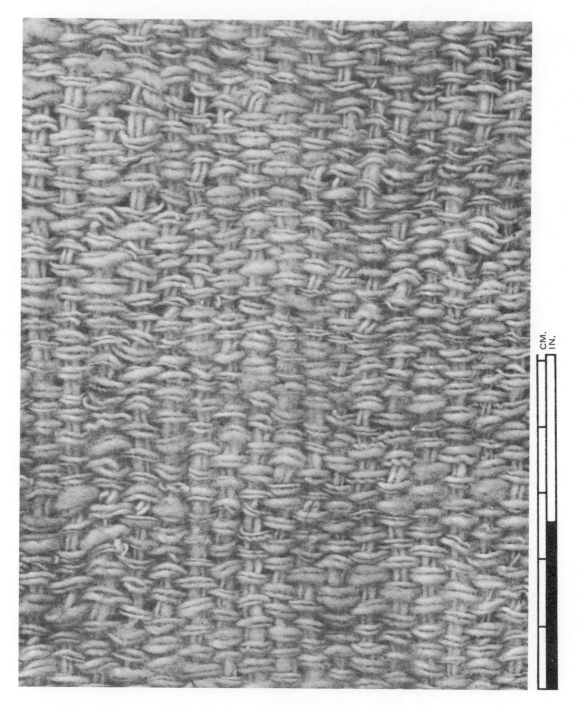

A section of Specimen 30955a [1182g], enlarged to show texture contrast. See Figs. 33 and 34.

CM.
IN.

FIG. 36

CM.
IN.

Photograph of a part of Specimen 30955b [1182g]. See Figs. 33, 34, 35. All have been enlarged to the same scale.

FIG. 37

CM.
IN.

An enlarged photograph of some of the mixed brown and white yarns, 30933 [1176d].

FIG. 38

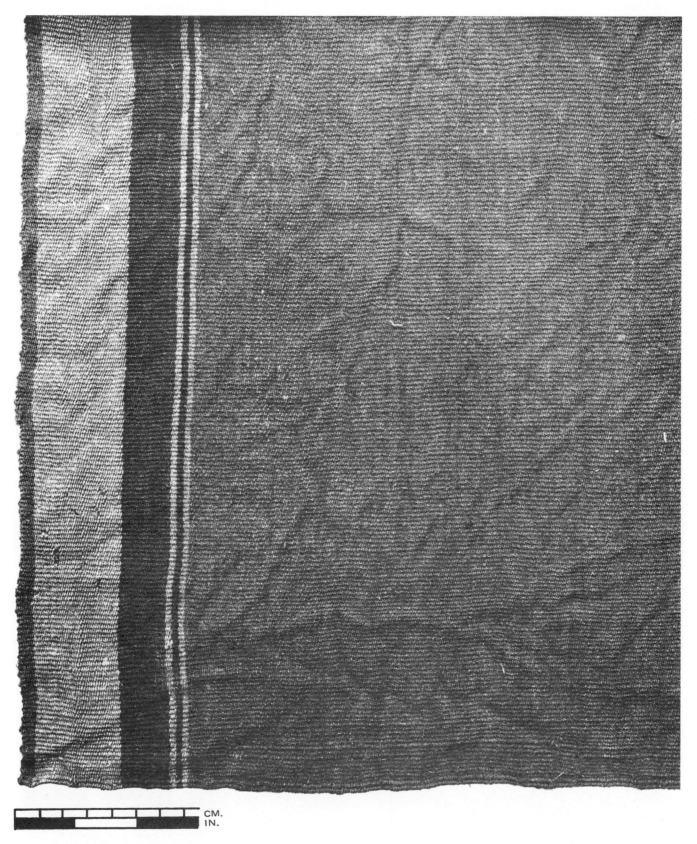

CM.
IN.

One corner of the outer edge of the striped web of one of two large brown wool shrouds, 29873 [3182]. The striping is in red and navy blue.

FIG. 39

A reconstruction of the blue-dyed cotton shroud. Specimen 29870 [1084b].

a. The fragments overlapped, as they are today. The minimum size has been estimated on the assumption that the four sections had like dimensions.

b. The probable positions of the four webs and the layout of the cloth before the central section rotted away.

FIG. 40

A diagram of the detail of the pattern weave of the preceding example (the shaded parts of Fig. 39). This shows the obverse face; the reverse face appears as plain weave.

Enlarged photographs, in the two following figures indicate the inconspicuous nature of the patterning on the obverse face and its absence on the reverse face of the fabric. The photographs show the meeting of adjacent patterned and plain areas, with the herringbone pattern discernible on the obverse face (Fig. 41). At one point within the area shown, a weft yarn of the unpatterned section turns back at the edge of the pattern, possibly one of many treated in like manner to compensate for the added bulk of the pattern wefts of the adjacent area.

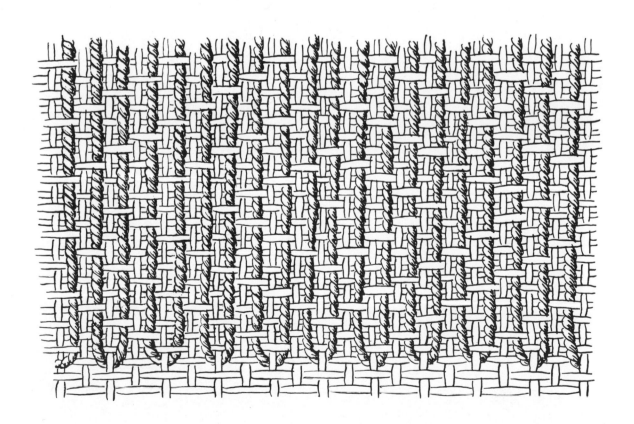

FIG. 41

CM.
IN.

A section of the obverse face of Specimen 29870 [1084b] where patterned and plain areas meet.

FIG. 42

CM.
IN.

The reverse face of the same section of Specimen 29870 [1084b] shown in Fig. 41.

FIGS. 43-44

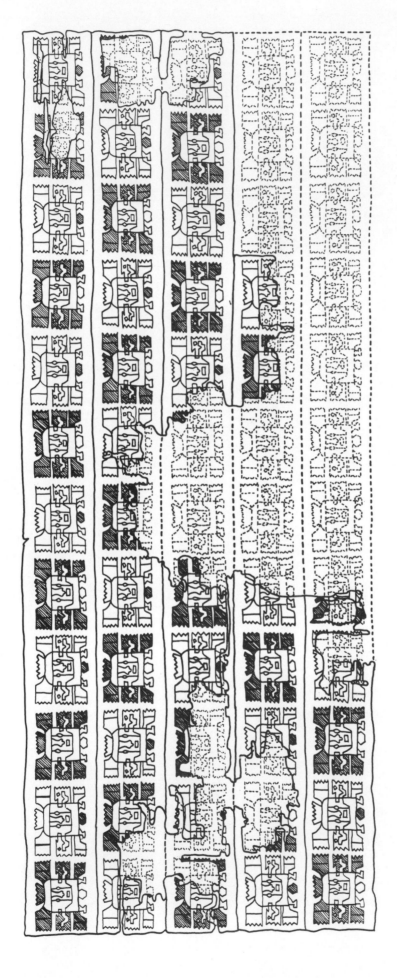

Fig. 43 (above). A reconstruction of the large tapestry shroud. Specimen 29492 [3179a, b].

Fig. 44 (below). A photograph of six of the figures of this shroud. Some of the minor variations between the different figures may be noted and the alternate dark-light sequence.

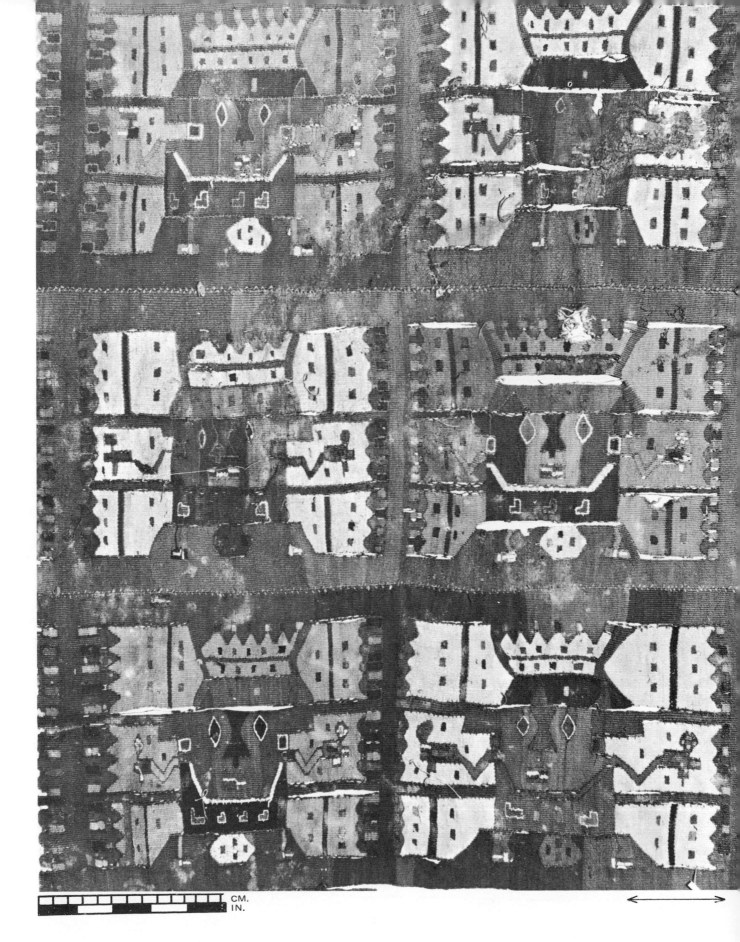

CM.
IN.

FIG. 45

c

a

b

Diagrams of three tapestry figures. All are from different tapestry fragments.

a. The figure from the large shroud, Figure 43.

b. From "another piece" classed with the above.

c. The figure from Specimen 29953 [1748f].

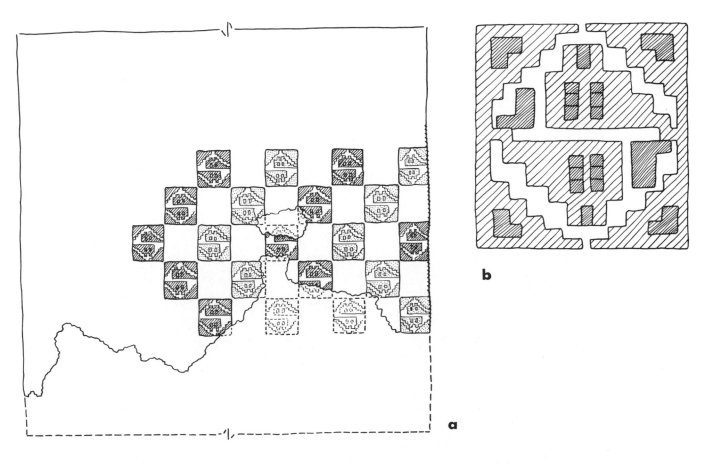

Fig. 46. The chevron-like arrangement of the figures of Specimen 29661 a,b [1084] and an enlargement of one of the figures.

Fig. 47. The two odd motives from Specimen 29662 [1085a].

FIG. 48

CM.
IN.

A section of one of the red wool "shawls" or frontlets, 29850 [3181], which has a silky texture.

FIG. 49

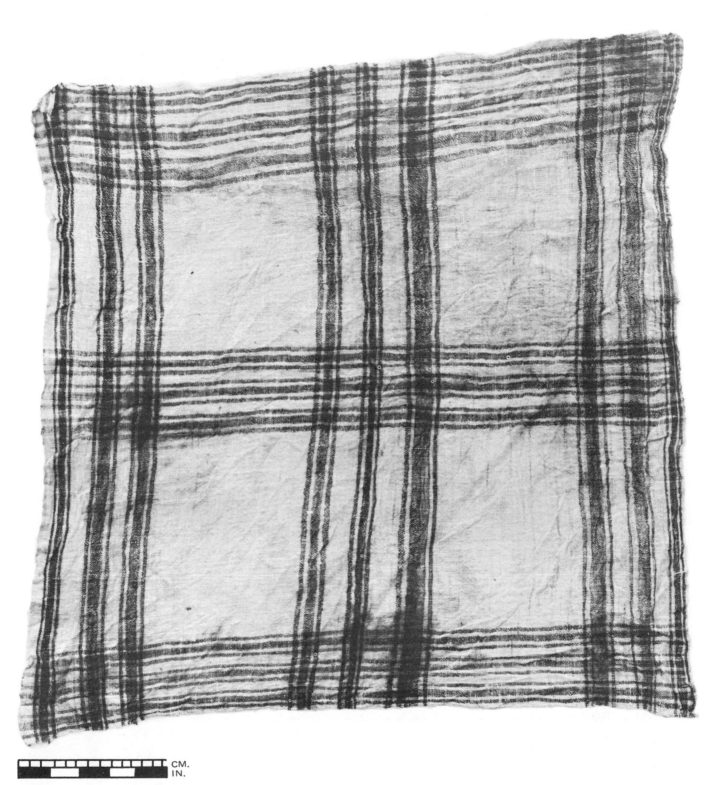

CM.
IN.

A square brown and white plaid cotton frontlet, 30273 [1099d] .

FIG. 50

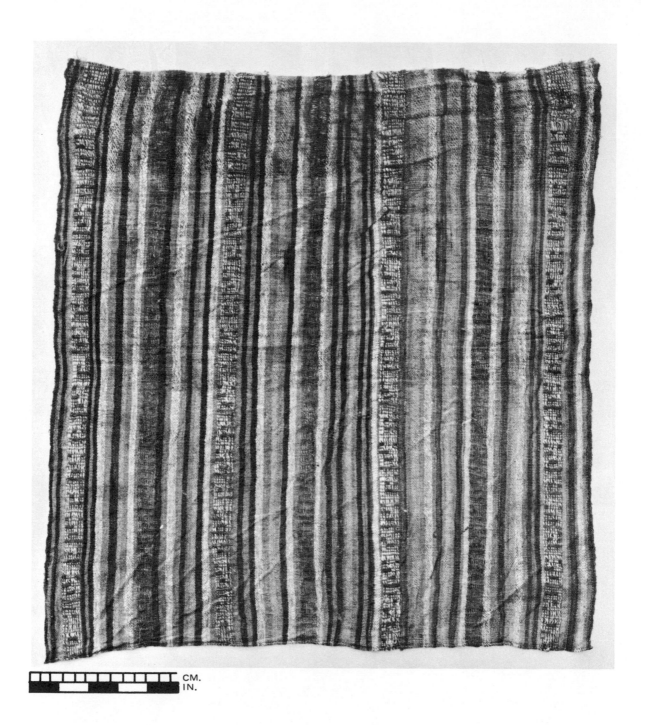

CM.
IN.

A striped cotton frontlet, 30242 [1099c], in which seven stripes in a simple pattern weave, the alternates with different value contrasts, are approximately equidistant, with unpatterned stripes between.

FIG. 51

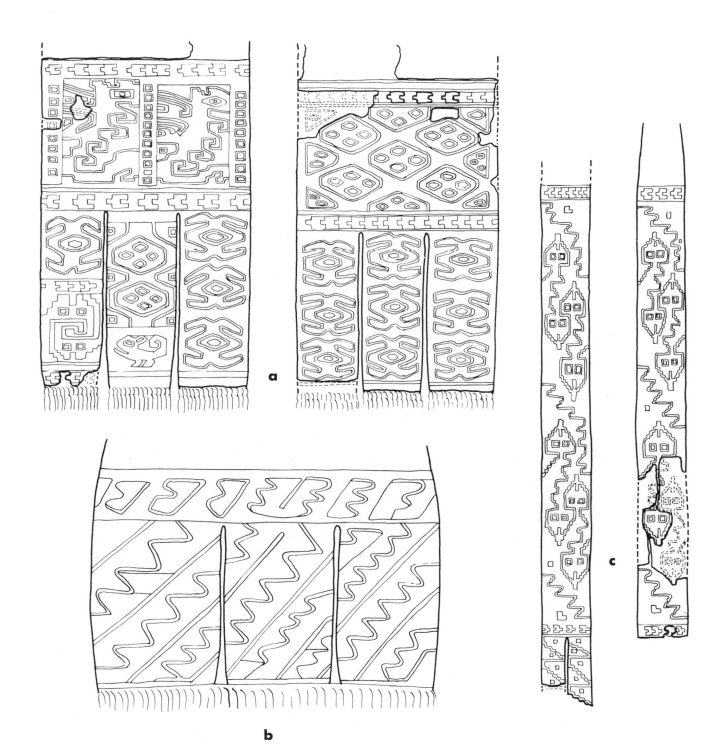

Patterns from the tapestry end borders of three bands having the terminal sections divided into two or three tabs.

a. Specimen 29668 [3256].

b. Specimen 29541 [1090u].

c. Specimen 29884 [3270c].

FIG. 52

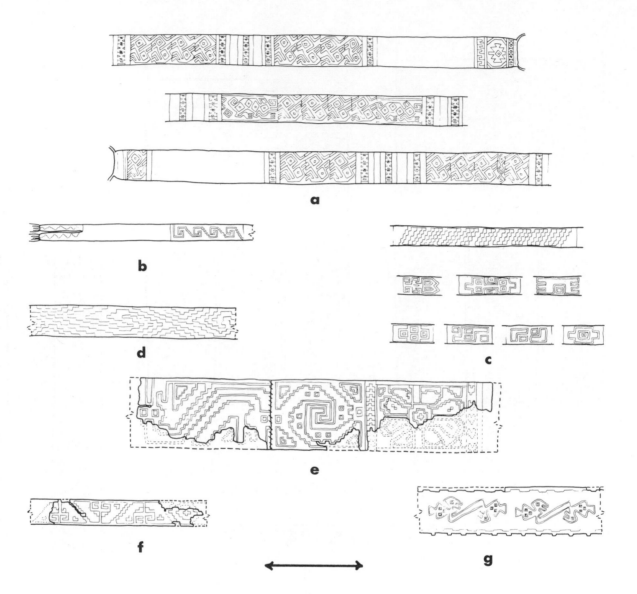

Diagrams of the patterning of various bands and borders.

 a. The patterned sections of Specimen 29666 [1079d].

 b. One pattern block and the end section of Specimen 29697 [3187].

 c. The design motives from Specimen 29696 [1176b]. These units have been arranged to form a continuous pattern, with the sequence of the motive varying.

 d. The interlocking latchhook pattern of Specimen 29911 [1090a].

 e. The complete design from Specimen 29682 [1176c] of which Uhle shows only the central unit (1903, Pl. 6, Fig. 12).

 f. All that remains of the patterning of a fine bit of tapestry. Specimen 29687b [3214c].

 g. The design from a tapestry border fragment, Specimen 29909 [1090a].

FIG. 53

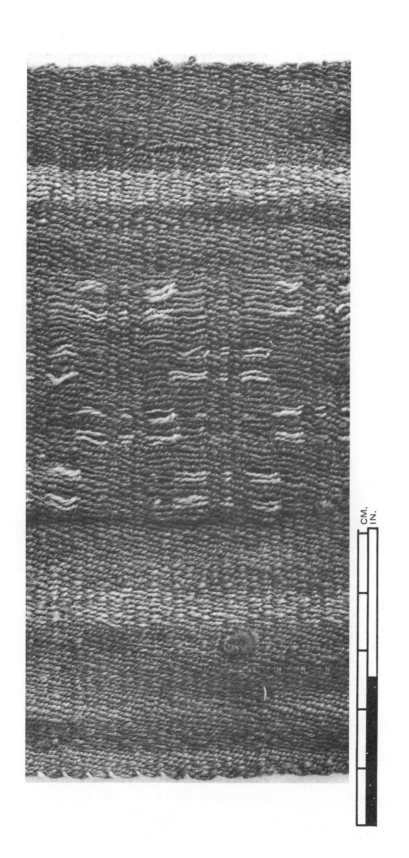

CM.
IN.

A section of the striping of a narrow wool fabric, 30060 [1090b].

FIG. 54

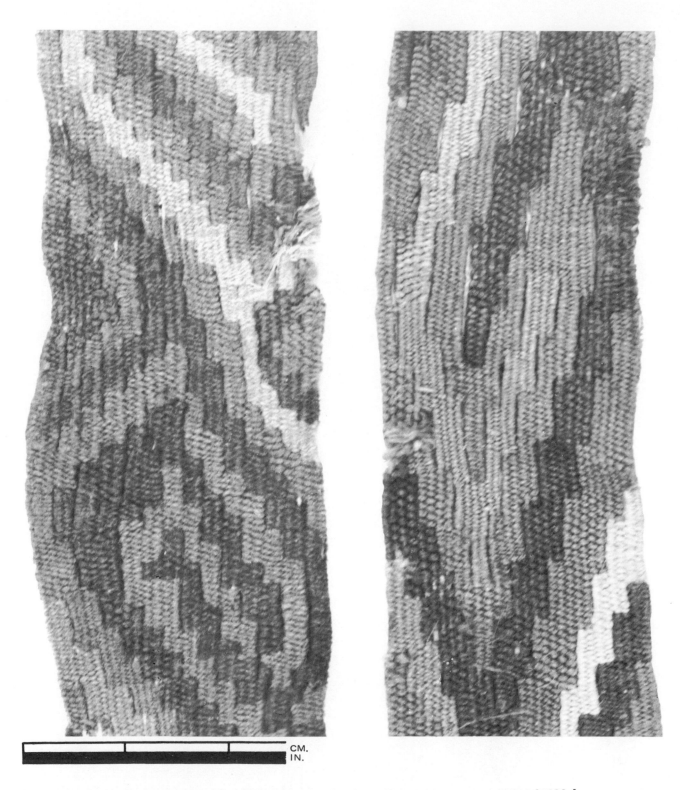

CM.
IN.

Two parts of a narrow tapestry band in which the pattern has been distorted in weaving, 29911 [1090a].

FIG. 55

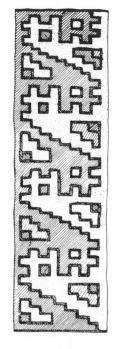

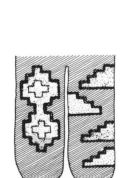

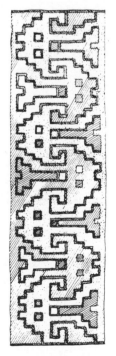

A long narrow band, principally tapestry, with plain red sections and many patterns. Specimen 29686 [3180].

a (left). The various designs. The only repeat occurs in one of each pair of the end tabs.

b (below). A diagram of the construction of the tab ends.

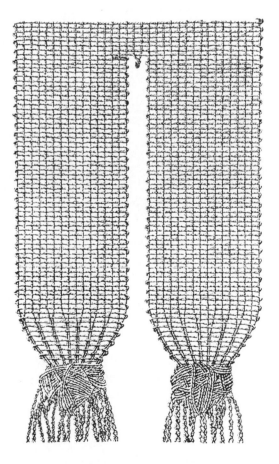

FIG. 56

Outlines of the small and miniature rectangular fabrics showing their comparative shapes, sizes, and proportions.

a. The unpatterned and striped pieces with evidence of shaping. Specimens 30443 [1090m], 30425 [1162c], 30947a,b [1177b].

b. The unpatterned and striped webs with no shaping. Specimens 30255 [1090d], 30864 [1141q], 30266 [1162d], 30940 [1176e].

c. The two-web cloth. Specimen 30468 [1090q].

d. The patterned webs. Specimens 30427 [1090-l], 29773 [1141o], 29767 [1160b], 29768 [3193a].

e. The miniature unpatterned webs. Specimens 30589 [1090r], 30590 [1090r], 30591 [1090r], 30547 [3193d].

f. The miniature patterned webs. Specimens 29747 [1151d], 29838 [3214a], 29839 [3214a].

Fig. 57. Diagrams of the pattern weave of Specimen 30427 [1090-I].

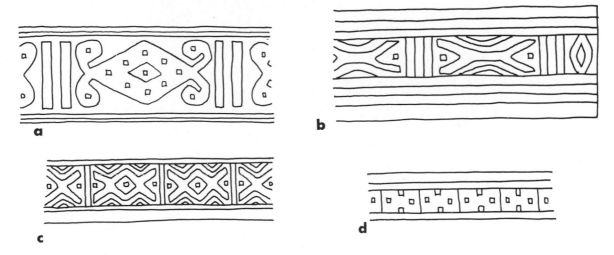

Fig. 58. The designs from the end borders of the three small and two miniature cloths.

a. Specimen 29773 [1141o].

b. Specimen 29767 [1160b].

c. Specimen 29768 [3193a].

d. Specimens 29838 [3214a], 29839 [3214a].

FIG. 59

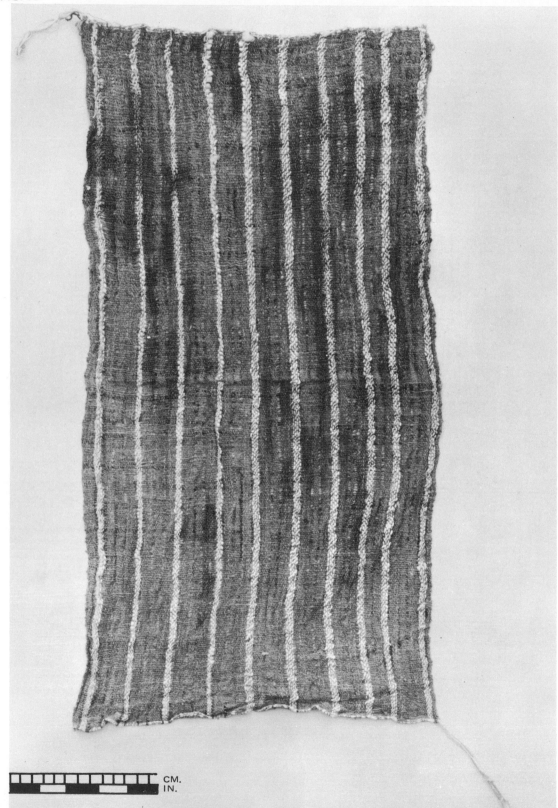

CM.
IN.

A warp-striped small web, in shades of brown and white, in which spaced warps have been used as part of the stripe sequence. Specimen 30255 [1090d].

FIG. 60

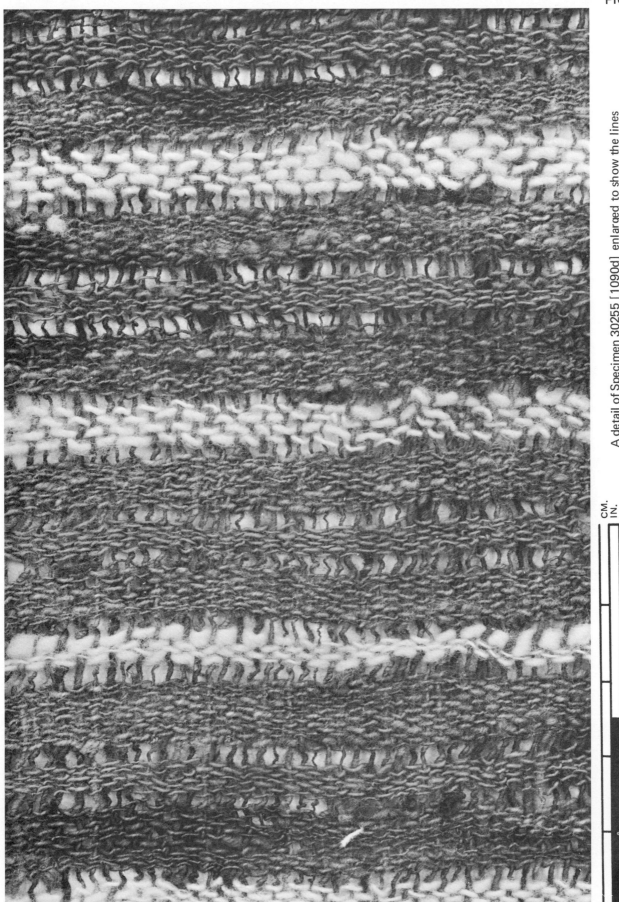

A detail of Specimen 30255 [1090d] enlarged to show the lines of the warp spacing. In the photograph these spaces look like shadows adjacent to the cords between the light stripes.

CM.
IN.

FIG. 61

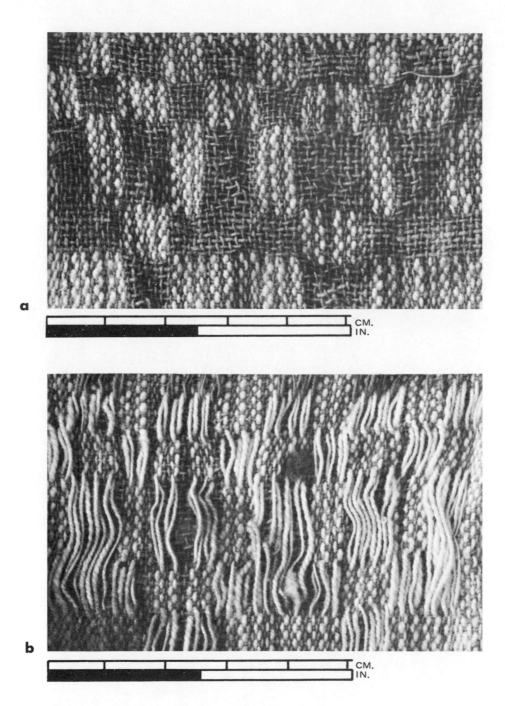

Details of the weave of one of the miniature fabrics, 29747 [1151d].

 a. Obverse.

 b. Reverse.

FIG. 62

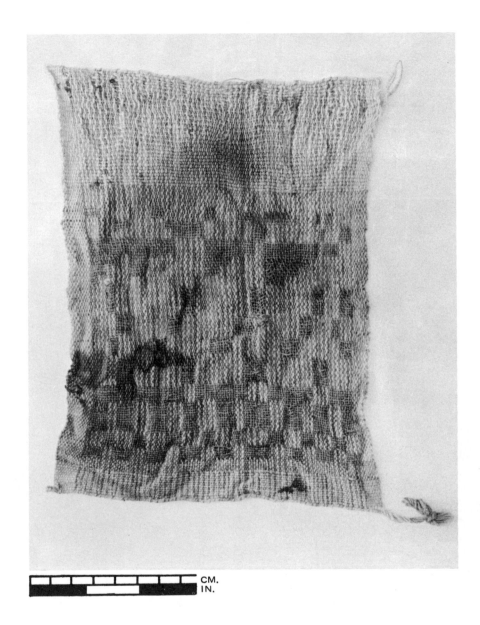

CM.
IN.

The whole of the fabric of which a detail is shown in Fig. 61. The design contrasts with the latchhook patterns of other specimens woven in the same technique (Figs. 10 and 24).

FIG. 63

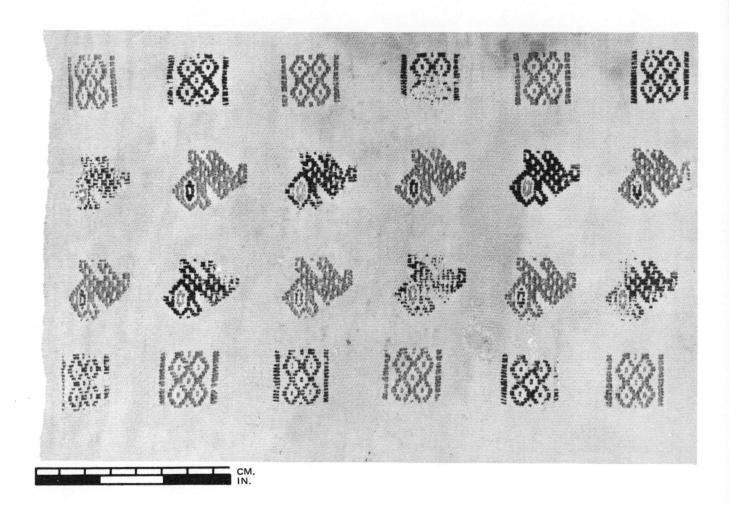

See Fig. 64 on opposite page.

FIG. 64

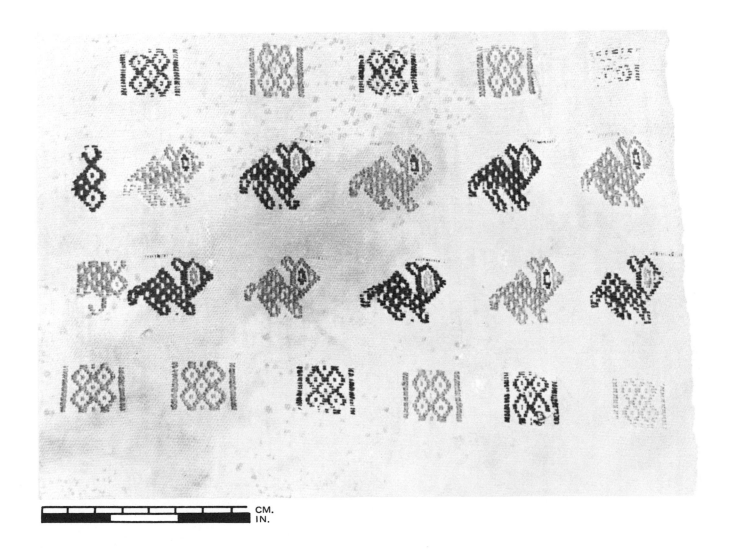

CM.
IN.

Figs. 63 and 64. The figured blocks at the end of one of the large two-web cloths, 29756 [3193b], showing their position in relation to the side selvages, the differences in the patterning of the two webs, with the inversion of the animal figures on one web.

FIG. 65

The design blocking on four two-web cotton cloths with small repeat patterns.

 a. Specimen 29756 [3193b].

 b. Specimen 29760 a, b [3258b], larger fragment, one of two pieces.

 c. Specimen 29757 [1182e]. d. Specimen 30153 [1090v].

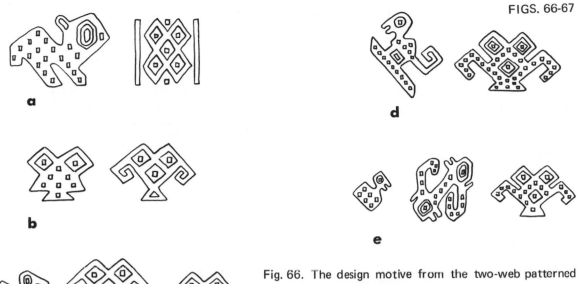

Fig. 66. The design motive from the two-web patterned fabrics shown in Fig. 65, with one additional fragment.

 a. Specimen 29756 [3193b].

 b. Specimen 29760 a, b [3258b] larger fragment.

 c. Specimen 29760 a, b [3258b] smaller fragment.

 d. Specimen 29757 [1182e].

 e. Specimen 30153 [1090v].

Fig. 67. The relative proportions of the individual webs of the patchwork fabrics.

 a and b. Specimens 29880 [1162b] and 29781 [3785], two matching fragments.

 c. Specimen 30214 [1770r].

 d. Specimen 29991a [1272f].

 e and f. Specimen 30226 [1149d].

Fig. 68. A section of the side selvage of a cloth, 30207 [2032], where the tie-dye pattern extends onto a sewed-on web fragment.

Fig. 69. Enlarged photograph of some of the mixed brown and white yarns of Specimen 30421 [3190].

 a. The tweed-like effect produced by the intermixture of brown and white in the yarns.

 b. Sections of one set of heading cord ends, with one untwisted to show the component yarns.

FIG. 70

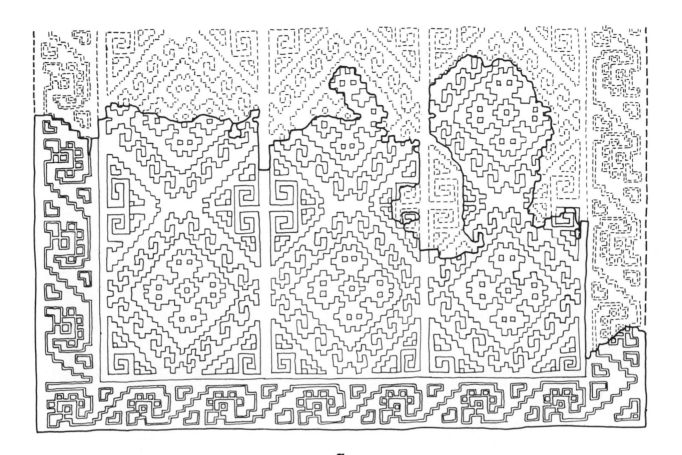

Reconstructions of parts of the patterning from fragments of tapestry and tapestry-like fabrics.

a. Tapestry. Specimen 29683 [1141q].

b. Tapestry-like. Specimen 29667 [1141q].

c. Tapestry-like. Specimen 29889 [1155b].

FIG. 71

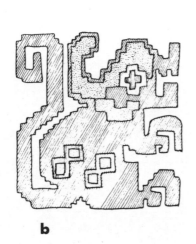

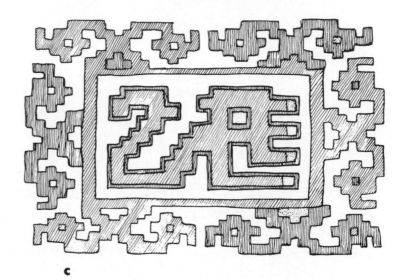

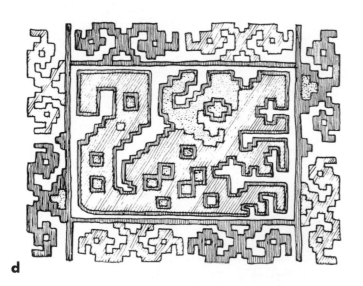

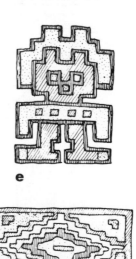

Diagrams of the reversible block patterns from five textile fragments.

 a. The two motives from Specimen 29654 [3791g].

 b. The squirrel-like motive from Specimen 29653 [3791f].

 c. Animal figure with enclosing border with a bird motive. Specimen 29652a [3791e].

 d and e. The two figures from Specimen 29650 [3792].

 f. The motive from Specimen 29759 [1182f].

FIG. 72

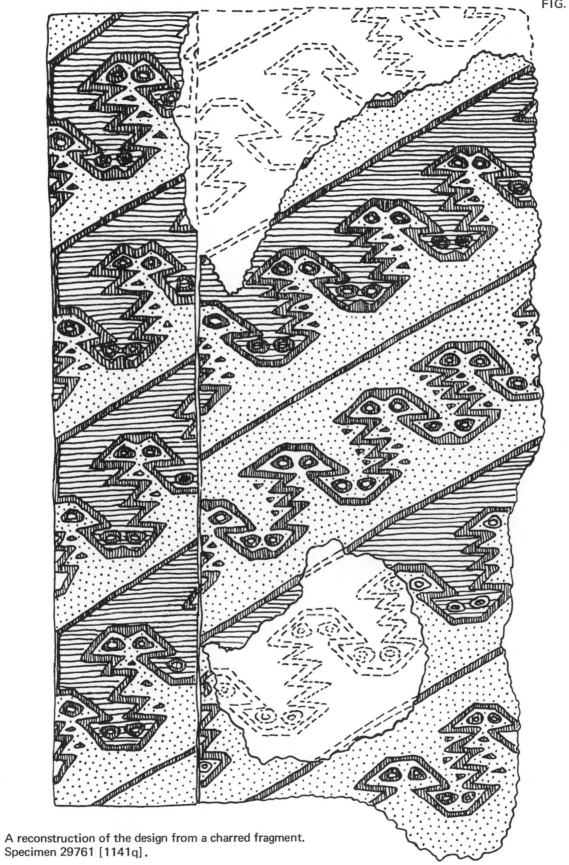

A reconstruction of the design from a charred fragment.
Specimen 29761 [1141q].

FIG. 73

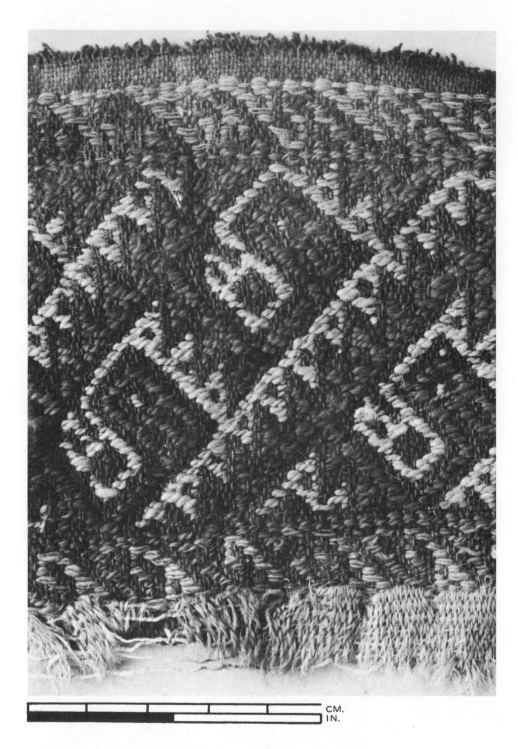

CM.
IN.

Detail of one of the non-reversible styles of pattern weaving, 30321b [1149b] , obverse.

FIG. 74

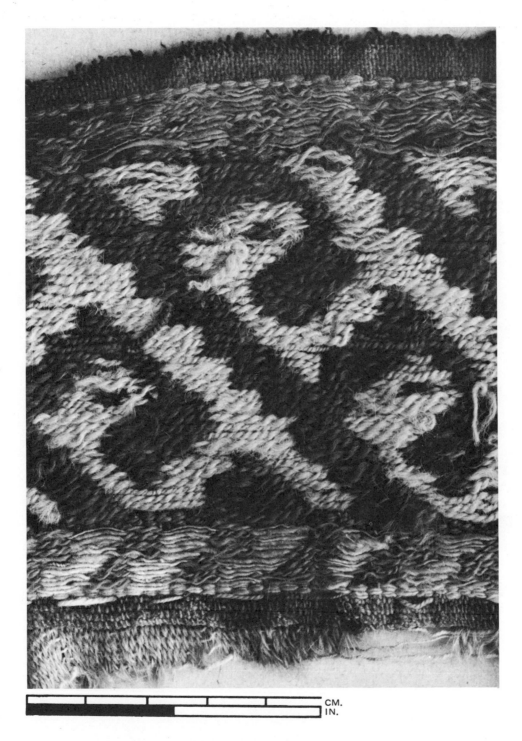

Detail of one of the non-reversible styles of pattern weaving, 30321b [1149b], reverse.

FIG. 75

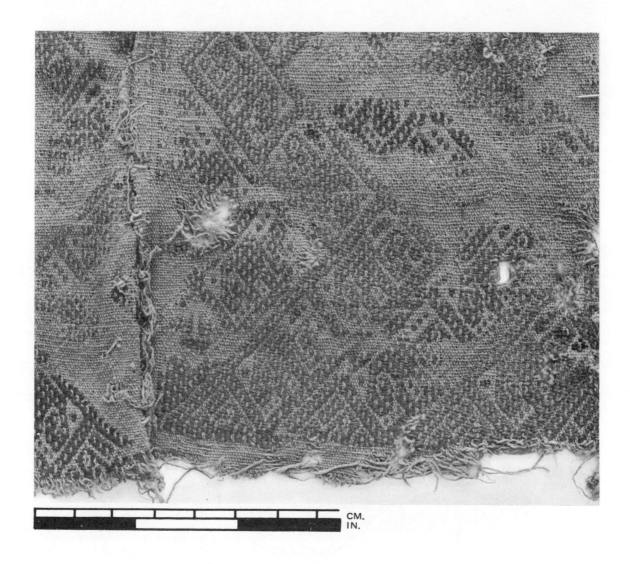

Another style of diagonal patterning. This shows the lattice-like or "negative dot" style of pattern detail characteristic to a number of the Pachacamac textiles. The obverse of one section of 30176 [3793].

FIG. 76

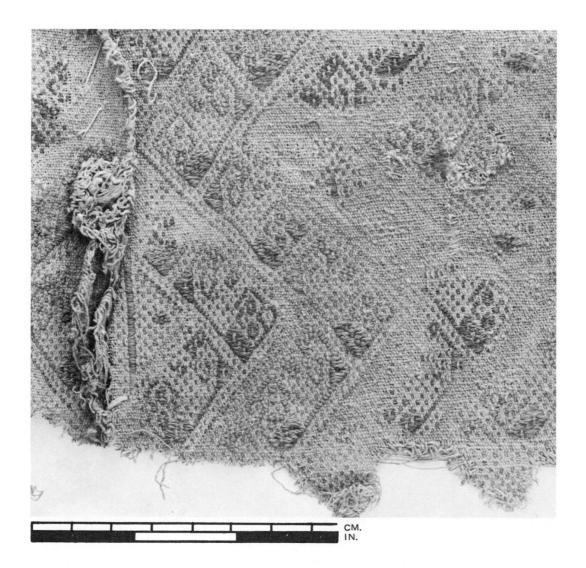

The reverse of an adjacent section of the specimen shown on Fig. 75.

FIG. 77

The simple diapered repeat of Specimen 29664 [3222a].

FIG. 78

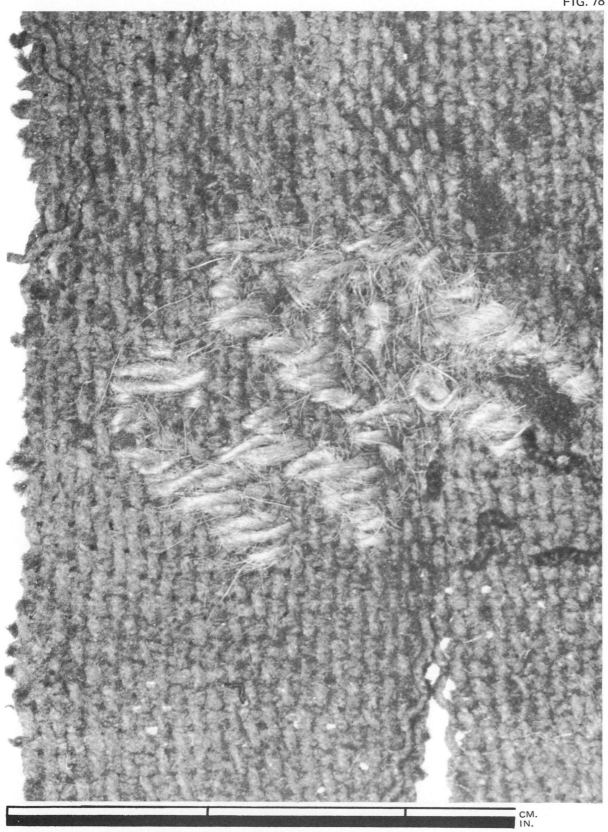

CM.
IN.

One of the motives and a bit of the ground of Specimen
29664 [3222a], enlarged to show the embroidery detail.